VISUAL IMPACT IN PRINT

VISUAL IMPACT IN PRINT

How to make pictures communicate; a guide for the photographer, the editor, the designer

GERALD D. HURLEY

ANGUS McDOUGALL

Designed by Everett McNear

AMERICAN PUBLISHERS PRESS • CHICAGO

Photoengravings by Baker Reproduction Company, Chicago, Illinois.

Printed and published by American Publishers Press—V.I.P., 500 South Clinton Street, Chicago, Illinois 60607.

Library of Congress Catalog Card Number: 71-176260

International Standard Book Number: 0-913426-00-8

". . . Gerald D. Hurley and Angus McDougall of International Harvester *World* magazine. They were the keynote speakers, both well known to the gathered newspaper photojournalists. McDougall served his time as press photographer on the *Milwaukee Journal* and now with Hurley was writing a book about publication photography. Hurley, primarily a writer-editor, and McDougall, an ex-English teacher turned photographer-editor working hand in hand, living examples of the kind of cooperation that can make for great picture-word combinations. As they spoke I noted the possibility that Milwaukee may know something about editor-photographer relationships that other centers don't care to learn about. Before my eyes a picture-oriented journalist and a word-oriented journalist talking like each gave a damn about the other's medium. This was a moving demonstration of team journalism."

John Durniak in *Infinity* magazine.

Why a book on picture editing at this stage of the game? For one thing, the game isn't going well. In too many areas of journalism, the picture gets short shrift. Most editors are word-oriented people. Few of them lavish on pictures the care and attention they devote to their prose. As for pictures in magazines, recent trends have been counterproductive. Emphasis has been placed on graphics at the expense of content. Meaning is often subordinate to "design."

This book is based on the premise that communication is the prime function of pictures in journalism. A premise equally important: communication is best achieved when pictures and words reinforce each other, when they can be made to work in concert.

An underlying assumption is that the printed page will continue to be with us. If it is to flourish, its visual impact must be heightened. More and more editors will have to be brought to the realization that the camera is a truly powerful communications tool. Photographers will have to be made aware of layout considerations. Layout people will have to regard pictures as *pictures,* not as decorative elements. Whether photographer, editor and layout man are three different people or one man wearing three hats, the three roles must mesh. None can be slighted. The cameraman's role is to comprehend the subject, to put his perceptions in visual form. The editor's job is to hone the photographer's material, to shape the message for his specific audience. The designer's task is to enhance readability by bringing refinements and esthetics to the picture-and-word presentation. From such collaboration and common purpose comes effective communication.

The picture handler's best guides are his own good taste and judgment. But there are basic principles and proven techniques that can help him. Unfortunately, there have been few attempts to analyze and reassess these principles since the early 1950s. Lamentably, too, picture use in intervening years has failed to keep pace with progress in photography itself.

Observes a highly respected freelance magazine photographer: "Subject matter for great picture stories is all around us, yet I've never had a picture story published. The picture story has become a rarity. Somewhere we've gone wrong. We've gotten away from the basics and gone to the pizzazz." Lacking substance and often frenetic, pizzazz in print may involve distorted images, psychedelic shapes, splashes of color, tricky type arrangements, trick engraving screens. It is often the mark of an editor grabbing straws, perhaps overreacting to the inroads of television. Amid such gimmickry, the classic picture story—when it does appear —has freshness and vigor. Typographically clean and uncluttered, one picture intensifying the next, the superior picture story offers stunning affirmation that the still picture, properly used on the printed page, can be more personal, more penetrating and palpably more lasting in impact than the fleeting images on screen or TV tube.

This book deals with the picture story in some detail. It also attempts to bring precision to the language of picture use. What, after all, *is* a picture story? How does it differ from the picture essay? What about the large segment of picture use that often masquerades under the story or essay label? To identify this use of miscellaneous pictures on a single subject, the book introduces the term, "picture group." A section called "Photographic Narration and Interpretation" examines the differences among story, essay and group. Awareness of these basic distinctions can clarify thinking in both the taking and the handling of pictures.

Two other terms to recur in the book are *continuity,* which is 180 degrees from single-picture thinking, and *spontaneity*, which results from a willingness on the part of editor and photographer to let things happen naturally. Spontaneity begets credibility and continuity permits interplay of pictures, a requisite if pages in picture journalism are to be easily and quickly read.

Making pictures relate is one of the book's central themes. But visual impact must begin with the individual picture. Introductory sections on cropping, sizing and retouching illustrate the variety of ways the single picture can be helped. A prime objective here is to condition the editor to look as critically at his pictures as he looks at his sentences, to be alert for fat and irrelevancies, to edit for pace and impact.

In these sections and those that follow, the approach is as practical as possible. Down-to-earth presentations are enlivened by examples of good and bad editorial techniques. For purposes of organization, subsequent sections are headed "The Photographer," "The Editor," "The Designer." Since the concerns of each should be the concerns of all, each group of pages has general relevance.

Included also is a section on "The Newspaper Picture Page." There was a time when the line of demarcation between magazine and newspaper photography was clearly drawn. Happily, many newspapers have moved beyond the stage of single-picture thinking. As their reproduced pages make clear, a number of picture-conscious newsmen have succeeded in adapting the principles of good magazine layout to the newspaper's vertical format.

The book concludes with a bibliography that is more than an academic exercise. Twenty leading photographers, editors and educators recommend books for the aspiring photo-journalist, most of them commenting on their choices. The benefit is two-fold: a potential reader can evaluate a book on the basis of who recommends it; each comment reveals something of the respondent's philosophy toward photojournalism.

Whether *Visual Impact in Print* finds a place among "books most valuable" remains to be seen. It is aimed at anyone who has anything to do with pictures in print: the photographer who makes pictures for publication (or who would like to); the editor who uses pictures; the layout man who arranges them on pages; the student interested in one or all of these pursuits.

Less verbose than most textbooks, the book has been assembled as magazines are assembled, one spread at a time. All of the elements in each layout—headline, illustrations and copy—work to the same end. Each spread is designed to make its point quickly. With visual impact.

In subject content, the pictures are practical and relevant rather than far-out and exotic. They parallel closely the kind of material editors and photographers work with every day. Many of them demonstrate the rich potential in down-to-earth subjects—given perceptive thinking and seeing.

There are no four-color illustrations in the book. None was necessary. Color may be an important characteristic of some subjects, but basic black and white is altogether adequate most of the time. Color, of course, can disguise weak content; people who look superficially at pages are often impressed by "pretty color." Conversely, nothing distracts like color poorly reproduced. But the major disadvantage of color, aside from the technical difficulty of getting the pictures originally, is the cost of engraving and printing. Dollars splurged on a color cover could buy several pages of professional black-and-white photography.

Of course, dollars alone will not insure quality in picture journalism. Behind every publication with visual impact are untold hours of dedication. The picture journalist works in a field where few rules are hard and fast. His taste and judgment will tell him when to be innovative and when to stay with the tried and true. He has to sharpen his judgment continuously and he must trust his instincts. The name of his game is communication. He has a message he wants to transplant in the heart and mind of his reader. If he is truly professional, he will put it there with a surgeon's deftness and care.

ACKNOWLEDGEMENTS

For counsel, encouragement and total cooperation as this book developed, the authors are indebted to a small army of photographers, editors and educators, each of them dedicated to improving the effectiveness of photo-journalism. Many of these talented people, the photographers notably, are credited on other pages. At this point, special thanks are conveyed to the following:

To Robert E. Gilka, director of photography at *National Geographic,* and Professor Cliff Edom, University of Missouri, for critiquing much of the book in its early stages. Their comments sharpened both thought and presentation.

To Fred K. Paine and Edom, for sanctioning the updating of their study of "books most valuable to the aspiring photojournalist."

To Robert M. Lightfoot III, Ted Spiegel, Howard Sochurek and Ted Rozumalski, for helping bring into clearer focus "The editor and the freelance photographer."

To Chester Gerstner and Bruce Bendelow, Bendelow and Associates in Chicago, for sharing their expertise on retouching.

To Frederic Ryder Co. for typographic examples on pages 174–179.

To Ben Lavitt, Astra Photo Service in Chicago, for shedding light on darkroom operations as they involve editors.

To Gerry Amber and Paul W. DeRoo, for doing the same in areas of photo-engraving and printing.

To John J. Dierbeck, Jr., for his contributions during the formative stages of the project.

To Howard Levin, University of Chicago Press, for his counsel on book promotion.

To Attorney W. Mack Webner, for highly professional services.

In addition, editorial samples and aid in various forms were provided by: John Durniak, *Time* magazine; Howard Chapnick, *Black Star*; Harvey Weber, *Newsday*; George Lockwood, *Milwaukee Journal*; Mitch Milavetz, *Decatur (Ill.) Herald and Review*; Bill Kuykendall, *Worthington (Minn.) Daily Globe*; Rich Clarkson, *Topeka Capital-Journal*; Bill Strode, Louisville *Courier-Journal*; James A. Geladas, Dubuque *Telegraph-Herald*; Dick Sroda, Paddock Crescent Newspapers; Barry Edmonds, *Flint Journal*; Jim Vestal, *Sacramento Union*; Sam Vestal, Watsonville (Calif.) *Register-Pajaronian*; Sey Chassler, *Redbook* magazine; Edward Oxford, N.Y. *Telephone Review*.

Among educators who helped were R. Smith Schuneman, University of Minnesota; C. William Horrell, Southern Illinois University; Werner Severin, University of Texas; J. B. Woodson, West Valley Junior College; the late Wilson Hicks, University of Miami.

Finally, an appreciative word for John W. Vance, retired director of public relations for International Harvester, who gave this book project his blessing. Beyond that, he respected professionalism, provided a climate for editorial innovation and championed editorial freedom for corporate publications.

TABLE OF CONTENTS

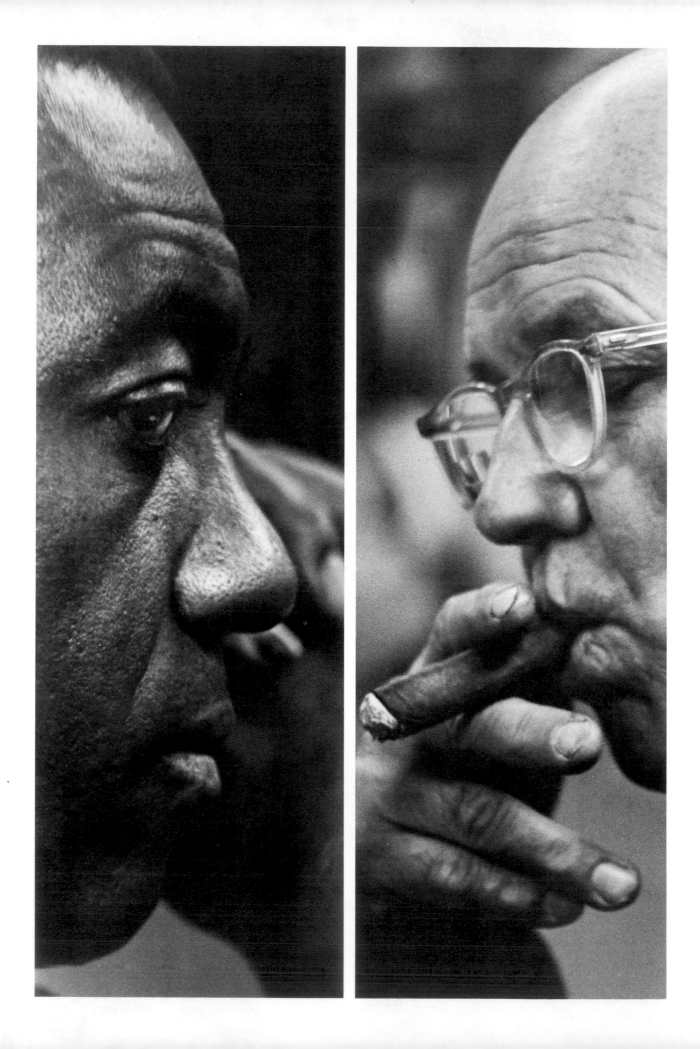

EDITING THE PICTURE

As you crop
so shall you
reap

The artist has one advantage over the editorial photographer. As he confronts his canvas, the painter is the sole arbiter of what is in his picture. Or not in. Within a predetermined frame, he arranges his subject matter as he chooses, controlling all elements of composition. A photographer on editorial assignment rarely works that way. Irrelevant or distracting elements will often appear within his frame of view. He may detect them as he shoots but be unable to eliminate them. What he records is affected, too, by the size and shape of his negative. Its proportions do not always coincide with the image he has in mind. For one or another reason, his full-frame enlargement may be merely raw material. Refinement will come with corrective cropping. But cropping is a sharp-edged tool that cuts both ways. It can help a picture speak emphatically or it can destroy. The editor's taste and judgment are crucial here. With slices of faces (opposite), one editor gave dramatic impact to the essential attitudes of his subjects. Ears came off, but ears don't express emotion.

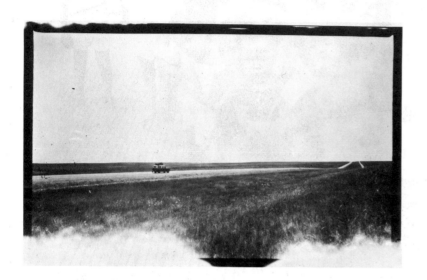

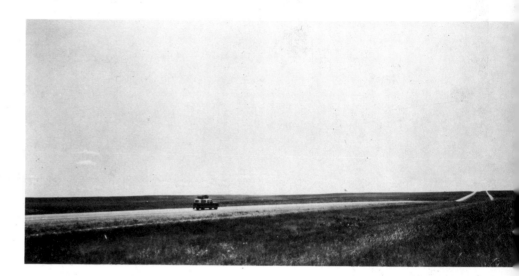

Shallowness can be a virtue, too. Unlike prose, pictures are often eloquent without depth. This prairie scene lost its first slice as a result of fogged film. When he cropped to erase the technical error (above right), the photographer also nullified a shooting error: he got rid of the centered horizon, improved the composition. But there was more surgery ahead. Regarding the bald sky as expendable, the editor made a severe and final cut (below), conveying the feeling of endless prairie with a shallow picture that goes on and on.

Distinctive, change-of-pace shape can give a lift to a layout. And despite its length, narrow horizontal normally occupies no more page area than does the conventional horizontal.

Shelly Grossman

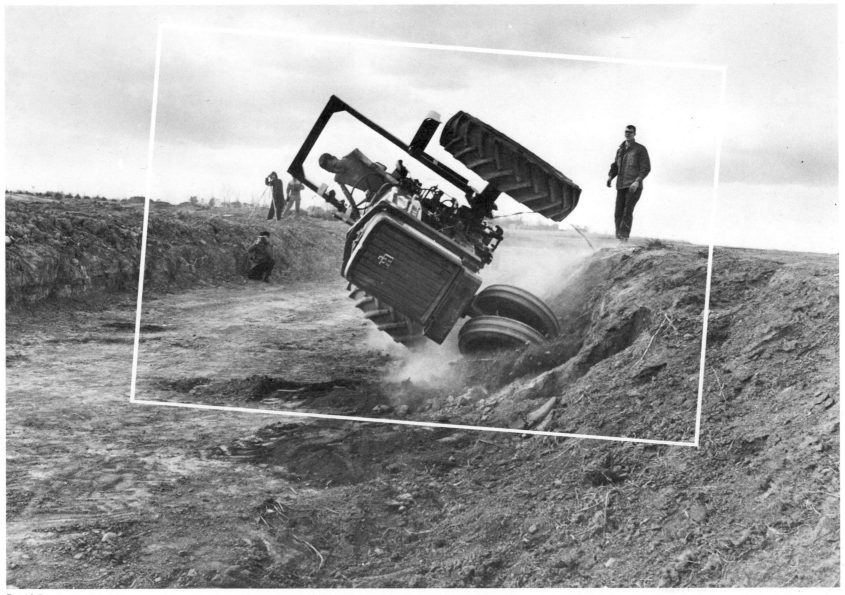

David Cupp

With a tractor careening toward him, the photographer could hardly be faulted for his camera tilt. But there's no excuse for the editor who permits his horizon to run downhill. In this instance, angle cropping not only restored the horizontal but removed excess foreground and diminished the apparent distance between camera and tractor. Viewer impact was heightened. Left and right crops are obviously not absolute, permitting degree of latitude in layout.

Cropping: when the camera can't

Pictures, like quail, often materialize abruptly. They must be shot quickly or be lost forever. In now-or-never situations, the photographer might wish for a better vantage or even a lens with proper focal length. But his instinct will tell him to fire away; in effect, to shoot now and correct later. Compensation will come with cropping. As these examples make clear, crop marks adroitly placed work wonders for visual statements hastily made.

Perceiving a "face" in a moving crane, Tony Linck had only a brief moment to focus. He explains: "I was photographing the hot metal being moved when I saw by the reflected light from the ladle the 'Egyptian Queen' image in the arm of the overhead crane. I just raised my sights and photographed it." Tight cropping did the rest. With irrelevant elements erased, out popped the remarkable, ephemeral face.

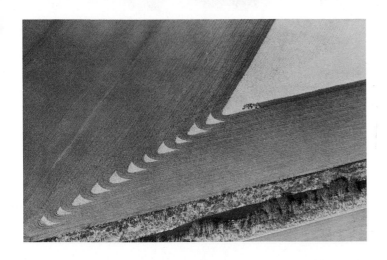

Half-moons left by a disk harrow caught the photographer's eye. But a moving airplane and a moving tractor gave him no time to frame the pattern picture he saw. He shot anyway, aware that cropping could dispose of the drainage ditch and bring the tractor into proper perspective.

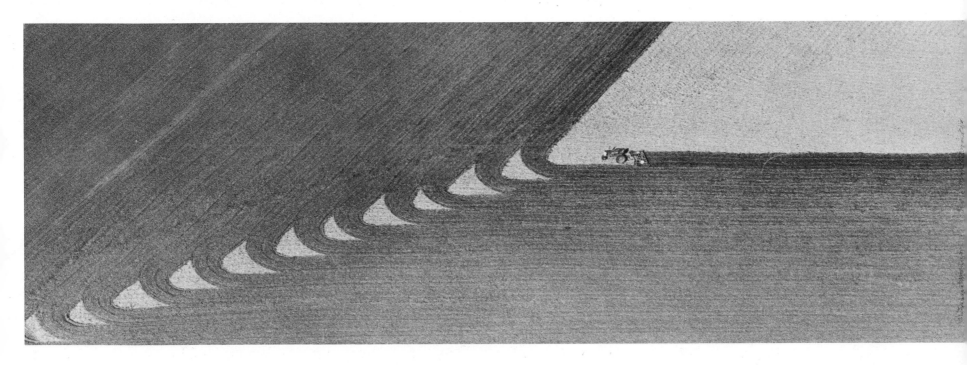

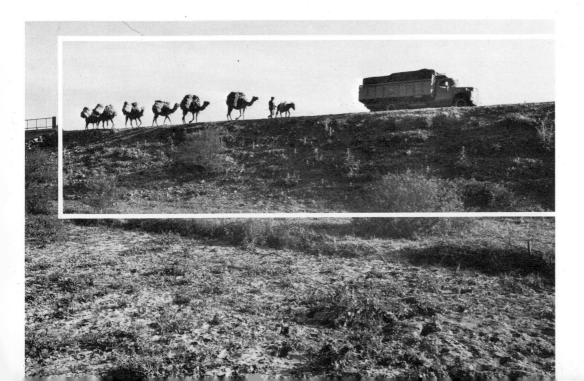

Seeing a truck pass a camel caravan, Ted Spiegel reacted quickly to catch this contrast between ancient and modern cargo-haulers. The scene required almost the full width of his 35-mm negative, but camera-to-subject distance gave him depth to spare. Instinctively providing a base for his picture, he chose foreground rather than sky. Horizontal crop produced the photo he visualized but, for mechanical reasons, couldn't shoot. Crop at left produced final refinement.

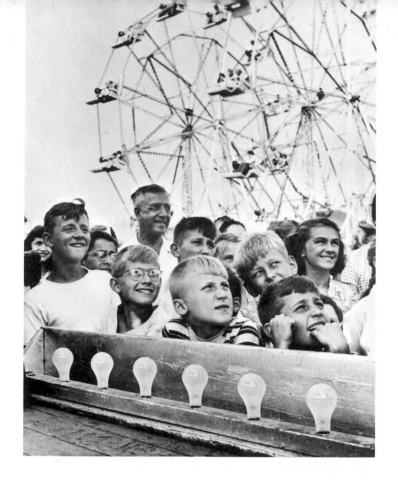

The case for close cropping gets telling support here. A carnival scene comes alive as the crops get tighter. Preliminary cropping disposed of meaningless figures on left, a distracting face on right. Empty stage in foreground disappeared next, leaving footlights and ferris wheels. Next question: wouldn't just a suggestion of the wheels suffice? Final crop took the reader to the heart of the picture: a study of spectators under the spell of a carnival come-on.

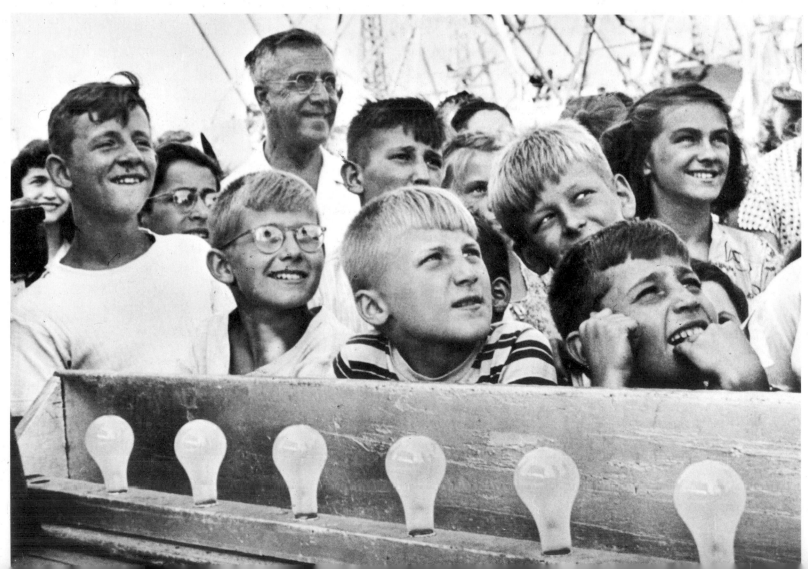

Cropping:
the heart of
the matter

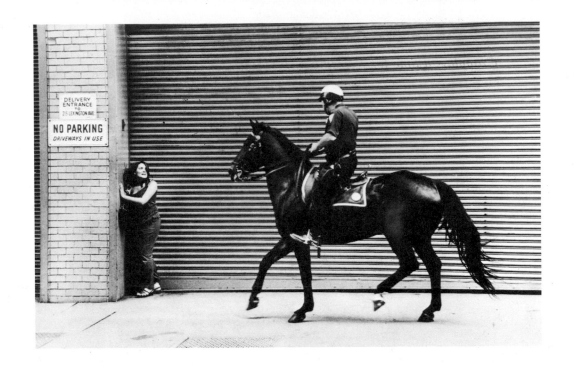

Cropping can be the zoom lens that brings the reader in close. With a normal lens, Melvin Adelglass caught a scene commendable for its composition. From a design standpoint, all the elements are well-placed and pleasing. Until . . . until the *meaning* of the picture comes through. Immediately the reader wants more; he wants to study the tension on the face of the cowering woman. The editor helps by moving in, by cropping out the distracting wall signs and part of the policeman's horse. The confrontation is sharply focused on the reader's mind. Instead of a pretty picture, he sees an eloquent one.

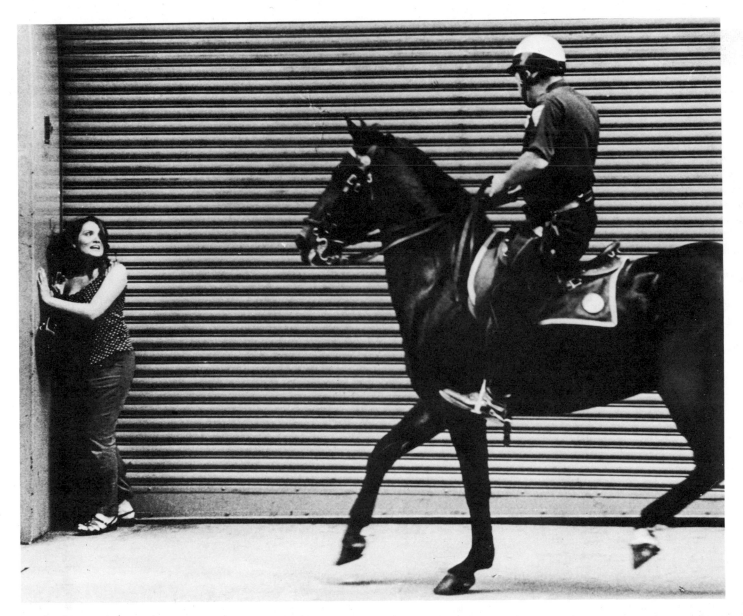

Cropping: a time for restraint

The effective photo-cropper hews to a fine line. He leaves the essentials intact while paring away the insignificant. He takes a second look before he chops, would rather drop a picture than use half a picture. Given a full-frame basketball photo like the one below, he wouldn't consider performing the kind of surgery perpetrated at right. He would preserve the ingredients that make the pictures arresting: the referee's position on the empty court; his relationship to the markings on the floor. Spectators' heads and feet would be deemed irrelevant. They would go. So would some of the floor area behind the figure. The picture's composition was essentially good to begin with. Conservative cropping enhances it. Effectiveness can best be judged by masking the area outside the crop marks.

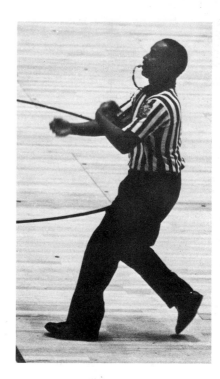

David Cupp

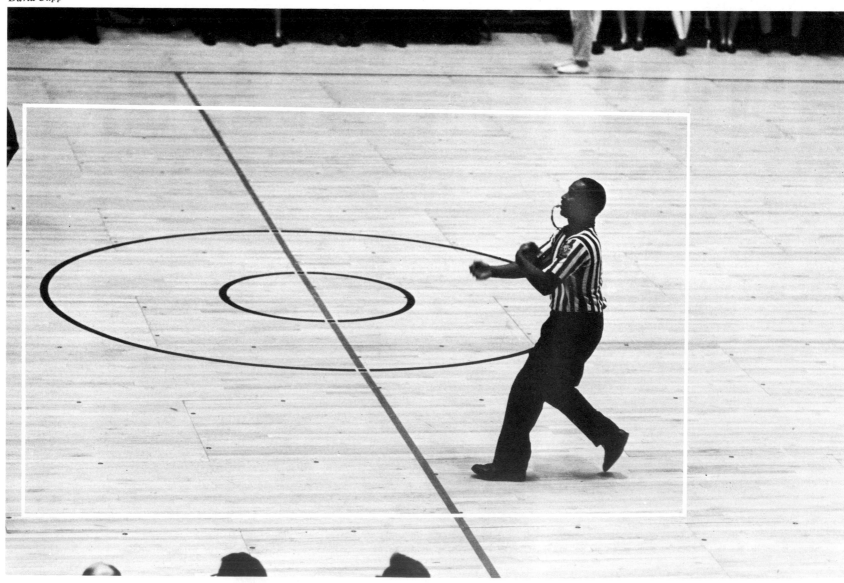

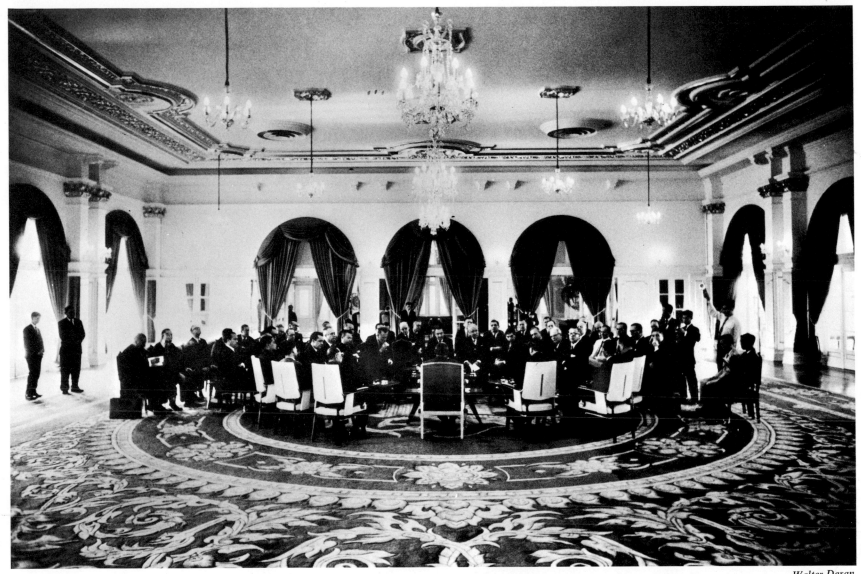

Walter Daran

The mature editor exercises self-control. He crops when he must but knows when to leave a good thing alone. Consider these meeting scenes. In each case, the setting makes the picture; the "where" is as important as the "what." In each, tight cropping would have been ruinous. The union leaders (right) are huddling during a break in negotiations. Littered bargaining tables hem them in. American business leaders (above) are meeting with Thailand's prime minister. Ornate surroundings bedazzle the eye. Zeroing in would result in a pair of zero pictures.

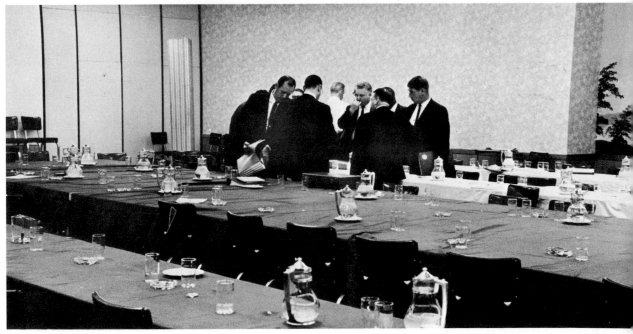

M. Leon Lopez

The five were design students, hired for the summer to try their styling skills on a new kind of automotive vehicle. Selected for the opening magazine spread were five photos of the designers at work. One long view, rich in detail, quickly established what the students were up to. The background atmosphere in the other full-frame photos now became superfluous. Tight, vertical crops placed the emphasis on creative stress but did not violate the essence of the pictures.

A summing up

Rarely is a crop absolute. A bit more or less will not normally hurt the picture's composition. Indeed this give-and-take in the picture's frame can often solve an awkward layout problem.

But one point must be etched in every editor's mind: the practice of making pretty layouts, then chopping pictures to fit is one of the cardinal sins in visual communication.

Equally indefensible is the indifference which results in no cropping at all. Passed up all too often are opportunities to improve composition, achieve clarity, heighten impact. Documented on preceding pages are the capabilities a pic-

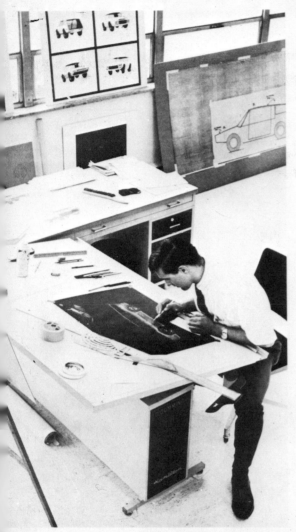

photos by David Cupp

STUDENTS STRUGGLE with problems of creating a new type of vehicle during IH's first styling seminar. The aspiring industrial designers toiled over drawing boards and clay models to meet 10-week deadline.

SUMMER ASSIGNMENT: PUT SOMETHING NEW ON WHEELS

In first IH

styling seminar,

collegiate designers

face up

to a challenge

IT WASN'T a snap as summer jobs go. As participants in the first IH styling seminar at the Fort Wayne motor truck engineering department, the eight designers wrestled with an assignment that outstripped anything they had encountered in school. The students (all college juniors) were put on the IH payroll to design a vehicle so unique their supervisors could describe it only as a "Multipurpose Safe-ty Utility Vehicle." The MPSUV would be neither a car nor a truck. It would be smaller than a compact but carry as much as a pickup. And it had to be rugged enough for a man to use on a hunting trip, but stylish enough for his wife to drive to a club meeting.

"The entire program is an attempt to simulate practices the student will encounter after he graduates," says Ted Ornas, IH chief styling engineer.

Given the ground rules, the group—five industrial designers and three sculptors—set to work with sketches and clay. Soon, they seemed more like IH engineers than visiting students. Said Darold Cummings: "You just gotta think of everything. You have to think like part of the company." Another student who was settling into his IH role confided: "My big dream was always Detroit, but now I'm not so sure."

18

19

ture-cropper has for deleting distracting elements, correcting camera tilt, eliminating technical errors, raising and lowering horizons, reducing apparent distance between camera and subject.

Malleable though they are, pictures should be reshaped only to improve their ability to communicate. The editor need not leave his imprint on every picture.

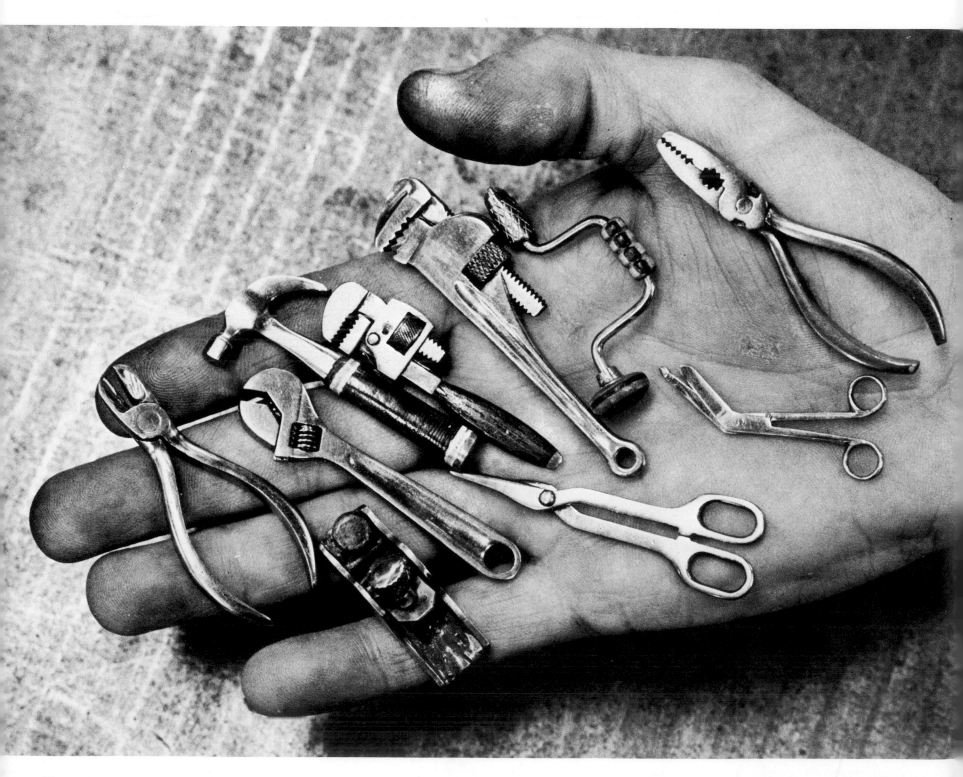

Pitfalls
in
thinking
small

Too many picture-handlers think small. Too many pages are cluttered with little pictures. Just *why* is a mystery. One theory is that editors place higher value on words than on pictures; untouchable text can mean photos of postage-stamp size. The other theory is that editors mistake the photo's function. They regard pictures as elements of design, as shapes on a page. Of less concern is what a photo says, how quickly it communicates. Overlooked is the necessity for making pictures large enough to be read. But sizing for readability should be only a starting point. Sizing, as an editorial weapon, is highly sophisticated and under-exploited. Psychology comes into play. Opposite is a closeup greatly enlarged. Faced with this larger-than-life image, a reader's first reaction is "Wow!" His second reaction, as he drinks in the detail of workmanship, is intellectual. Faced with the smaller image above, he will not react at all.

Sizing:

large for legibility
large for impact

In sizing, as in cropping, the picture-handler usually has flexibility. But given a long shot with interesting detail, his sizing choices are limited. For legibility — as well as for impact — such a picture *has* to be large. The space-saving editor who plays it small wastes each square inch he gives it. Within the general scene below of litter left by 65,000 horseplayers are details of people looking for discarded winning tickets. To lose the details is to lose the picture.

Impact is the psychological effect a large pic-

ture has on the reader. It is the "stopper" quality that flags the attention and shouts: "Stop! Look at me. This is important." It is achieved with long view or closeup, though few closeups ever get stopper treatment. Lowell Georgia saw the face of winter (opposite) on a sub-zero day. Played small, this closeup might have been passed over by the casual page-flipper. For impact, the thermometer face requires generous size. So does the ladle face on page 16.

Paired, their impact would be all the greater.

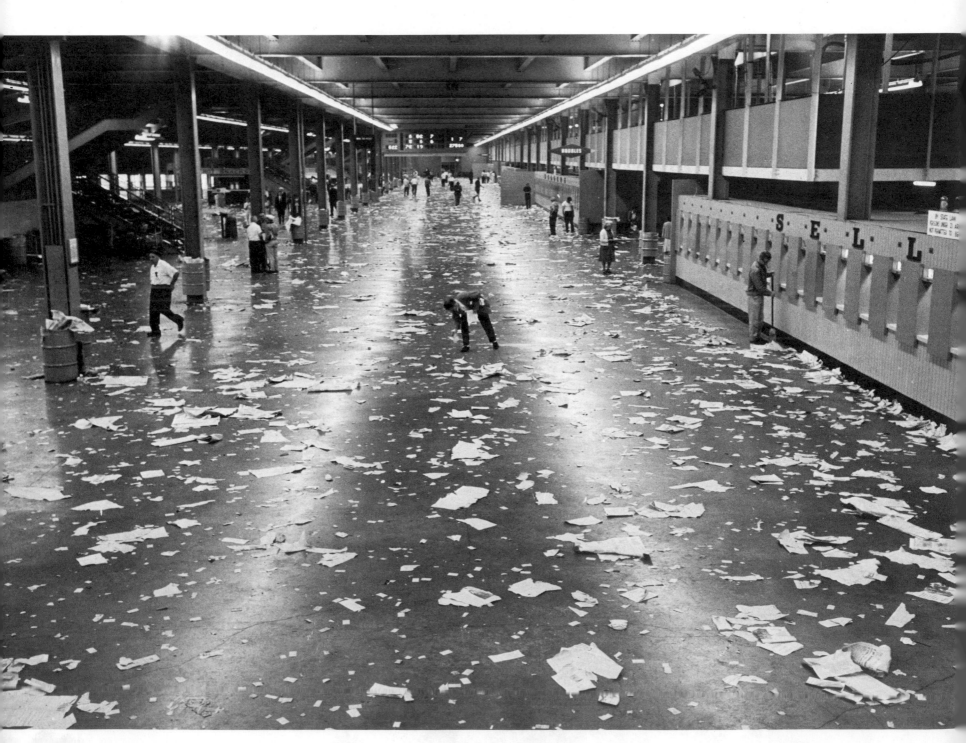

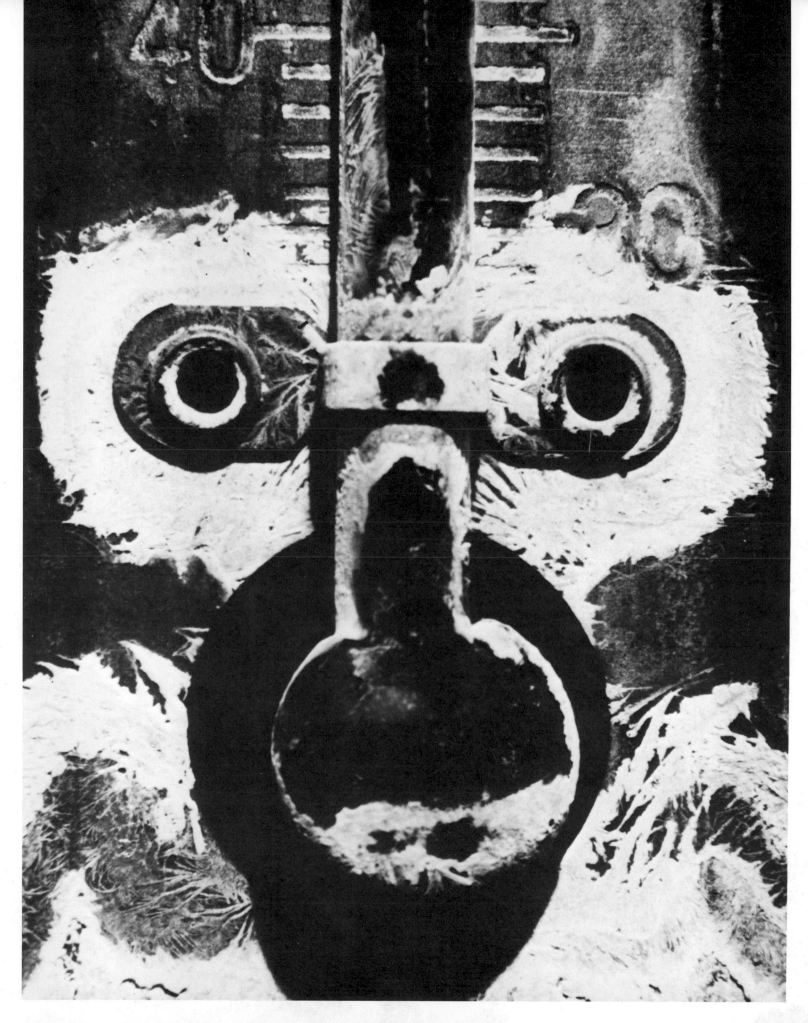

Sizing a single picture is one thing. When two or more pictures appear on a page, a new set of criteria applies. Size then becomes relative and change of pace a virtue. Whether large or small, pictures all sized alike can have a deadening effect on a viewer, for the maxim that all emphasis is no emphasis applies to picture-handling with special force. The editor must decide which picture in a group deserves to speak more loudly. Criteria of legibility and impact should continue to guide him, but no one picture need carry the entire load. If, for example, the editor had only a general view of grain-pit activity in the Chicago Board of Trade, he would use it large to call attention to the gesturing bidders. For legibility and impact, the large view below obviously surpasses the smaller view at right.

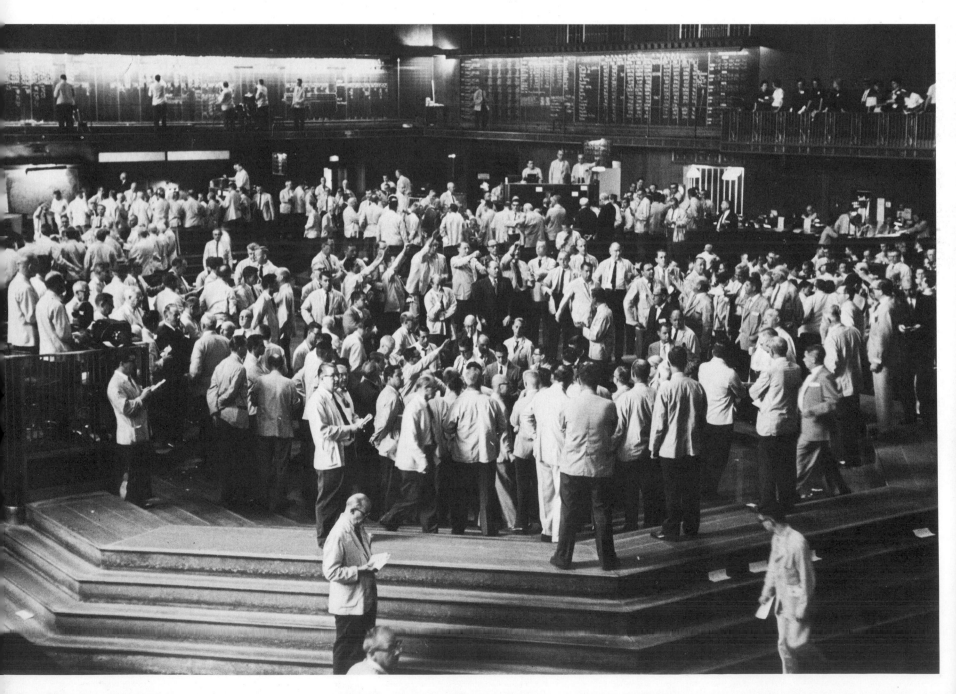

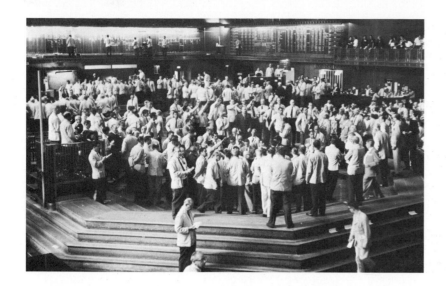

Given a long shot of the grain pits *and* a closeup of brokers bidding, the editor could decide with justification to keep the general scene small and enlarge the closeup. His rationale: the frenzy in the closeup has the impact; the long shot merely establishes the locale, sets the stage for the picture with punch. When long shot and closeup interplay this way, their effectiveness increases. Contrast, in size as well as viewpoint, will heighten reader interest.

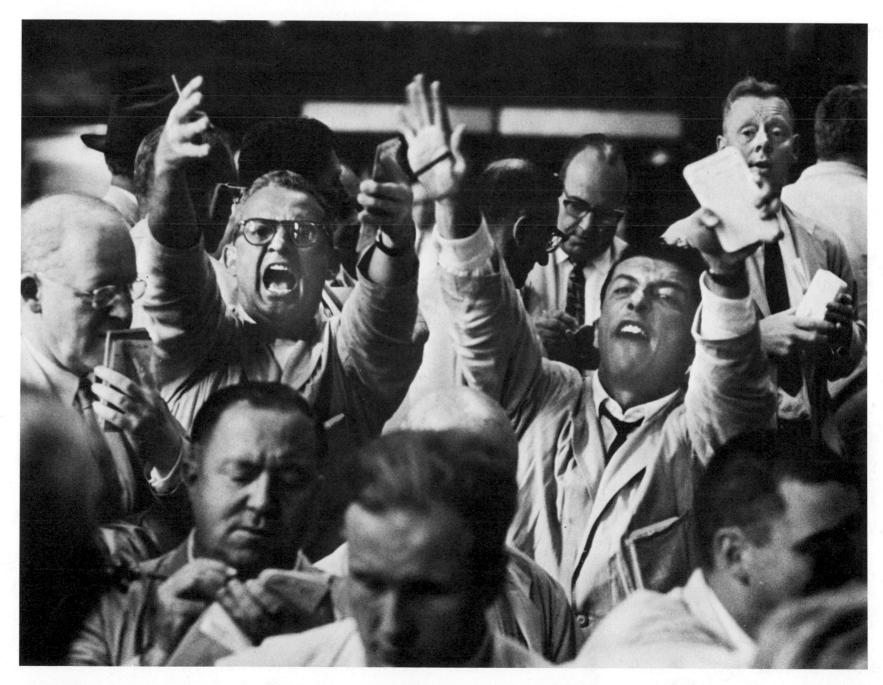

Sizing:

large when face is strong

When he parcels out space, the editor usually gives portraits small portions. A closeup of a face, he reasons, can be quickly comprehended. Why waste space? If he traffics in retouched, cosmetic portraits, small size is sufficient. It is *not* sufficient for honest portraits that reveal character. Used large, a strong face will trigger emotional response. Given a chance, a portrait will speak eloquently, in full face or profile. Type reversed in a dark background has impact, too. But legibility suffers when copy runs long.

small when technique is weak

The average picture gains interest as its size increases. The technically weak picture does not. Such a picture may be marred by camera movement or faulty focus but strong in subject content. If reproduced at all, the unsharp picture should be large enough to communicate and no larger. Oversizing will only call attention to its deficiencies. The same thing can happen when a small portion of a 35-mm negative is greatly enlarged. At some point, grain and apparent lack of sharpness will get in the way of the message.

The television screen aptly illustrates the relationship of size to apparent sharpness. Viewed from across the room, a TV picture may be pleasing. Watched from a foot away, the same picture becomes little more than coarse scanning lines. Like the fuzzy photograph, the TV image is palatable on the printed page when played small. Blown up, the pattern structure begins to intrude and no additional information is conveyed.

A summing up

Visualizing is the key to sizing. The 8x10 print on the layout table—will it be readable at one-fourth that size? Would it be worth using at all if run so small? The five 8x10s in a group—doesn't one of the five deserve to dominate? If it were half again as large as the others, wouldn't impact be heightened? The simple, uncomplicated picture—will size really help it? If sprawled across the spread would it have enough content to engage the reader. Does it have enough to say?

The effective editor sidesteps the pitfalls of sizing, but never overlooks its possibilities for impact. He knows when to make a long view small, a closeup huge. He knows, for example, that a strong face will produce emotional response; the greater the size, the greater the response.

He will proceed on the premise that bigger pictures have more appeal than little ones. Given a great picture, he will play it to the hilt. He will find ample running room for the superior picture even if it means tossing out pictures that are highly acceptable. Even if it means cutting text he's written himself.

But he will be aware, also, that all emphasis is no emphasis. He will not use big pictures exclusively. He will use sizing for its change-of-pace effect, for the variety it brings to his pages. Of one thing he will be certain: the smallest picture he uses will be big enough to be read. At a glance.

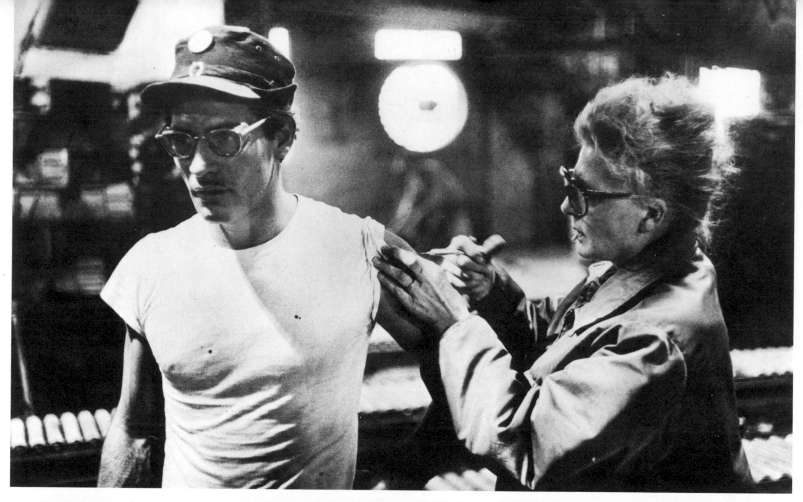

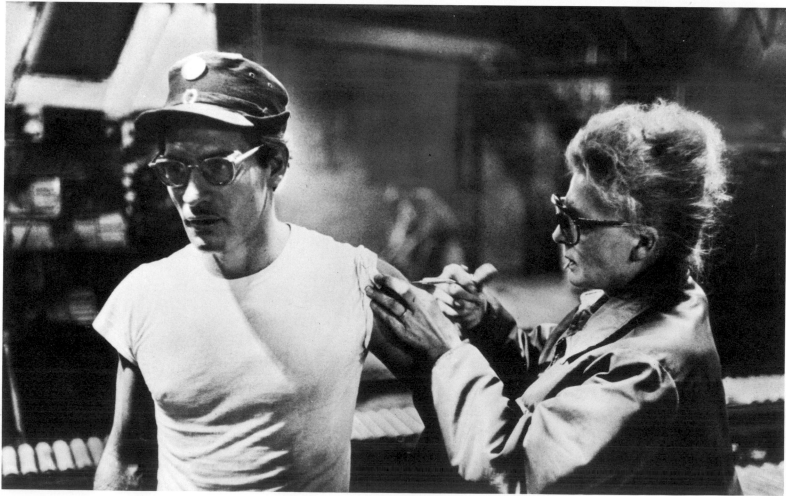

EDITING THE PICTURE

"Out
damned spot!
Out,
I say"

For pictures as for people, cosmetics often work wonders. Imperfections fade away, distractions disappear. Many defects can be erased by cropping, but not all. Within the crop marks is where the retoucher works. He works best when he leaves no trace. Retouching should be as imperceptible as an actor's haircut. If cropping is a sharp-edged tool, retouching is more dangerous by far. Obvious retouching can destroy believability, the most valuable quality a photograph can possess. A handy tool for enhancing, cleaning up and clarifying, retouching should under no circumstances change the meaning of the picture or the photographer's intent. The reader accepts a photo as an honest reflection of things as they are. To condone dishonest retouching is to violate this trust. But to keep hands off when a photo cries for help (see opposite) is indefensible, too.

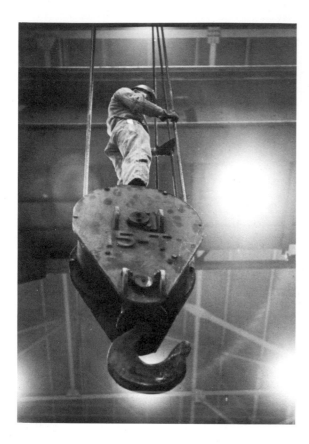

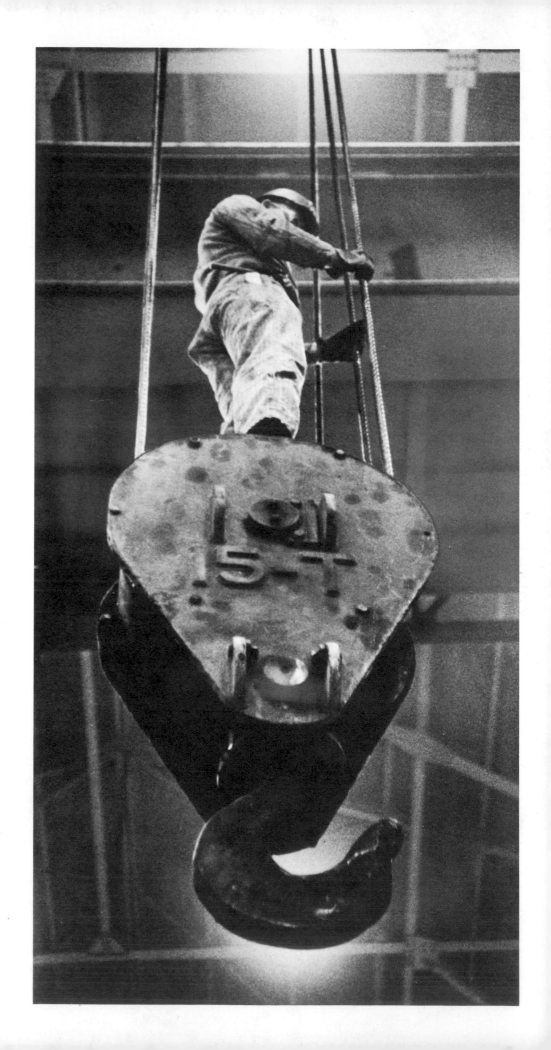

Just as a moth is attracted to a candle, the viewer's eyes are drawn to the brightest spot in a picture. If the spot is meaningful, all's well. If it isn't, the editor has recourse to two spot-removers, both effective. In the scene above, the lights burning along the picture's edges were safely removed by cropping. But the glare opposite the crane inspector was too close to the center of interest. Crop marks caught part of it; the rest became the retoucher's problem. While at it, he obliterated lesser flaws: the lens flare left of center, the arc in the lower right. Regarding the light behind the hook as an effective accent, he dimmed it only slightly. His handiwork (right) kept the reader's eyes where the editor wanted them.

Lights in

Lights distract and lights enhance. Dramatically framing a hand on a hoist hook, these out-of-focus lights become an integral part of the picture's composition. Using a fast telephoto lens at full aperture on a reflex camera, Enrico Sarsini knew precisely how the lights would appear in his picture. It was an excellent job of "seeing." To retouch or crop would be to meddle with the photographer's intent.

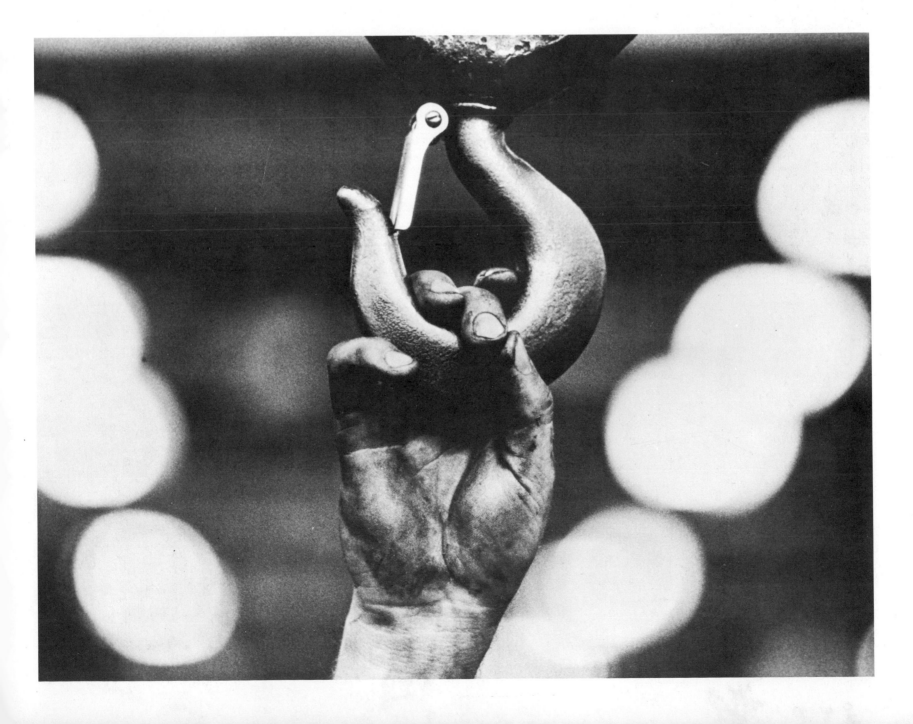

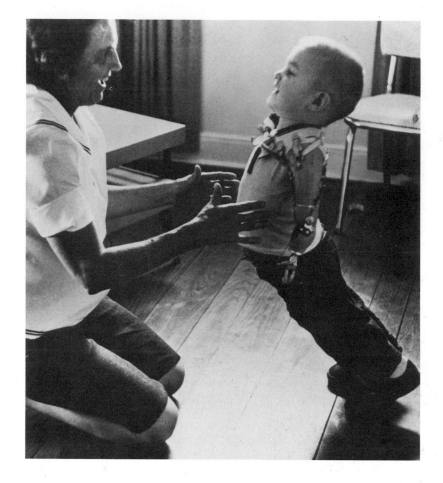

Unfortunate merger marred this appealing picture of mother and handicapped child. Wire in background appeared to be coming out of youngster's mouth. When retoucher was through, defects had vanished. Reader could focus on action without distraction.

Shooting indoors, the photographer has lights to cope with; when he moves outside he is plagued by power lines. There are times when wires themselves are worthy of attention. But for every dramatic picture of wires (see below), hundreds are spoiled by the ugly intrusion of wires. Consider the picture below left, reproduced from a magazine page. Had the photographer taken a few steps forward, he would have eliminated the wires that bisect his backlighted clouds. Had the editor been less insensitive, he would have taken just one step: an S O S to a retoucher to make his picture wireless.

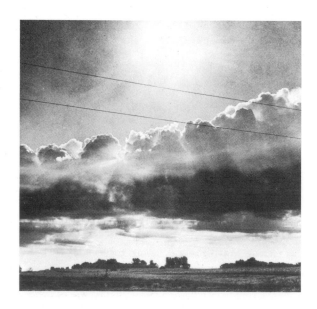

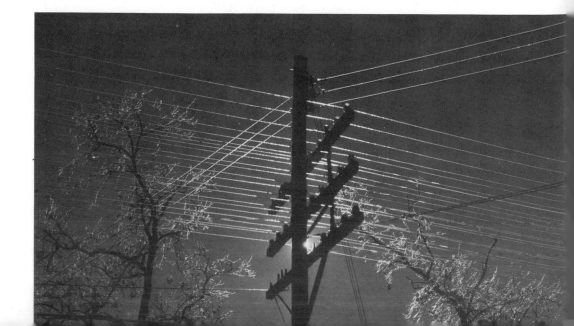

Nolan Patterson

Practical answer for a problem picture: lighten background, separate tones for better reproduction. A crude technique not recommended is the white outlining illustrated at lower right.

The engraver's camera has its limitations. Working with high and low key photographs, it may fail to hold the subtle tonal values in highlights and shadows. For practical reasons, this camera has a seeing problem. Its vision is broken up into hundreds of dots by a halftone screen. Because shadings are represented by dots, the halftone reproduction will not possess the full tonal range of the original photograph. The values from black through the grays to white are compressed in a shorter scale. Unless a retoucher carefully separates the deep tones, for example, the camera may not be able to distinguish between a dark-suited subject and a dark background. Without an assist from the retoucher, the subject's hands and face are apt to float in a black void on the printed page.

Retouching: Background deleted, background diluted

Bad backgrounds are the bane of the journalistic photographer. Recording life as it is lived, he seldom controls the setting. He cannot (and should not) move his subjects about to suit his preference. Happily, a retoucher can clean up after him. Fortunately, too, a retoucher would rather correct a background than intrude on the center of interest. In the photo above, distraction took the shape of a shoulder and back of head. Cropping the offending shoulder would have meant amputation of essential fingers. An airbrush spared the fingers, saved the picture. (Speaking of cropping, the narrow shape at top would be difficult to justify. Picture improves when second hand is included. Photo now becomes easier to grasp.)

A wall divider stabs this union steward's shoulder, diverts attention from his tight-lipped expression. Simple—and inexpensive—deletion pays off with stronger picture, better composition.

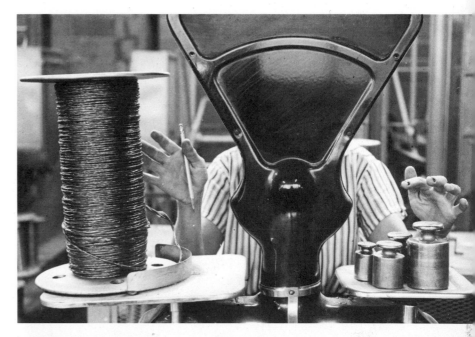

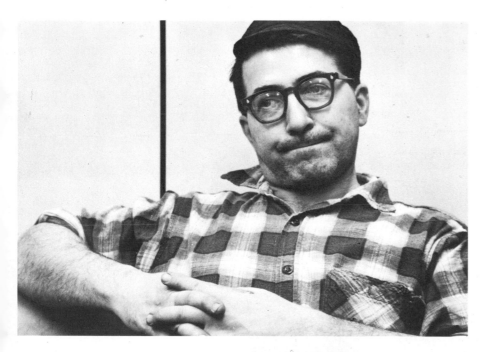

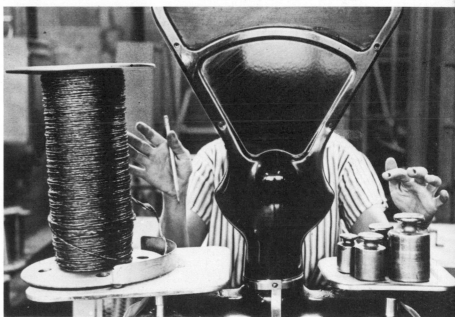

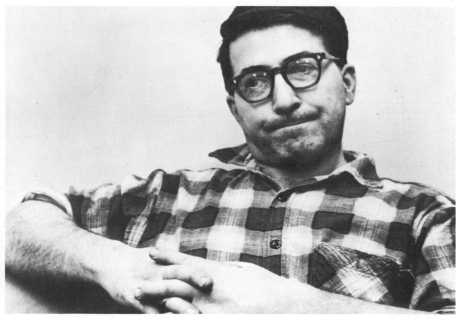

Busy backdrop confuses viewer, detracts from center of interest. "Dusting" background with transparent water color, retoucher makes foreground "pop" while retaining work area atmosphere.

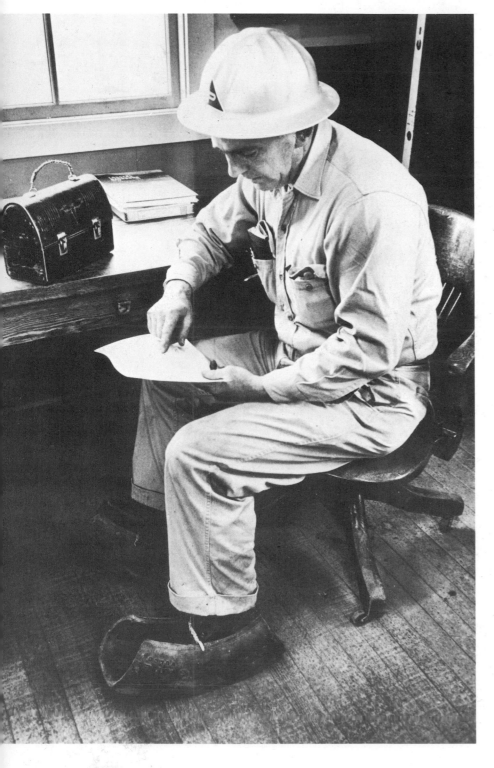

Comes the millenium, every viewer will see exactly what the editor wants him to see. In the meantime, picture-handlers will have problems. A quick look at the photo on the far left reveals a man in a hard hat reading something. Only after taking in details less important will the eye move down to the tire casings on the subject's feet.

The camera subject is a logging foreman who wears tire overshoes to keep his calked boots from chewing up the floor. Unfortunately, boots and floor are similar in tone. Indeed, the boot on the right foot is virtually obscured in the shadow of the table. Trying to achieve better separation, the photo lab did some dodging during exposure and some bleaching with ferricyanide after the print was developed. But because of underexposure in this area of the picture, the lab could make no better print.

In the second example, the retoucher achieves what the darkroom technician could not. The retoucher flags attention by brightening the floor area around the footwear and by adding highlights. Question: will the viewer's eye now go directly to the tired feet? Answer: not necessarily.

To rivet attention to the picture's vital area, the editor can wed the retoucher's art to the technique of cropping. (See right.) The presumption is that the editor has other pictures to establish the logger's identity. In a personality story, he need not include the subject's facial features in every picture. To do so would be boring. So he crops severely. And when he pairs the cropped, retouched picture with a closeup of hobnailed boots, no reader will miss the point.

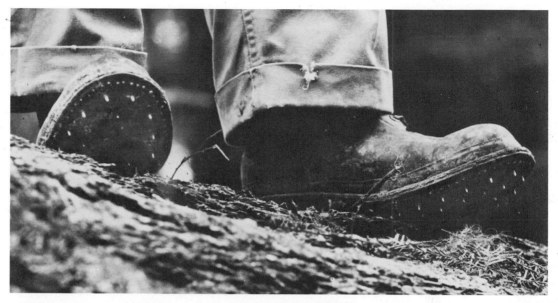

Ted Spiegel

Retouching:

lettering adds, lettering detracts

The photograph busy with lettering can be an eyesore on the printed page. There are times when labels and words within the picture's frame are blatant enough to clash with typography and compete with headlines. More frequently they divert attention from the picture's center of interest. In the portrait at right, both the "ad" on the new cap and the lights surrounding it are serious distractions. But total erasure (second photo) wasn't totally satisfactory; the picture now lacked naturalness. Trying again, the retoucher restored credibility while making the lettering less blatant. The portrait below contained a free commercial, too. But when a Hershey candy box is employed to taunt a general named Hershey, the lettering stays. It may clash with the type and fight the headlines, but it makes the picture. Esthetic considerations are outweighed.

L. Roger Turner

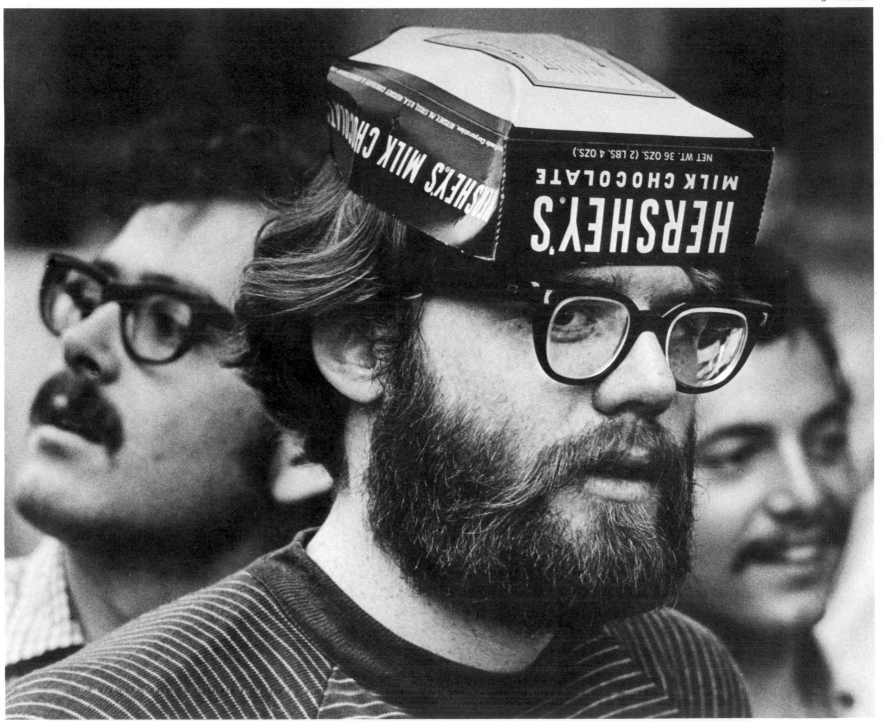

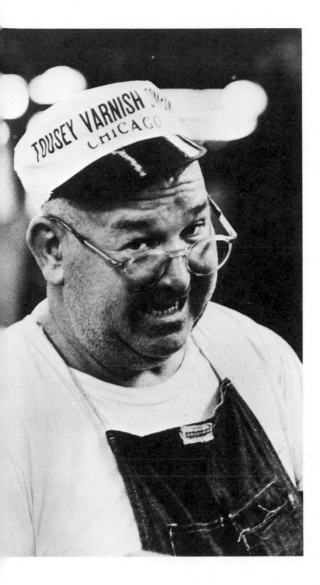

A summing up

Retouching is the picture handler's last resort. Before he summons his retoucher, the editor must be certain his lab can produce no better print. With proper darkroom techniques, there may be no need to correct highlight and shadow detail. Certainly there should be no dust spots or scratches. But if retouching is indicated, several reminders are in order:

The print to be retouched should be larger than the area it will occupy on the printed page. Size reduction will minimize awareness of the retoucher's efforts.

A lighter print is easier to retouch; it is easier to add a dark tone than to lighten an area.

Prints not thoroughly washed may cause retouching materials to change color.

Smooth surface paper *not* ferrotyped for gloss is the most suitable

for retouching. (And perhaps the best for reproduction.)

Results are better when the retoucher works on background rather than on the picture's center of interest. In that connection, irregular, out-of-focus shapes are less in need of erasure than shapes sharp and regular.

The retoucher works best when told the effect desired, not how to achieve it. If he is worth using, he will not need minute instructions. He will be aware that changing one value in a photo may necessitate changes in another area of the picture.

Use of transparent and opaque water color is one retouching technique; bleach and dye another. Fast to work with, water colors are applied to the surface of the print, can be smudged by careless fingers. Bleaching and dying changes the photo emulsion, is less apparent to the eye. To the engraving camera, the results are identical.

MAKING PICTURES RELATE

Interplay
is the
key

When one picture can do the job, no competent editor would use two. But when one picture complements the other, a new rule applies. Just as the whole can be greater than the sum of its parts, successfully paired pictures will reveal much more than either picture reveals alone. The more obvious pairings—day and night, before and after—are usually preplanned and deliberate. But some of the better pairings are the result of chance. They materialize when the editor is discerning and the photo coverage complete. Poring over proof sheets, the editor will be alert for mannerisms that match, for moods that vary. He will find dissimilarities in like subjects and subtle similarities in unlike subjects. The better he makes his pictures relate, the easier his pages will read. Interplay is the key. In the two-picture sequence at left, elation turns to dismay as instructor and trainee listen to a playback of a practice interview. Alone, neither photo says enough. Together, they do.

Pictures in pairs

Try two for size

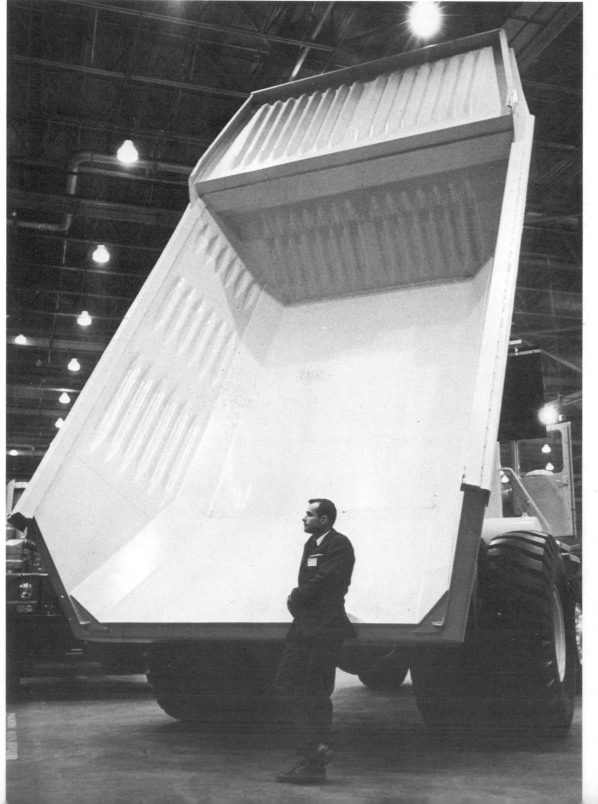

When it tries to make size comparisons, the single picture sometimes falls short. On the printed page, two different perspectives may be needed. Consider these two views of an off-highway truck. By standing a man alongside for scale, the photographer accentuates the vehicle's outsize dimensions. On a highway project, dwarfed by its own output, the same truck photographs like a toy. The first picture shows size but not work. The second shows work accomplished but gives no clue as to the vehicle's size. Side by side, two partial statements become whole. Proper evaluation becomes possible.

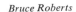

Bruce Roberts

Two to sum up, two to open

The story dealt with a breakthrough in union-management relations. Their bickering behind them, the two camps found a new way to get along. Roll after roll of film was exposed as small cameras studied the faces on both sides of the table. Effective photo-pairings surfaced by the dozens as the company editor waded through his reservoir of proof sheets. One such pairing popped up on the magazine's back cover in the form of a pictorial postscript. Said the caption: "The manager of manufacturing and the grievance committeeman had more than mannerisms in common. Refreshingly, they were also seeing eye to eye." In a visual parallel, a theme was tellingly reprised.

In picture spreads as in poker hands, it often takes a pair to open. Particularly is this true in "The Two Roles of Joe Blow," a publication perennial. The layout problem is how to begin, how to draw a contrast between a man's vocation and his avocation. Once again, the editor's best friend is the photographer whose coverage is thorough. In the case of the engineer-turned-bullfighter, the photographer probed both roles, the familiar as intensively as the far-out. Out of the shooting came natural openers, a pair of pictures with a strong visual link. Besides the parallels in expression, posture and dress, they revealed an engineer who handles a drawing much like a cape.

Normally, in a pairing of this kind, pictures would be arranged to permit the heads to face inward. Doing so here would create an awkward juxtaposition of hands.

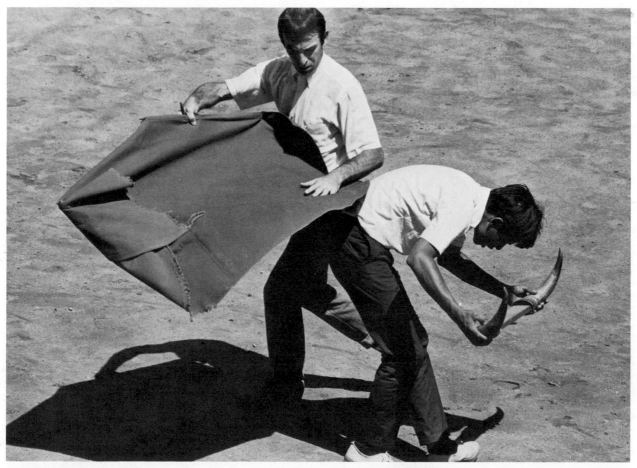

a mismatch and a match

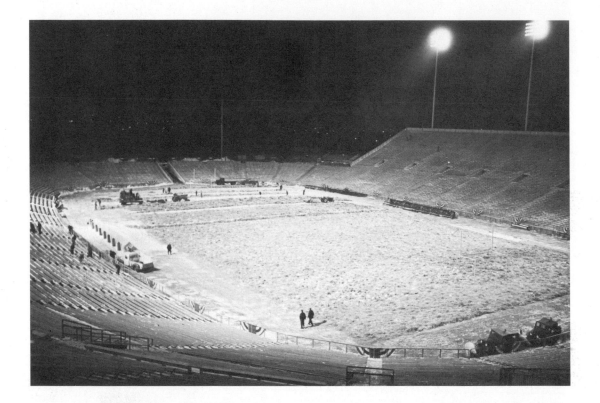

Ten inches of hardened snow, 20 tons of hay blanketed the football field, with the pro championship game 72 hours away. The photographer's instructions: "Shoot the activities of the ground crew preparing the field for play; be sure to include before-and-after pictures for pairing."

Requirements for before-and-after pictures are obvious: shoot from the same spot; include the same area. Indeed they are so obvious the editor didn't feel the need to spell out specifications. He was sorry later. The photographer's proof sheets yielded in some quantity pictures taken before and pictures taken later. What they failed to yield were two views that matched.

The closest pairing turned out to be the mismatch at left. In quest of his "after" picture, the photographer found the right stadium aisle but wound up in the wrong row. From a lower altitude he was unable to take in the features that provided orientation in his earlier picture: light standards and stadium silhouette. (He erred also in not waiting for action to come to his end of the field.)

More successful was the shooting at right, the now-you-see-it, now-you-don't pictures of smog in Los Angeles. There was a time interval here —indeed time enough for billboards to change —but the photographer remembered his point of view. His comparison came off.

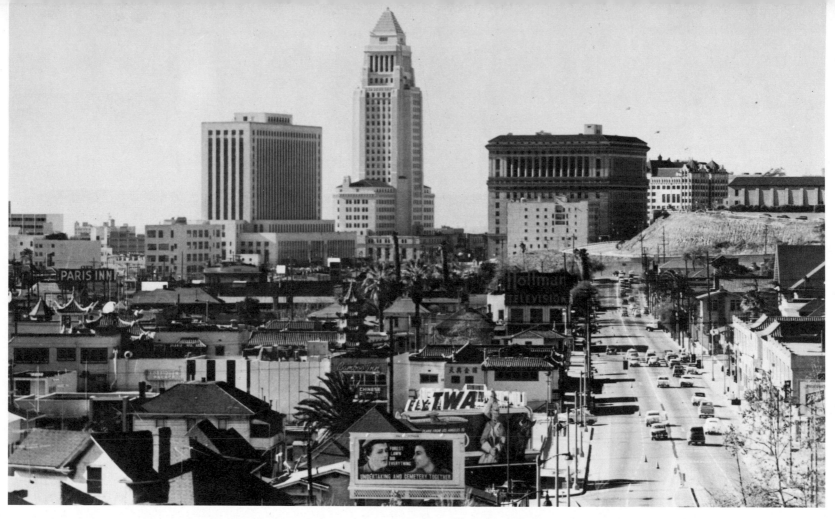

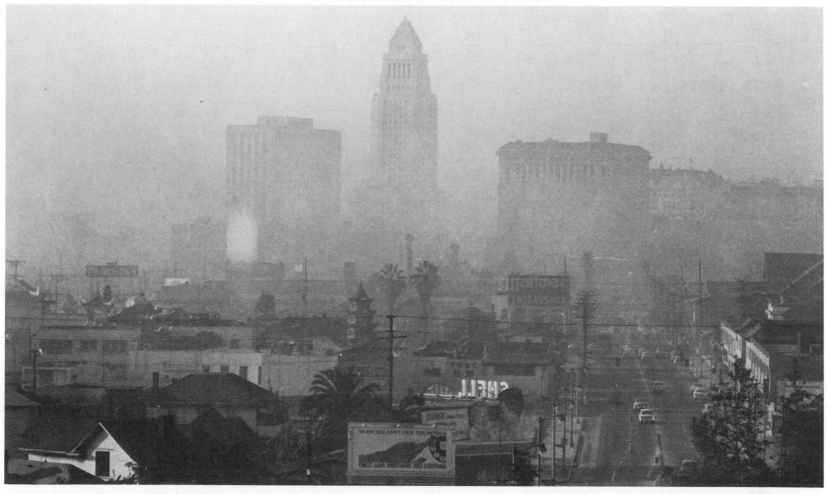

In visual arithmetic, one and one can make three

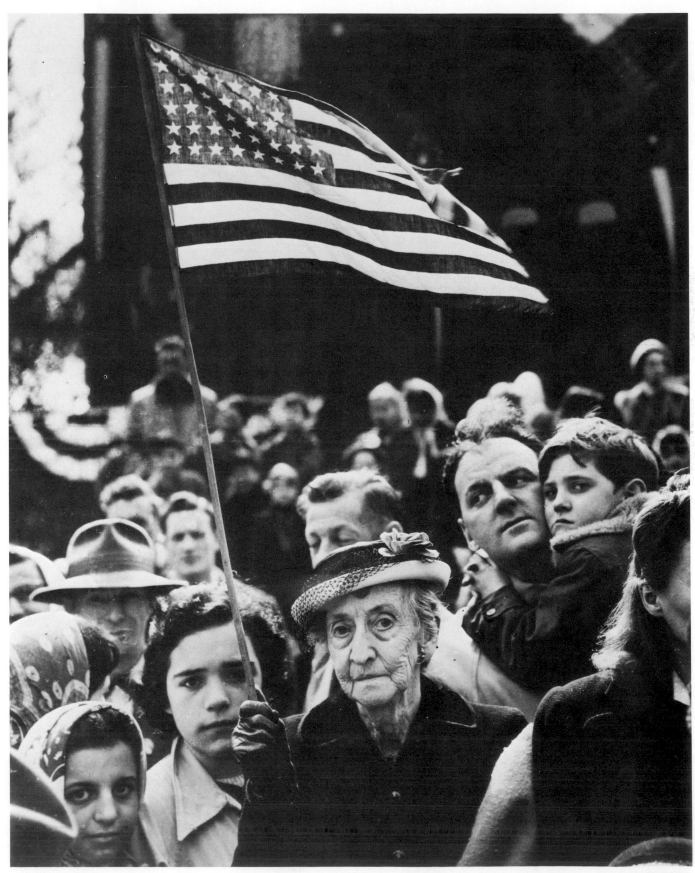

George P. Koshollek

One was a quiet picture of "The Patriot" awaiting the return of a war hero in the 1950s. The other was a look at "The Protester" in a fury over a war in the 1960s. Presented independently, each picture made a single statement. Paired, they establish a "third effect" by commenting on each other.

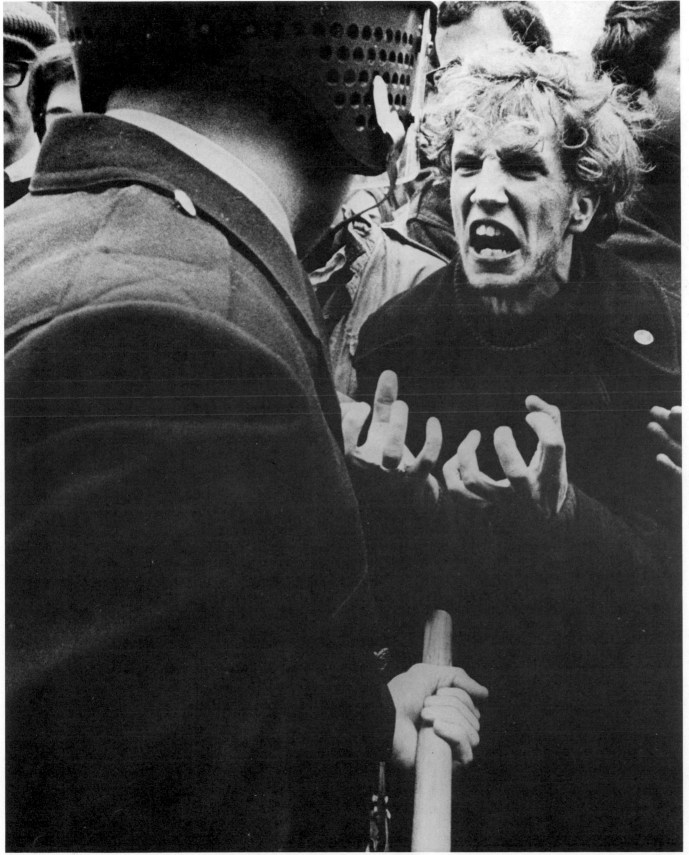

Dennis Connor

53

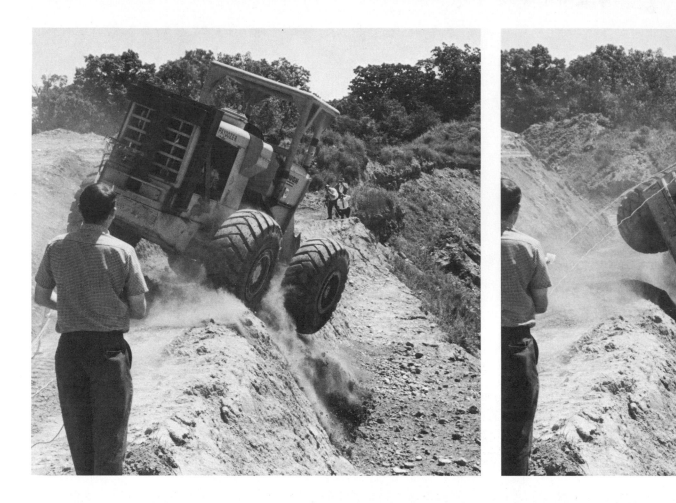

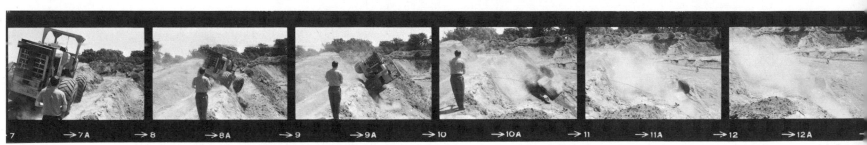

Pictures in sequence: to make a still picture move

It lacks a sound track but the printed page, in one important respect, can rival the motion picture. It can simulate action. Its movielike device is the picture sequence. When taken within a brief period of time from a single point of view, still pictures can move across the page with the impact of movie footage. Handled skillfully, they can sweep the viewer along, make him feel he's a participant in the action.

The editor's skills are important here but it's the cameraman who holds the key. The true sequence has to be consciously photographed that way. The photographer must be alert for sequence possibilities, must anticipate the direction of the action, must choose the best vantage point from which to record it. In turn, the editor must pick frames that best highlight the action, must crop to convey movement, must size his pictures for maximum impact.

In this series on a rollover test of a safety canopy, picture-selection is no problem: the first frame is too static; dust in the final frame obscures detail. Of more interest is the cropping and sizing. Taking care to keep his horizon in line, the editor gives the machine some falling room in the opening picture, crops in on remote control operator in picture two and removes him entirely in picture three. Tighter and tighter cropping conveys the feeling of a camera panning to the climactic picture. And the climactic picture gets every inch of play the right-hand page permits.

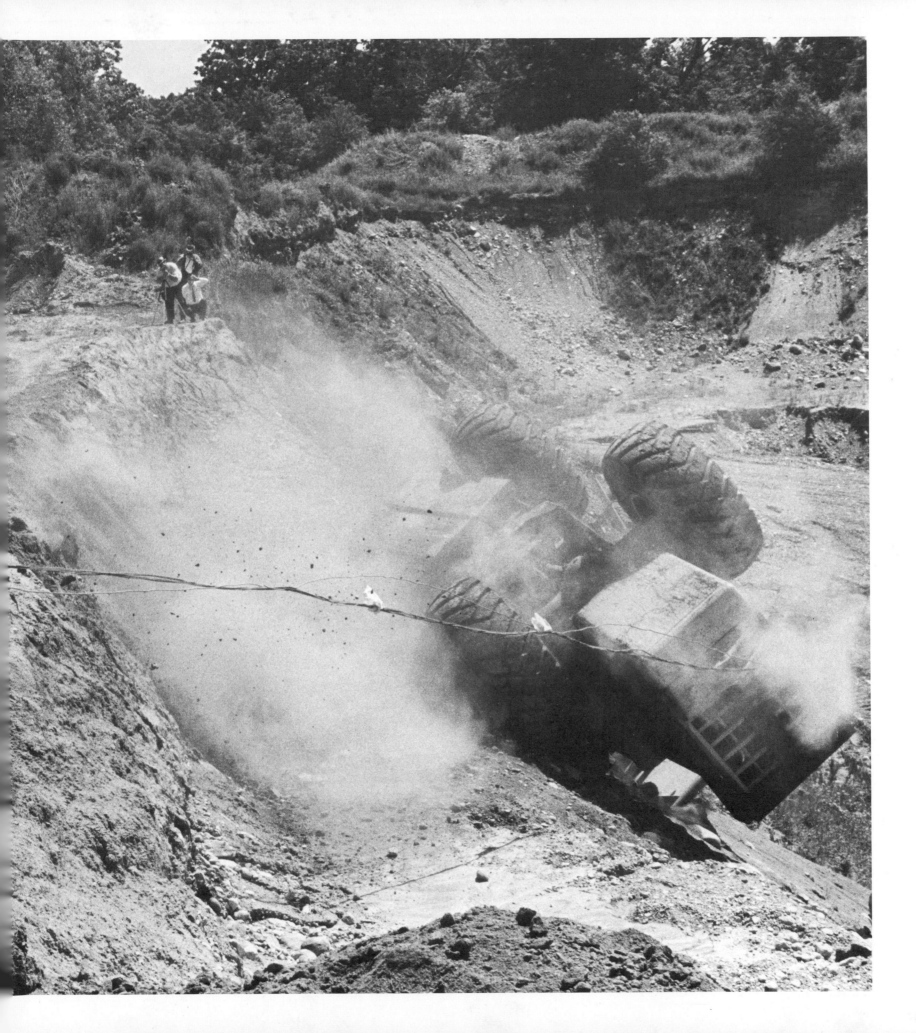

Two-picture sequence:

side by side, up and down

Behind nearly every successful sequence is an editor willing to make hard choices. In the sequence situation, the camera will click in rapid-fire fashion. Inevitably, action will overlap. The editor's job: preserve the continuity; eliminate the repetition. Covering a falcon release, the photographer caught the action in six quick frames. After a hard look at the contacts, the editor decided he could make do with two. He found the essence of the sequence in frames 12A and 13A. The views were close enough in time to convey unbroken action yet different enough to hold reader attention. He accentuated the difference with tight cropping of frame 12A. It became a narrow vertical, a tight closeup of hands and bird. The climactic picture, which explains and amplifies the first, was given the size it needed. With side-by-side picture placement, the layout followed the left-to-right flow of action.

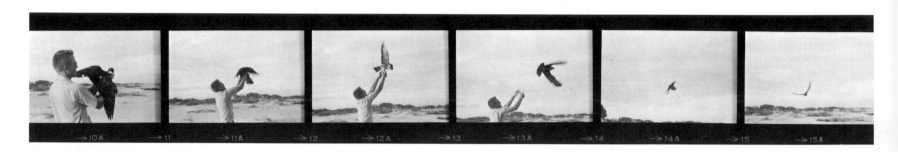

Marc St. Gil

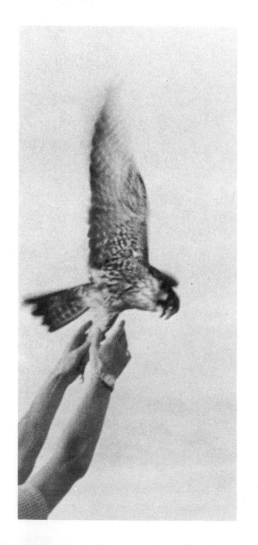

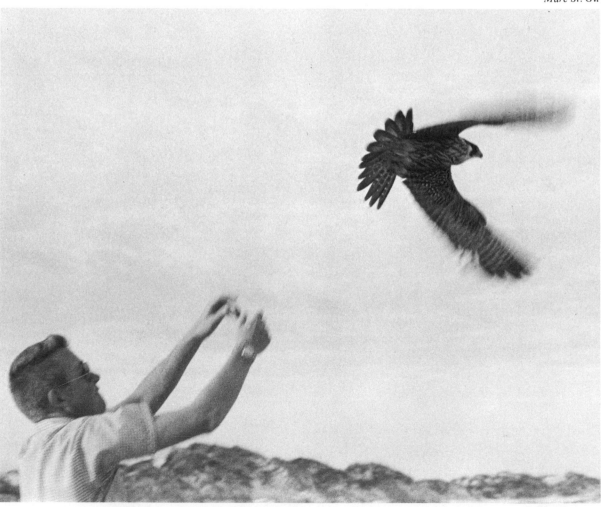

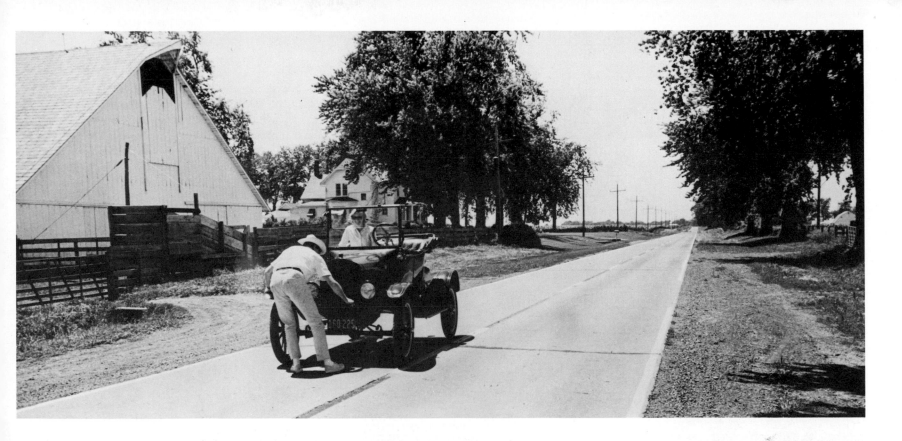

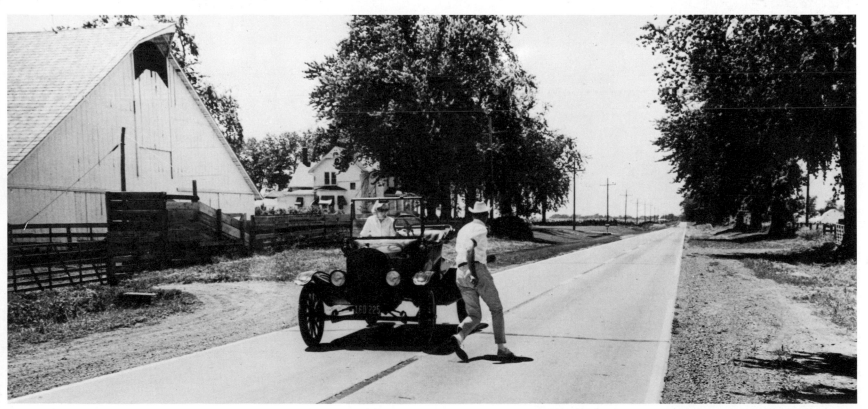

Standing pat while his subject raced from Model T crank to throttle, Photographer Dick Swanson anticipated a series and framed it effectively. When action takes place within a fixed frame as it does here, the sequence reads best with one picture below the other. With the static elements in the same relationship, eyes of the viewer will go immediately to the action.

three essentials,

three pictures

To master the picture sequence is to take a giant step toward mastery of the picture story. Indeed in essence a sequence is a simple picture story chronologically told. A strong opener, developing action, climax and closer—all of these elements the sequence shares with stories more elaborate.

Properly handled (see opposite), the sequence can stand alone. But it can be equally effective (see below) as an offbeat or illuminating segment of a larger story.

Covering a begging beagle and handicapped Tommy, two photographers encountered varying techniques for getting one's way. Each cameraman supplied five or more views of the unfolding action. In each instance the editor decided the essentials were summed up in three pictures: (1) confrontation, (2) direct action, (3) aftermath or reaction. The editor resisted the temptation to tell too much, to slow the action with pictures not different enough from those preceding or following. What's left out of a picture sequence is almost as important as what stays in.

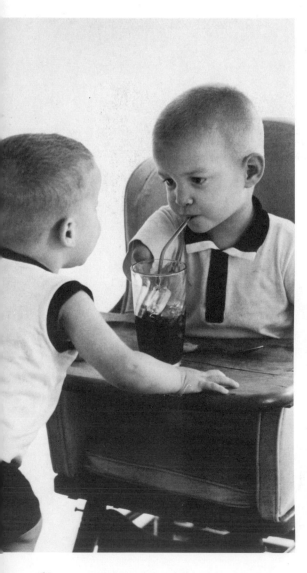 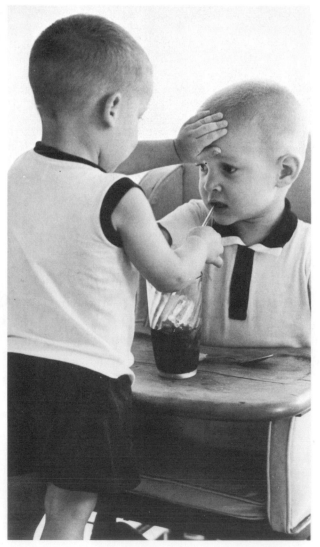 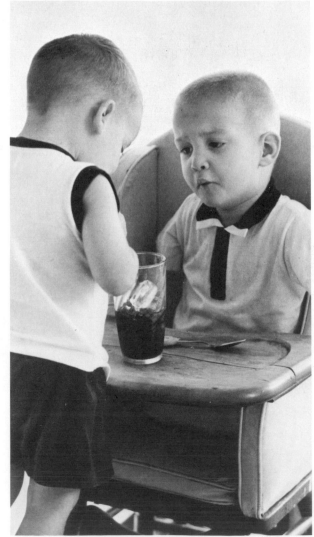

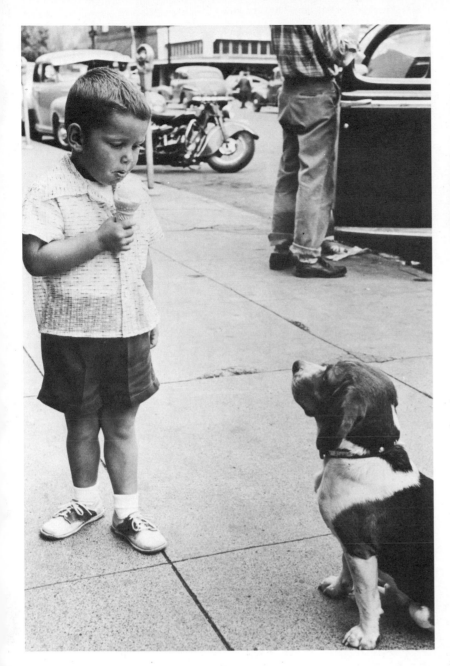

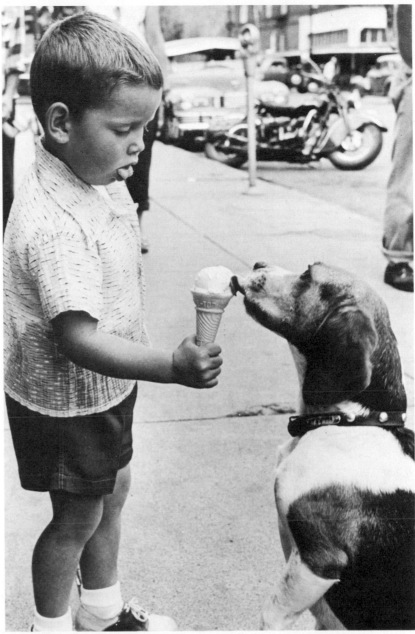

Where it begins, where it ends, what comes in between are variables that make sequence-handling a challenge. In "Scooter Cons a Cone," Photographer Joe Van Wormer's first frame was shot an instant before the beagle established eye contact with his pigeon. Second frame (above) was logical opener. The next choice was harder to make. Alternatives were the proffer of the cone (upper right) and succeeding frame (not shown) of dog taking his first big bite. The bite lost out, even though it helped explain the final scene. More appealing was the boy's empathy with the dog's lick. It rivalled Tommy's grimace (opposite) over a "shared" Coke.

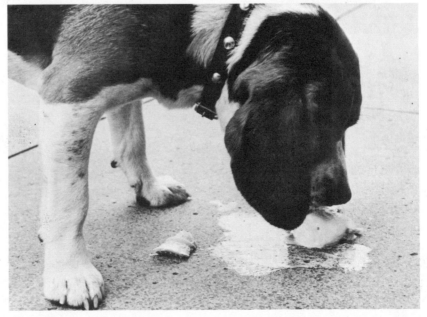

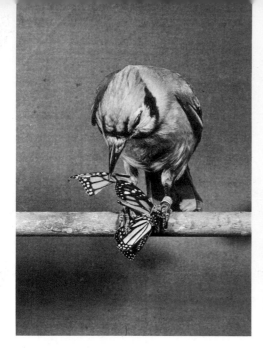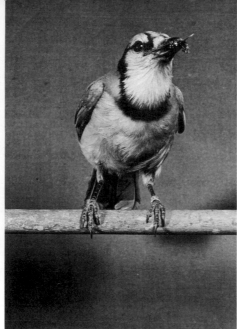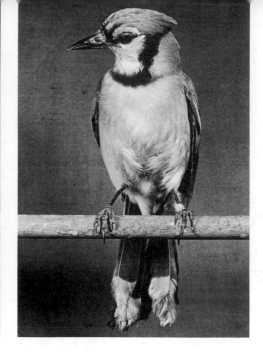

Pictures in sequence:

by design, by chance

In elapsed time, the photo sequence can range from milliseconds to months. In most cases, the span is brief; time enough, perhaps, for a blue jay to dine on a butterfly or two. The remarkable blue jay pictures were illustrations by Dr. L. P. Brower for his article on "Ecological Chemistry" in *Scientific American*. In the first series, the blue jay eats a palatable monarch butterfly. The second series records the bird's reaction to a monarch that fed on poisonous milkweed in the larval stage. The jay swallows it, reacts in comic-strip fashion, vomits and shakes its head. It soon recovers but rejects subsequent monarchs on sight.

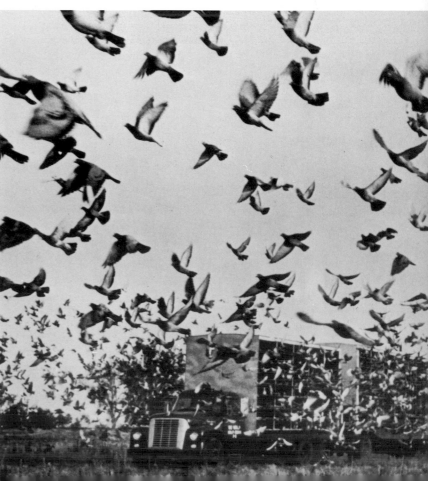

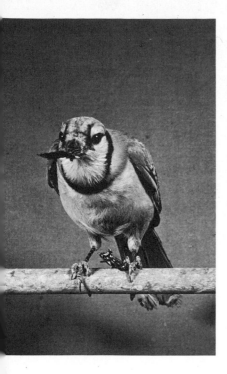

If the blue jay series was premeditated, the pigeon sequence was not. It was uncovered by an editor studying his proof sheets. Having found his key picture in the pigeon release, he noted a light-hearted similarity and contrast in two pictures taken 18 hours apart. The head-to-toe involvement of the pigeon owners in the first photo had a visual parallel with the reluctant bird in the final photo. The camera angle and camera distance were not quite the same, but cropping helped the pictures make their point and provided the necessary unity. The pigeon blizzard gets the prominence it deserves in an unintended sequence with a twist at either end.

Fred Swartz

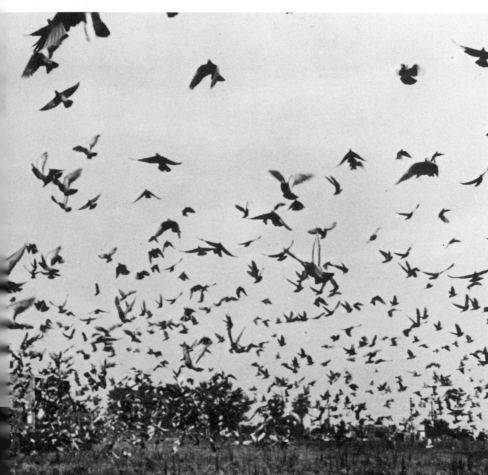

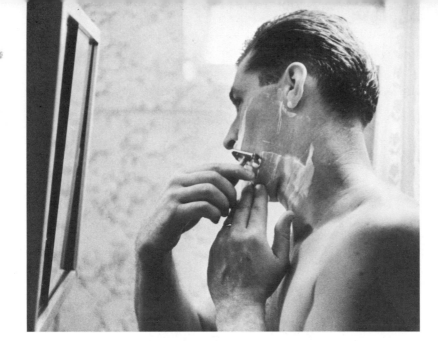

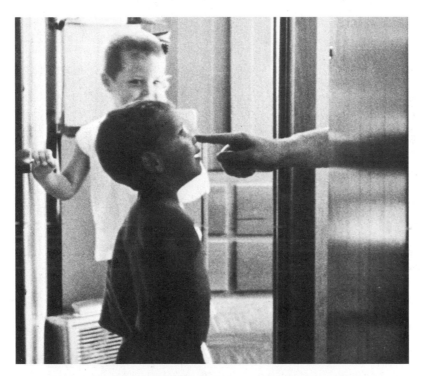

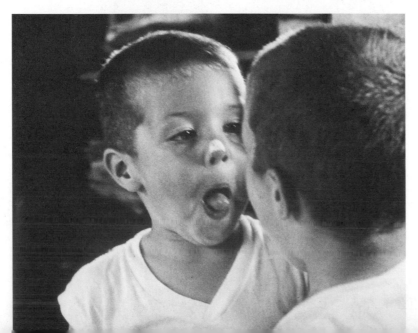

shifting scene, single scene

Tagging along as a story subject lives his life, the photographer will shoot sequentially as a matter of course. Continuity can be achieved whether the camera remains in a fixed position or moves with the action. In the multiple-scene sequence at left, lad who challenges dad during shave receives "a poke in the nose", a dab of lather proudly worn. As the scene shifted from bathroom to hallway to bedroom mirror, the photographer had to move quickly to catch the progression. Used alone, any of the pictures would have been meaningless. Together they're coherent.

Quite another matter is the domestic scene opposite, involving strong emotions. Abrupt movement by the cameraman would have distracted his subject. Unobtrusiveness and a single point of view insured a telling sequence.

what to cull, what to keep, then what?

Cowboy Mike became a might rankled when his mother ordered: "Don't touch that dial!" He protested, then begged for "just one little minute" of his favorite "towboy tartoon." When all else failed, like any self-respecting westerner, Cowboy Mike went for his gun. Staying with the confrontation, the photographer came up with more pictures than the editor needed. But how many are enough? How many can be safely dropped? Do any ideas for layout suggest themselves? Before turning to the variations on the next page, the reader is invited to fashion a sequence of his own

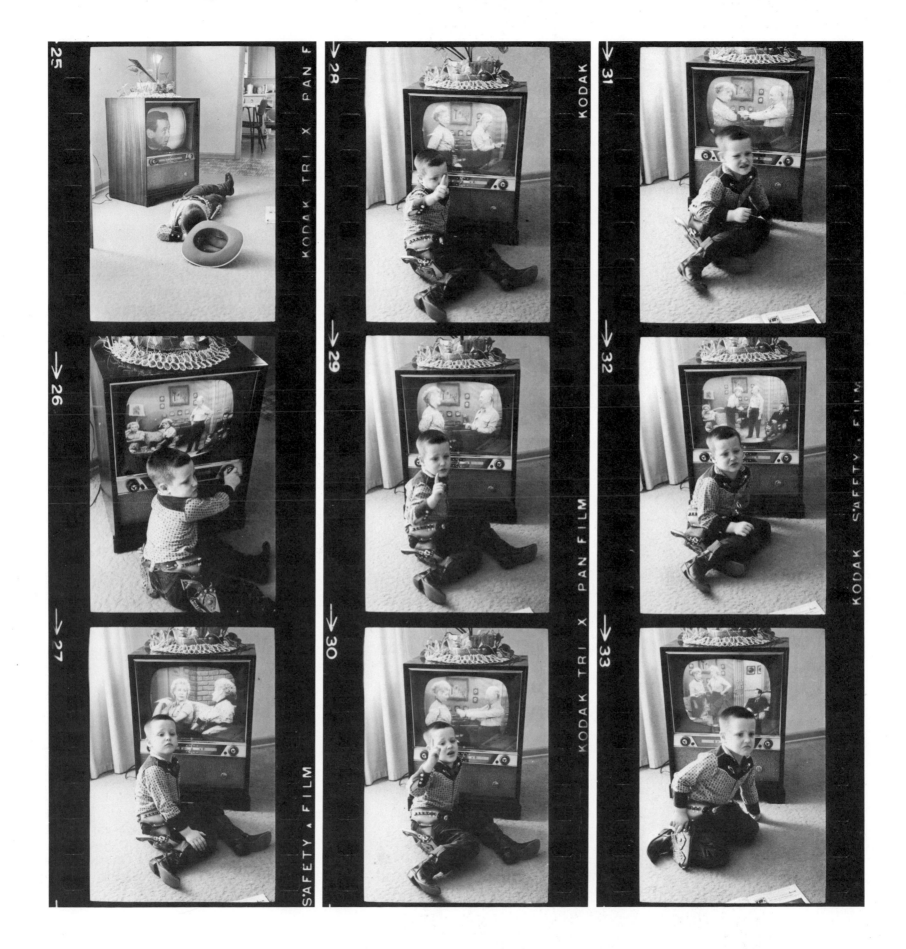

63

Pictures in sequence:

some options in selection, sizing and arrangement

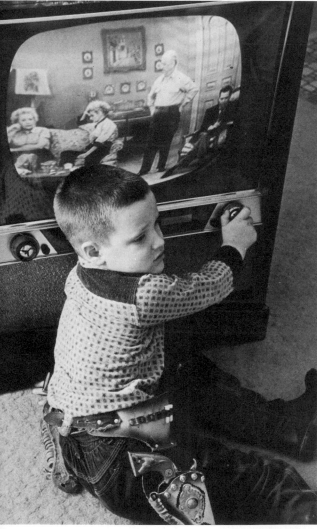

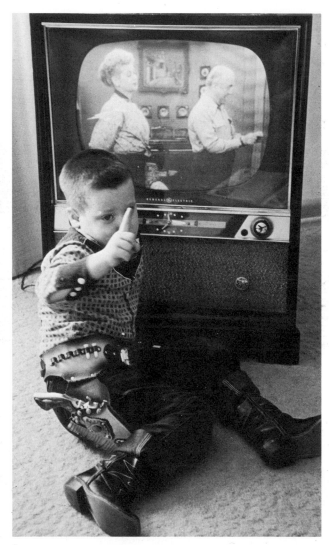

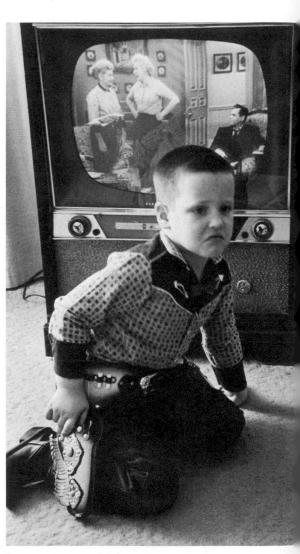

1

2

3

One thing an editor discovers early: there is rarely a "right" or "wrong" way to make a layout. Depending on the completeness of the photo coverage, the editor usually has a number of options, each acceptable. Sequence A may have one virtue; sequence B another. Handed nine frames on Cowboy Mike, the editor might decide to go with three. By selecting frames 26, 28 and 33 from the preceding page and giving them equal play (see above), he produces a

straightforward sequence, easily read. On the other hand, he could not be faulted for the layout at right. With two more frames, he puts additional emphasis on young Mike's attempts at persuasion. With intelligent sizing, the action builds. The climactic picture, with Cowboy Mike going for his gun, justifies the buildup. (A third alternative: in layout at right, drop photos 2 and 4 and move photo 3 to the number 2 position. Insert text in the area below first two pictures.)

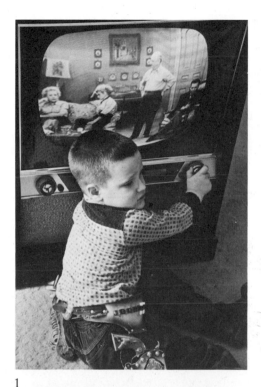

1

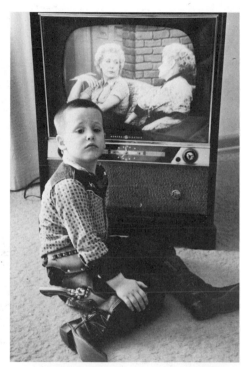

2

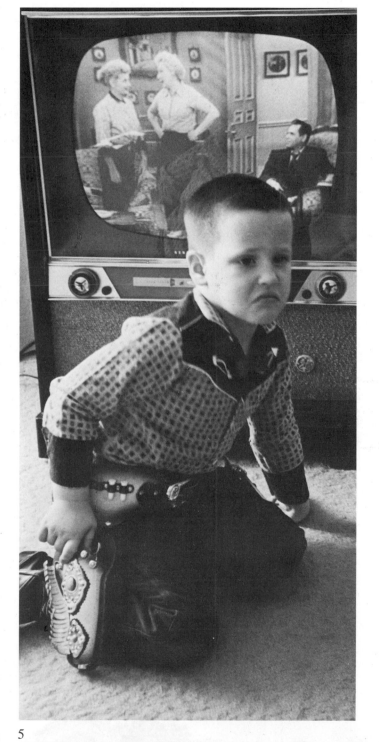

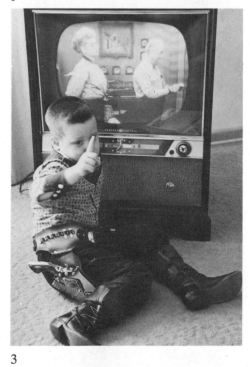

3

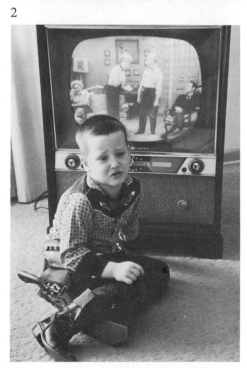

4

5

Pictures in sequence:

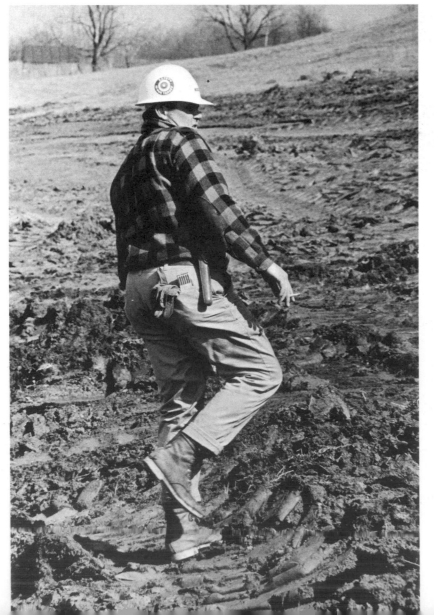
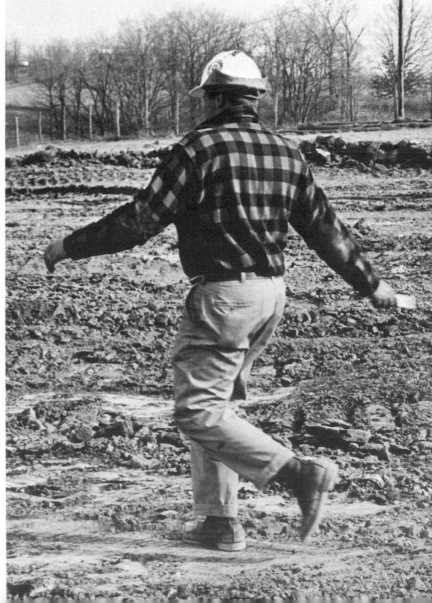

out of context, but still a series

Often as not for the picture-handler, improvisation is the name of the game. His material may be marginal or skimpy. There may have been lapses in photographic coverage, near-misses in execution. With ingenuity, the day can be saved. Unpromising proof sheets will often yield unexpected nuggets when studied with a resourceful eye. The contact proofs at left were part of coverage on a school for operators of heavy earthmoving equipment. From time to time and from different vantage points, the photographer trained his camera on the man in charge of scraper instruction. Impressed with the instructor's rhythmic moves, the editor searched the contacts for one natural and satisfying sequence. Failing to find it, he improvised. He pieced together a series by selecting one picture from four different sets. With careful cropping, he kept the size of the figure relatively constant. With orderly arrangement, he achieved the desired effect. His two-page spread, "Dance master on a muddy floor", provided the twist his story needed. A long look at his contacts gave his layout a lift.

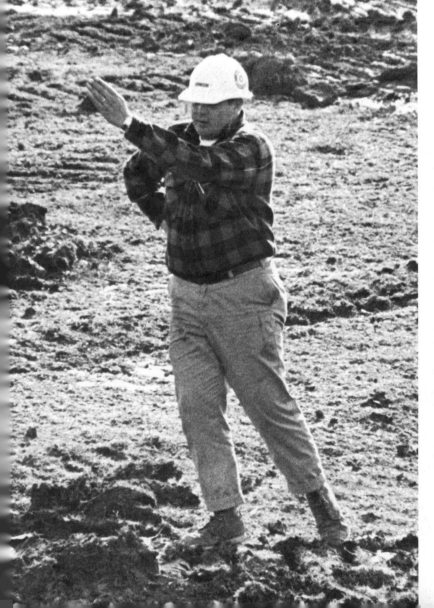
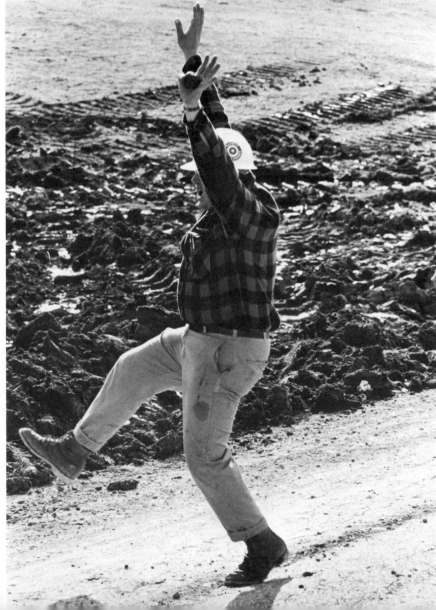

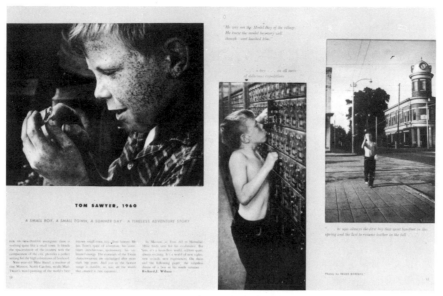

Picture story

Picture essay

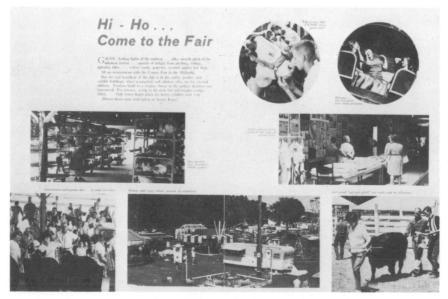

Picture group

PHOTOGRAPHIC NARRATION AND INTERPRETATION

Cogent in content;
coherent in form

More sophisticated than the sequence, the picture story and the picture essay achieve visual coherence through the integration of words, pictures and layout. Often incorrectly labeled as picture story or essay is the picture group.

The picture story has visual continuity. Its form is essentially narrative.

The picture essay sets out to prove a point or explore a problem. It is basically interpretive.

The picture group is an arrangement of miscellaneous pictures on a single subject. It has neither the picture story's continuity nor the essay's point of view.

Although they may appear to be arbitrary and academic, the definitions above are designed to bring precision to the language of picture journalism. Awareness of these distinctions can clarify thinking in both the taking and the handling of pictures.

The language of picture use has been ambiguous. Literary terms have been imperfectly applied. Thus the catchall "picture story" has come to mean any multiple use of pictures. "Photographic essay" has been vaguely defined as picture use of a more sophisticated kind. Often as not, the terms are used interchangeably. It would be idle to discuss them if they were merely labels. But they can have practical application. Understanding the essential differences among story, essay or group will make better communicators of both photographers and editors.

The picture story: essentially narrative

It was a simple story. In a small town one summer day Photographer Bruce Roberts tagged along with a small boy, recording his activities. There was no camera-consciousness on the part of the boy, no posing, no pretending. The pictures Roberts brought back were believable and easily grasped. Even without words they told the story of small-town boyhood in 1960. *With* words the pictures took on a new dimension. The editor's contribution was to caption the pictures with quotes from Mark Twain. Integrated with heads, captions and text, the pictures now demonstrated that boyhood in 1960 hadn't changed essentially since Tom Sawyer's day.

The editor made one more contribution: picture organization. It would have been easy to arrange the pictures in chronological order.

It might also have been deadly. A more meaningful approach was to group pictures by activities: the rough-and-tumble scenes on one spread; the haunted-house sequence on another. The function of the opening spread (below) was to introduce the boy and establish the setting.

In picture-story layout, the basic unit is the two-page spread. It's not the single page, but two pages facing each other. Each spread should have logical construction, coherence and continuity. Pictures on a spread should be selected to make a single statement, to create a single impression. They should be accompanied by a headline to reinforce that impression.

Simplicity should be the key. Gimmicks or trickiness, either with type or in the handling of pictures, serve only to get in the way of the story. With a straightforward approach, this editor did justice to his material and best served his reader.

TOM SAWYER, 1960

A SMALL BOY, A SMALL TOWN, A SUMMER DAY A TIMELESS ADVENTURE STORY

FOR AN IMAGINATIVE youngster, there is nothing quite like a small town. It blends the spaciousness of the country with the compactness of the city, provides a perfect setting for the high adventures of boyhood. Nine-year-old Mike Snead, a resident of tiny Maxton, North Carolina, recalls Mark Twain's word-painting of the world's best known small-town boy, Tom Sawyer. He has Tom's spirit of adventure, his sometimes mischievous spontaneity, his unlimited energy. The essentials of the Twain characterization are unchanged after more than 100 years. And just as the Sawyer image is durable, so, too, are the words that created it (see captions).

In Maxton, as Tom did in Hannibal, Mike finds vent for his exuberance. For him, it's a boundless world, seldom quiet, always exciting. It's a world of new sights, new sounds, new experiences. On these and the following pages, the scriptless drama of a boy in his ninth summer.—**Richard L. Wilson**

10

"*. . . a boy . . . on all sorts of delicious expeditions . . .*"

"*He was not the Model Boy of the village. He knew the model boy very well though—and loathed him.*"

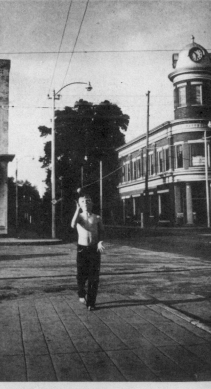

"*. . . he was always the first boy that went barefoot in the spring and the last to resume leather in the fall . . .*"

Photos by BRUCE ROBERTS

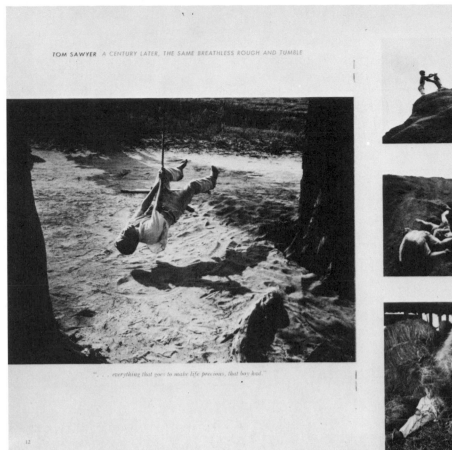

TOM SAWYER *A CENTURY LATER, THE SAME BREATHLESS ROUGH AND TUMBLE*

*"In an instant both boys were rolling and
tumbling in the dirt, covering
themselves with dust and glory."*

". . . everything that goes to make life precious, that boy had."

*"He was always willing to take a hand in any
enterprise that offered entertainment and required
no capital, for he had a troublesome superabundance
of that sort of time which is NOT money."*

*"All the different ways of getting hot
and tired were gone through with . . ."*

12

13

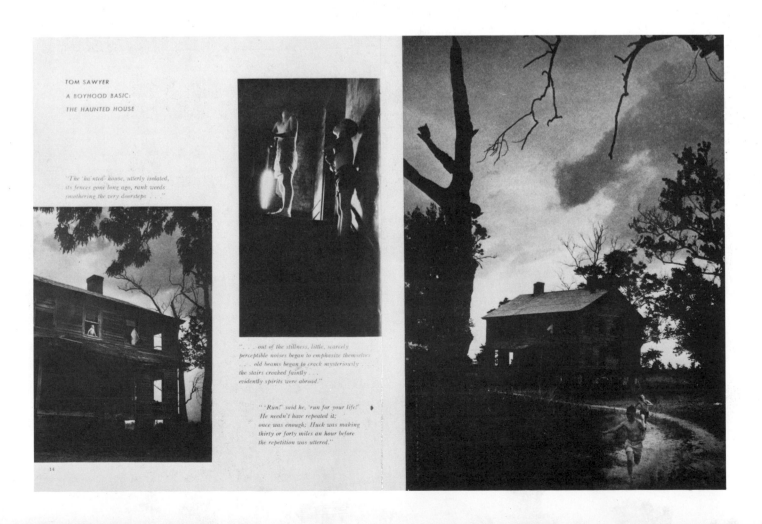

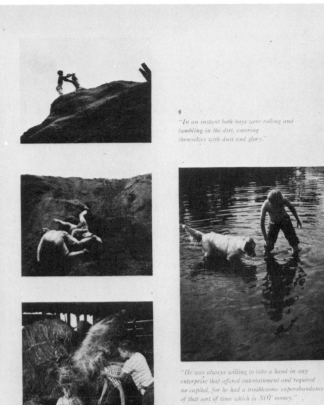

TOM SAWYER

A BOYHOOD BASIC:

THE HAUNTED HOUSE

*'The 'ha'nted' house, utterly isolated,
its fences gone long ago, rank weeds
smothering the very doorsteps . . ."*

*". . . out of the stillness, little, scarcely
perceptible noises began to emphasize themselves
. . . old beams began to crack mysteriously . . .
the stairs creaked faintly . . .
evidently spirits were abroad."*

*" 'Run!' said he, 'run for your life!'
He needn't have repeated it;
once was enough; Huck was making
thirty or forty miles an hour before
the repetition was uttered."*

14

71

The picture essay: basically interpretive

When he followed a small-town boy through a summer day (preceding spread), the photographer used his camera as a story-telling tool. He made narrative pictures and he brought back a *picture story*. Something totally different occurred in the photo coverage reproduced here. The camera became an advocate. Photographer Rudolph Janu set out to support a point of view, to reinforce an editorial position. On the printed page his pictures became elements in a *picture essay*.

Perhaps because it sounds more elegant, the term "picture essay" is often misapplied to the picture story. Actually there are distinctions in both content and form.

The picture essay is more likely to argue than to narrate. It intellectualizes. It analyzes even when it presents both sides of an issue. It's more likely to be about something than someone.

The picture story's visual continuity is not a characteristic of the picture essay. Unrelated in time, unconnected in story development, essay pictures do not lean on one another. Each picture is selected to make a large point; each can stand alone. If pictures in the picture story are comparable to sentences, the essay picture more closely resembles a paragraph.

In the essay on these pages, the editor of *Cyanamid Magazine* set out to disprove the charge that corporations foster conformity. Execution was admirable. The opening picture, set up for effect, riveted the reader's attention. Pictures on the second spread appeared to corroborate the conformity charge. The third spread refuted it. Summary statements, in larger type and second color, capsuled the essence of the essay and drew the reader into the text.

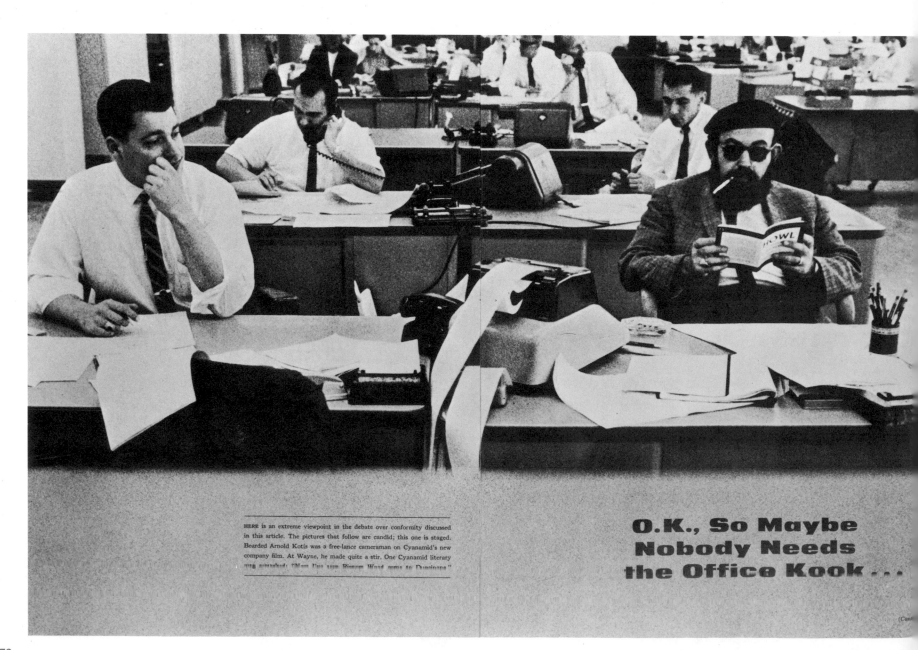

HERE is an extreme viewpoint in the debate over conformity discussed in this article. The pictures that follow are candid; this one is staged. Bearded Arnold Kotis was a free-lance cameraman on Cyanamid's new company film. At Wayne, he made quite a stir. One Cyanamid literary

O.K., So Maybe Nobody Needs the Office Kook . . .

(Cont

Photographed at Cyanamid Headquarters by Rudolph Janu

... but corporations get blamed for fostering "soulless conformity." If true, this is a serious charge. More likely, it results from a glib, generalized view ...

Not long ago, a man in his thirties came to work for Cyanamid. On his first day in the office, the boss took him around to meet his co-workers—nine of them.

All nine said: "Glad to have you aboard"—or some close variation of that phrase. The new man winced each time he heard it.

"What have we got around here, a bunch of conformists?" he asked later. "You'd think *someone* would have said something different, like 'hello.'"

This man is probably confusing conformity with plain human shyness or lack of imagination. But his words point to a subject that seems to be much on the minds of a lot of Americans. Are we losing our sparks of individuality?

We brood about it. "A Nation of Sheep" was the title of a recent best seller. "The Decline of the Individual" was the name of an article by Vice Admiral H. G. Rickover. *Time* Magazine lately pondered at length about the status of the individual. Simpson College in Iowa held a two-day "Festival" in which learned men came together to talk over the concept of conformity.

In many such discussions, corporations—particularly those the size of Cyanamid—come in for a good part of the blame. If you work for a big company, you are supposed to be losing your identity.

It's time industry took a hard look at conformity. Industry must: 1) seriously consider those parts of the charge which might possibly be true, and 2) be frank in expressing impatience with critical statements that reflect shoddy thinking and lack of information.

Number one, first. Without a doubt, modern technology demands standardization. Everyone, for instance, likes good telephone service. But the Bell System has worked its wonders by having a woman in Newark plug in a telephone jack and press a key in precisely the same way that a woman in San Diego does. Chemical products are made by exact formula. Any deviation could wreck the equipment or ruin the batch. Then, too, safety demands rigid procedures.

But what is the *result* of all the new methods of standardization and efficiency? Look around you. There is a wider variety of products and services available for everybody. There is more *choice* of things to buy and things to do. Individualism is hardly squelched by our standard of living, it is catered to.

Nevertheless, when a man or woman is at work, there are certain modes of behavior and standards of efficiency which are important. Communist countries know this well. In their pell-mell rush into industrial maturity, these countries find it necessary to release floods of literature praising the joys of glorious conformity.

Our Western society is in no position to relinquish its advances in technical efficiency. But at the same time, it cannot afford to overlook the one thing it has in addition to efficiency: respect for the individual. Corporations today must continue to make technology serve people, but they must be careful to stop short of that mark where people begin to serve efficiency.

Business must be careful, too, not to fall in with its critics in thinking too often about people as faceless members of conforming groups. Modern marketing methods make use of sociological studies and statistical models. These lump people into various buying groups, age-levels, taste groups, opinion-leader groups, and the like. Such methods can be valuable shortcuts for decision-making, but they are not by any means precise. For instance, all the experts were certain a lot of people would buy the Edsel car. Statistics said so.

But people didn't behave as predicted.

Which brings us to the second point stated above.

Industry can well accuse its critics of glib, generalized observation. In the first place, some aspects of conformity are so much a part of all human beings—in industry or out of it—that to cry out against conformity is about the same as accusing people of having pelvic bones. At the same time, however, absolute conformity is true of literally no one. And industry, far from seeking conformity from its employees, is actually in need of the reverse: more individual contributions.

In parts of our globe there are still people who live in proscribed tribal patterns. At Mesa Verde, you can see the identical cubicle houses of the cliff dwellers. At Carcassonne, France, you can observe a medieval walled town. In London, you can see 18th-century row houses. Man has exhibited throughout his history a need to belong to a group and to live in the way his neighbors do. Psychologists insist that it will take a major mutation in human nature to achieve anything different.

As a matter of fact, the whole idea of rampant individualism is largely a legend. It comes from the flamboyant style of Renaissance patriarchs (as expressed, for the most part, in painting and sculpture), and from Romantic literature, where the hero is often depicted standing on the peak of some mountain, hair and cape a-billow, shaking his fist at the sky.

America has its own share of the legend. Ours involves "rugged" individualism and the "pioneer spirit." Engrained in our upbringing are words such as those of Emerson: "Whoso would be a man must be a nonconformist." There was Thoreau, who stalked off to Walden Pond and did other nonconformist things, like not paying his taxes. There were all those "giants in the land" who killed "bars" in trees. There was the West and "don't fence me in." And Huck Finn, who wouldn't wear shoes and who "lit out for the territory"

(Continued)

12 · 13

... and the case for conformity falls apart whenever a sensitive eye looks closely at how people really are

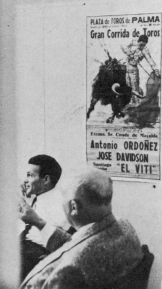

It's colorful; it's part of our heritage. But we can be seriously deluded by it. Aren't we too quick to forget the true pioneers—hardworking people who doggedly sought opportunity, who embraced communal living and strict modes of behavior as often as they could find them, and whose prairie towns and sod huts were as alike as anything now on view in Levittown?

There has been no golden age of individualism. 1963 is as good as any time, if not better.

What is industry saying now about conformity?

"I emphatically deny," said the late Fred Maytag II, chairman of the board of The Maytag Company, "that the progressive corporation seeks to recruit only those graduates who have already proved themselves potential organization men."

Says a Cyanamid personnel man: "I can't conceive of a 'Cyanamid type.' We need so many people from so many different backgrounds—people who know about farming, or mining, or medicine, or fashion, or inorganic chemistry, or the construction industry. We're looking for people who can do a job, not company men, whatever that may be."

No corporation can afford to carry on precisely as before. For that way lies profitless stagnation. Every company needs as many creative ideas, as many new concepts as possible.

Cyanamid, in fact, spends thousands of dollars every year to reward employees for their suggestions and new ideas. The company suggestion plan is a definite expression of policy: Cyanamid cannot grow and prosper without the unique contributions—big or small—of its various employees.

The best rebuttal to those who think business fosters conformity is to invite the critics to take a closer look. The critic should come in, sit down, and meet—who? People. That's who he'll find inside industry. Individuals, each with a unique mixture of hopes, fears, likes, aversions, ambitions, and anxieties.

Perhaps, after all, it's good that Americans are brooding about conformity. Because that way, we are certain to preserve what is valuable in our society: our concern with the individual. But we may brood too much and overlook the obvious: people *are* individual. To deny this is simply not to look closely enough. ∎

14

Hi - Ho . . .
Come to the Fair

GAUDY, flashing lights of the midway . . . silky smooth pitch of the sideshow barker . . . squeals of delight from pitching, rolling, spinning rides . . . cotton candy, popcorn, caramel apples, hot dogs. All are synonymous with the County Fair in the Midlands.

But the real heartbeat of the fair is in the cattle, poultry and exhibit buildings, where youngsters and oldsters alike vie for coveted ribbons. Tensions build to a ringing climax as the judges' decisions are announced. For winners: a trip to the state fair and tougher competition . . . while losers begin plans for better exhibits next year.

(Photos shown here were taken at Avoca, Iowa.)

"Take it easy, baby, I KNOW you're gonna win"

Whoopee . . . tilts and whirls raise blood pressures.

A fair without exhibits would be like apple pie without cheese.

Open quarters, close observation, rabbits, poultry

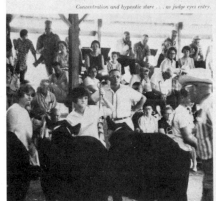

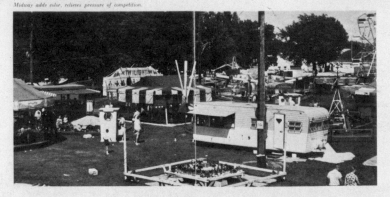

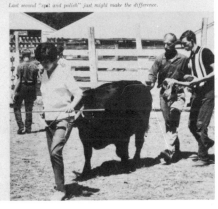

Concentration and hypnotic stare . . . as judge eyes entry.

Midway adds color, relieves pressure of competition.

Last second "spit and polish" just might make the difference.

Pictures in the picture group are no more than miscellaneous impressions. This group was flawed by photos with cookie-cutter shapes and by white space trapped in center of layout.

Less sophisticated but more prevalent than either the picture story or the picture essay is the *picture group*. It is a set of pictures best described as samplers. The picture group is a throwback to the single-picture days of news photography. Covering a rodeo, for example, the photographer tries to catch the essence of the event in pictures that stand alone: a crowd scene, a bull, a rider, a pratfall. In layout his prints become an arrangement of single pictures. Where pictures in the picture story need and enrich each other, pictures in the picture group are no more than miscellaneous impressions.

Intellectually, the picture group is picture use at a rather low level. But it has its place; it is not bad per se. In effect, the editor is saying: "There was an event. Had you been there, this is what you would have seen."

So it was with the picture group above. Differences in approach could have led to either a picture essay or a picture story. To take an extreme example, had the editor sought pictures to prove the fair an anachronism, to argue that it perpetuates crafts long outmoded, he could have produced a picture essay. Had the photographer selected just one facet—cattle judging, the midway or an exhibitor—and had he shot in depth and with continuity, he would have returned with ingredients for a picture story.

Photographer Leonard Nadel proves the point opposite with his picture story, "Jennie and the bulls". Nadel went behind scenes at the fair to cover a contestant preparing her animals for the show-ring. His narrative pictures had logical progression. They also had appeal. A happy choice of story subjects helped insure reader interest.

JENNIE AND THE BULLS

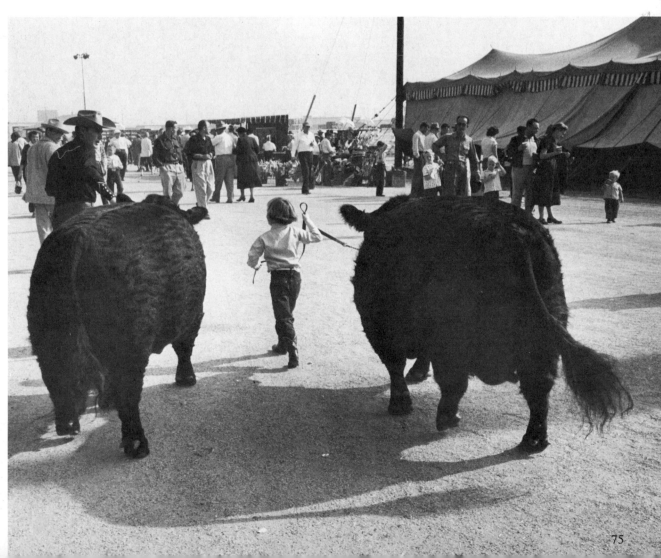

THE PICTURE STORY: A CASE HISTORY

**From
a hoked-up
ceremony
to pictures
that probe**

If picture stories are rarities, it's not for lack of subject matter. Story possibilities abound, waiting to be exploited. Too often they are given short shrift, dismissed with one perfunctory picture. A case in point: in many publications, particularly those issued by corporations and associations, the plaque-presentation picture is standard and dreary fare. Presenter and presentee fix their gazes on plaque, camera or each other and coverage is consummated . . . in a flash. Rarely is the story fleshed out with an honest look at how an award-winner gets that way. At left, a truck manufacturer turned over the keys of its millionth vehicle to a young truck-line president, then hoked up a scene for press cameras. After taking the picture, the company magazine took a second look at the customer. Wasn't there a meaningful story there? What's involved in running a truck line? What pressures swirl around the man in the president's chair? How about a searching look at Jim Seymour when he wasn't posing? Instead of a key presentation or a gimmick photo, the magazine carried an eight-page picture story. On the next 15 pages, a reconstruction of that story.

M. Leon Lopez

Jim Seymour proved to be an uncommonly good subject. Sympathetic to the honest portrayal of his activities, he gave the magazine the time required for a rounded look. It came to three working days. The editor who regards three days as wildly extravagant might take a hard look at his pages. If he fails to find realism there, it's because his photo coverage is hurried and superficial. His story subjects don't have time to get over their camera-awareness. Conditioned to being told what to do, they play-act until a flash goes off, become themselves when the camera is put away. Too often, and particularly when he's covering an executive, the editor feels he imposes when he takes a little time. Actually, he imposes only when he *poses* his man, when he busily creates an artificial situation.

A more profitable approach: let the subject get on with his work. Let him go back to being himself. Permit the camera to become a quiet observer. With small cameras and available light, there's no need to intrude. There may, however, be a warming-up period before the subject becomes oblivious of the clicking. Pictures taken in this stage seldom get into the layout, but they serve their purpose. Believable pictures will come later, and in profusion.

Jim Seymour ignored the camera from the start. Before the shooting began, the photographer made a plea; "I'd like entree to all situations that make good pictures, no matter how sensitive. You'll have a chance to clear everything, but it's important that there be no holding back." Jim Seymour gave his word and kept it.

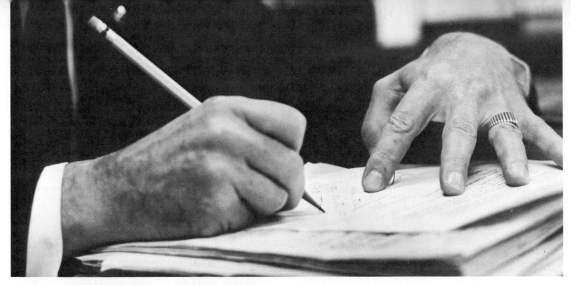

In the quiet of the corner office, the photographer's attention was attracted by the tapping of the president's pencil: "He held the pencil in his hand constantly, jotting with it, fingering it, chewing it, tapping it on the arm of his chair, even holding it in his telephone hand. It was a mannerism so I concentrated on it for awhile with a telephoto lens." Although erased at the layout table, the pencil sequence gave the editors an attractive option. Explained the photographer: "Coverage shouldn't be aimless. As you shoot, you have to decide whether a given situation is pertinent to your story. At the same time, you have to be alert for the sidelights that are both unexpected and revealing."

Deliberately, the photographer's presence was not explained to Jim Seymour's stream of callers: "Introductions would have been a mistake. It was important that people come and go as they normally do. Some of the time I'd sit quietly as they talked, shooting from a fixed position. As the conversation became more animated, it was a simple matter to move around for a better angle, behind one man or the other, without disturbing either."

The photographer's instinct told him also when to step out of the room: "You have to do that occasionally. You sense when it's time to give your subject a little relief. When you come back you'll be more welcome."

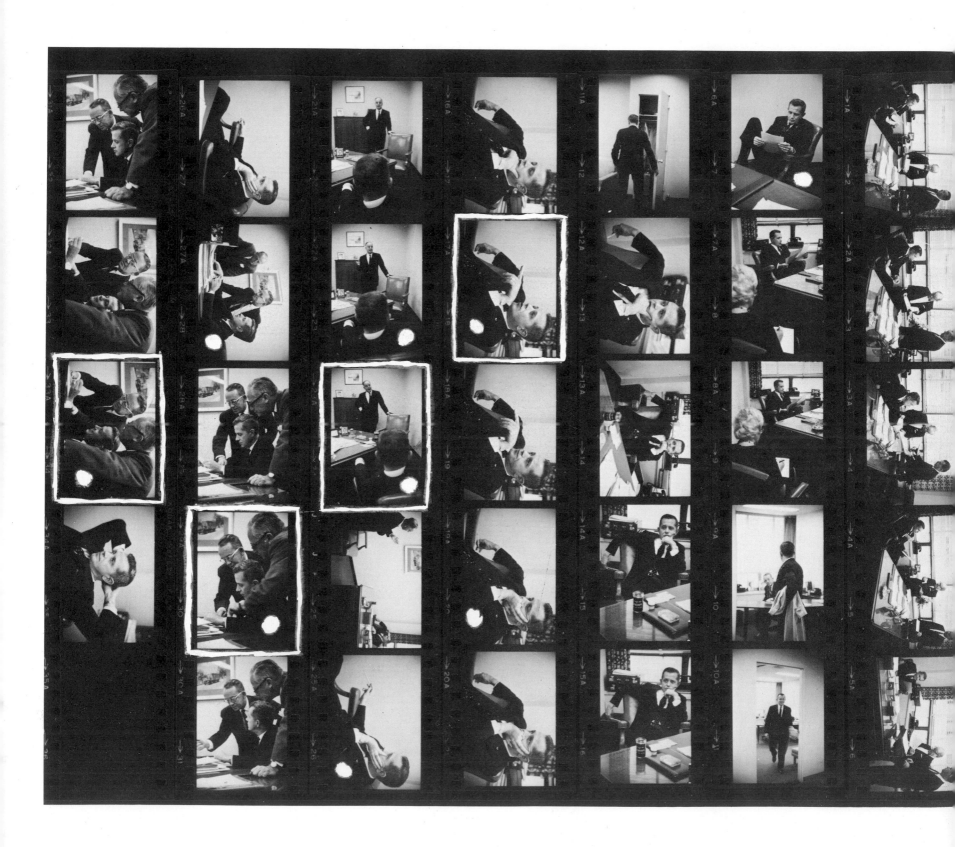

Shadowing Jim Seymour for three days, the 35-millimeter cameras clicked 614 times. Arrayed now on 20 proof sheets, 614 frames revealed what the cameras saw and something more. They revealed the thinking behind the clicking, the photographer's patience as he worked and reworked each situation. Even a cursory glance at the contact proofs disclosed a happy mix of horizontals and verticals, of long-views, medium-views and closeups. At a quick glance, some of the frames seemed repetitious. A closer look disclosed subtle differences in expression, gesture, posture. The painstaking selection process began. It was never a choice of good over bad, but of two or more pictures saying slightly different things. It was a choice, too, between that wide-angle view of the meeting on sheet 15 and the telephoto views on sheets four and five. Frames under consideration were dotted with a grease pencil. Squared frames represented the final choices. Of the 32 enlargements ordered, 17 made the final layout. All of them had to survive deliberations of the kind discussed in captions at right and below.

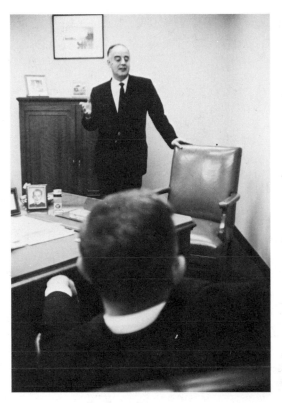

Viewing visitor from behind Jim Seymour's chair, camera caught gesture in one frame, hand on hip in next. Gesturing man is usually more interesting, but not in this case. Angle of head and better expression gave nod to photo at right.

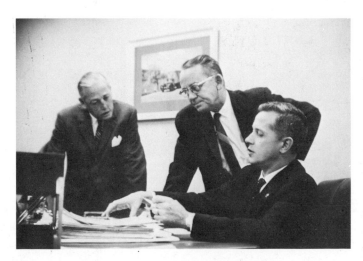

First frame of three men in a huddle was rather conventional. Studying document, men subsequently moved closer for better look. Camera position didn't change.

To permit flexibility at layout time, photographer caught tighter huddle in both vertical and horizontal frames. Photo at right, revealing more of Seymour's face, was editors' choice. Cropping in at right removed some coat and shoulder.

editing the proof sheet:

which picture says it best?

Because he considered going out for lunch a waste of time, a sandwich at his desk was the noonday fare for this company president. Decision-making went on without interruption, usually with a lunch-sharing visitor. Confronted with these four views of the work-and-eat situation, the editors decided quickly that one picture best summed it up. Which would you guess was their choice?

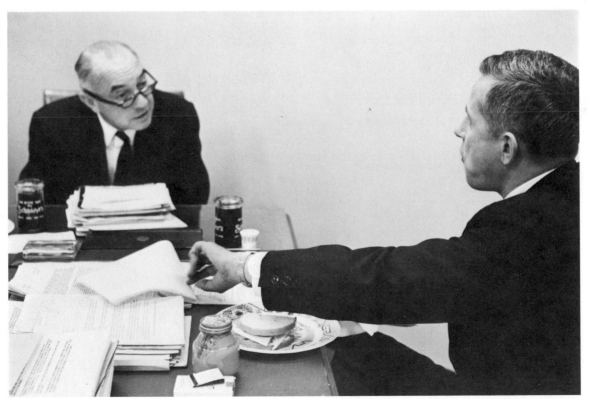

One of these four seemed a natural opener for the Jim Seymour story. Reproduced on the next page, it's the lead picture on the story's first spread.

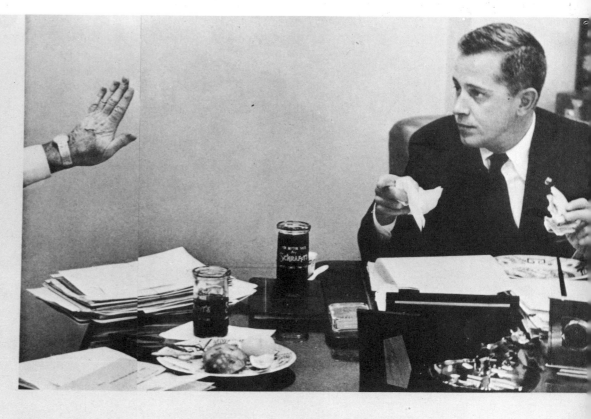

UNCOMMON CARRIER

Associated Transport's Jim Seymour has bypassed
tradition and time clock to keep his truck line highballing

BY OUTWARD appearances it would seem that James K. Seymour, youthful president of the nation's third largest trucking firm, had inherited a family birthright. He is the second president of Associated Transport, Inc. His father was the first. He is 40 years old. The average age of his top executive staff is 60. "Ask any president's son," Seymour insists, "and if he's a candid sort of a guy he'll tell you that being a president's son is never a handicap." But ask any other Associated man and he'll tell you

any suspicion of nepotism is clearly unfounded. Remarked one AT executive, "The Old Man would fire him if he couldn't do the job."

J. K. Seymour's "Old Man" is Burge M. Seymour, 70, who retired as president last August but stays on as Chairman of the Board. The company his son took charge of is one whose network extends from Boston to Charleston along the Eastern Seaboard and inland as far as Cincinnati and Nashville. Its revenues last year amounted

by M. Leon Lopez photos by Angus McDougall

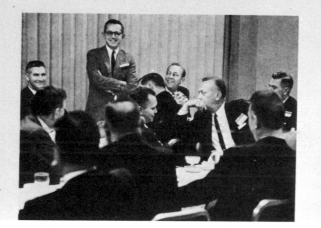

BUSINESS "LUNCHEON." Associated Transport's president considers going out for lunch a waste of time. Through noon hour he continues business in his Manhattan office—over sandwiches.

SHIPPER'S DINNER. Relishing also the social side of business (far left), Jim Seymour charms customers at annual party in Cincinnati. At 40, he heads third largest truck line in U.S.

TERMINAL TOUR. On narrow ledge at Cleveland, Seymour's cloak-and-dagger tactic is deceiving: He pulls no surprise visits—"So terminals get cleaned up at least once a year," he quips.

Case history: for a strong start, a special breed of picture

Lunch at the desk. Animated conversation. A visitor vigorous in his gestures. The camera moving in, backing off, favoring one man, then the other. Then it happens. A hand intrudes on the left; an intent president reacts on the right, napkin and sandwich forgotten. With one camera click, a strong opener is assured, a worrisome

hurdle cleared. It takes a special breed of picture to launch a personality story and this one met the major requirements: the gesturing, disembodied hand gave it "stopper" quality; lunch at the desk summed up the young executive's working philosophy; the camera caught enough face so readers could identify Jim Seymour on suc-

ceeding pages. The key picture was displayed seven inches deep, 11 inches wide, nearly 60% larger than the reproduction above. Enough area remained on the opening spread for two more visual statements. One documented Seymour's warmth as an after-dinner speaker; the second dramatized his thoroughness as an inspector.

Cropping left and right not only tightened photo's composition but gave greater size to the better faces in the audience. Lopped off were a distracting candle and meaningless backs of heads.

Cropping top and bottom eliminated distracting light area in overhanging roof and non-working gray space in foreground. It also helped viewer zero in on Seymour edging along ledge.

What's so obvious about the typical telephone picture is that nobody's at the other end of the line. "Pick up the phone", the photographer suggests. "Pretend to talk." Invariably, the acting's apparent. Real calls can take unexpected turns, including the turn to a second phone. Only flaws here were the odd light streaks that could have been eliminated by adjusting the Venetian blinds. But if he'd taken the time for that, the photographer might have lost the picture.

Tricky handling of pair of receivers took the telephone pictures out of the cliché category. It also provided such acceptable choices as photo at right. After consideration, top photo was ruled out for lack of action. Picture below, with Seymour's arm fully extended, had action, but soft focus precluded enlargement.

Having enough medium views, photographer moved in tight for photo at left. Vertical but less effective, it would have been picked only because of layout considerations. This would have been a poor argument, however. A picture should be selected for what it says. The layout should accommodate the picture.

This was editors' choice. They liked Seymour's body action and the pattern formed by stretched phone cords. Picture was opener for story's second spread, reproduced on next page.

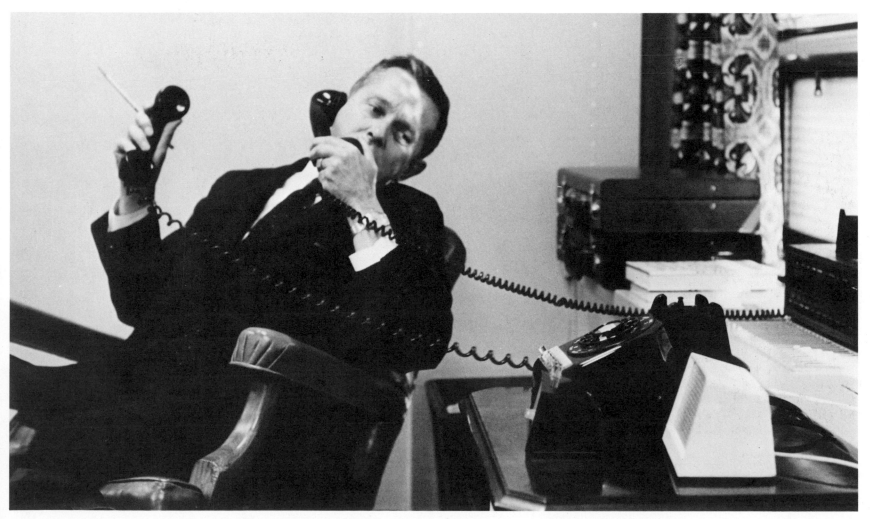

after 11 a.m.,
an open-door policy

A SKILLFUL JUGGLER of both phones and paper (which he sorts in neat stacks), AT's President Seymour reserves his mornings for sifting documents and letters. Above, he tells his secretary, Paula Zbar, to file away another report.

to $74.3 million, $2.8 million of it profit. ("We're small as companies go, big as trucking companies go," comments President Seymour.) Its fleet of 965 highway tractors and 1,158 local pickup-and-delivery trucks logged 103 million miles, hauled 5.7 billion pounds of freight. Yet, before the present glow of prosperity, Associated spent some of its corporate lifetime spinning its wheels. Until three or four years ago, there were few profits to speak of.

The reasons are not hard to fathom. First of all, for several years after its 1942 formation, the company remained something of a patchwork made from seven predecessor firms that had all been family-owned and doggedly independent. The elder Seymour, chosen by bankers to oversee the merger, had the task of getting the pieces to fit harmoniously together. Secondly, Associated, while sharing in an industry that transports two-thirds of the nation's goods, also shares the industry's problems. According to President Seymour, these are considerable.

"For one thing," he says, "we're one of the most thoroughly regulated industries on earth—at all governmental levels." For another, Associated's area contains close to 40 percent of the country's population. Not quite a blessing, Seymour contends: "It's also densely populated with competitors." And dense population means heavy vehicle traffic, which, to a trucker, spells high operating costs from stop-and-go driving and jam-ups at overcrowded loading docks. Wages and terminal rentals are high. So are costs for maintenance, short hauls and empty mileage. For these reasons, some truckers have been forced over the center line, with profits heading downhill even as revenues climb.

Associated is now better off than most, and much of the credit, according to insiders, goes to Jim Seymour. Since 1961, when he became AT's executive vice president and operational chief, revenue has increased slightly but profits have gone up sevenfold. They're expected to take another big jump, to $6 million, this year. But

A WILLING LISTENER after 11 a.m., Seymour keeps himself accessible to all comers. Left, his secretary ("Did you speak to Miss Hunt about the March of Dimes?"). Center, Don Palmer, his chief accountant, reporting on yard improvement costs. Right, Paul Imperato, his purchasing agent, discussing gasoline suppliers in Atlanta.

TO BUY OR NOT TO BUY is the question—whether profit potential warrants getting special trailers to haul plate glass. Seymour injects a joke in discussion with Ben Horton (left) and Bob Groat (right), v.p.s for maintenance and sales.

Case history: a split spread to mirror a divided day

As a matter of routine, Jim Seymour reserved his mornings for paperwork and phone calls, didn't open his door to callers until 11 a.m. Seeking to reflect that practice, the editors split their second spread horizontally. They depicted the closed-door phase in the top panel, showing the phone-juggling and a document handoff. In the bottom panel, the emphasis shifted from the president (whose facial features were now well established) to the people who appeared at his door. Was the layout a success? Conceded the editors: "Some layouts you're sure about; many of them you second-guess. In this instance you could ask whether we needed a second look at the secretary. We felt we needed that slice of door and we found the photo's vertical shape useful, but there were other tacks we could have taken." When the shooting is as complete as it was here, the layout possibilities multiply. So do the difficult choices. At right are alternative ways to illustrate "open-door" policy.

To narrow the gap between caller and Jim Seymour, photographer
focussed on each man in turn from same camera position. Separate
pictures of the two reacting to each other required less space than one
overall view, giving editors another option.

An added option: the president's open door photographed from the
corridor. There were good arguments for using this picture or another
like it, but editors chose to represent stream of callers with series of
verticals taken inside the office.

AFTERNOON DEBATE zeros in on contract figures for a terminal expansion. Seymour weighs advice from a v.p., his real estate advisor and contractor.

. . . then cedes his chair to Labor Vice President John Lane (on phone with union chief). Confab moved to a restaurant at 7:35 p.m., broke up at 2 a.m.

after 5 p.m., the feet go up
but the guard doesn't go down

Seymour, who came up mostly through sales, at first doubted his overall qualifications. "When the directors elected me," he relates, "there was one guy who realized I lacked sufficient experience—me." To compensate, he threw himself into a year-long self-education program, began to stump the length and breadth of AT's network learning the details of the company's operation. He shortly became known throughout the system as "the man with the question."

He then assigned first priority to the areas he thought could bring the most immediate cost benefits. He says: "We decided, for instance, we didn't like losing money in July. So we took the batteries out of 30 percent of our trucks, backed them up against a fence. We took off 90-some mechanics and 250 pieces of power. Of the trucks removed from service, 100 never went back." In 1961, Associated had 1,200 over-the-highway tractors. Today it runs 965 and hauls more freight. Seymour's cost-cutting onslaught withered initial resistance. "At first it took real missionary work," he recalls. "Now the job is a lot easier. We just raise a flag that says 'July' and everyone goes into action."

The most revolutionary part of Seymour's program was the decision to trade in Associated's entire road fleet every three years—just before the first major overhaul comes due. Seymour explains: "Our maintenance costs used to be the industry's highest; now, they're among the lowest, and still going down." This year, Associated bought 325 new International trucks—75 cab-over-engine Loadstars for local runs, 50 DCO 405s and 200 Fleetstar road tractors. All are fuel-saving diesels.

Seymour promoted better traffic management to reduce empty miles, a stepped-up program to expand and mechanize terminals, a data processing system to

Case history: an uncensored look at a man with headaches

Pictures for the magazine pages preceding were selected to dissect the Seymour style. For the spread reproduced above, they were picked to shed light on a pair of Jim Seymour's problems: the nitty-gritty of terminal expansion (lcft), a labor-management headache (right.) Because the right-hand page is all of one piece and unrelated to the terminal question, this layout is not so much a spread as two individual pages. But since they reflect a mood change, the pages mesh. The meeting at left is brisk and businesslike. As the labor dispute drags on into the evening hours, weariness sets in, formality fades. It's the kind of tension-charged situation a photographer always hopes for and is rarely privy to. To be wholly accepted and totally ignored is a tribute to the man behind the camera. It also speaks well for the man in the camera's eye.

Building-plans photo was strong candidate for layout's left-hand page. Faced with hard choice between photos saying slightly different things, too many editors default. Rather than pick one and give it size, they use both and sacrifice impact.

There's a time to move in, a time to stand back. In closeup, feet on desk are too obvious, almost a cliché. Overall view (*on opposite page*) is much more revealing, has better mood.

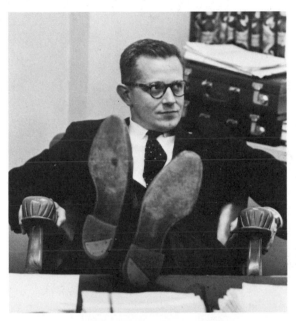

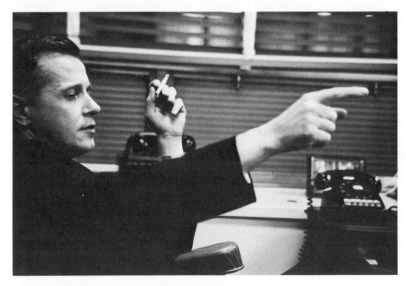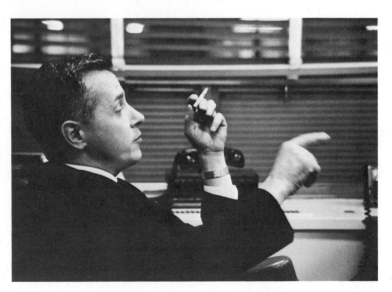

An uncroppable picture comes a cropper. Because of distance between head and hand, photo on left couldn't be narrowed. More manageable picture on right could be trimmed on both left and right, made the final layout.

M. Leon Lopez

SUITCASE AND BRIEFCASE accompany Seymour, who commutes from his Connecticut home, hops around AT's system by jet—and generally works in transit.

TYPICAL TERMINAL. Cleveland's has 49 doors and a "drag line" of chain-driven carts.

move AT's avalanche of paper. He encouraged efficiencies which turned a major weakness to a strength: Associated gets two-thirds of its business from hauling small packages in less-than-truckload lots. Such shipping commands the highest rates, promises a greater return. But—without careful management—the increased handling more easily turns profit to loss.

Seymour began his trucking career at age 18, as a stevedore and local truck "jockey" for another firm in Buffalo. Once, he swore he'd never work for his father's company. He's been violating the oath for 18 years. An executive who is both sophisticated and informal, Seymour guides his truck line with a hand that's firm but a manner that's easy and relaxed. He works a 14-hour day, trades jokes and jibes with associates (who call him Jim or Jimmy), inserts his jaunty wit into business discussions. Quick to point out that "90 percent of the decisions important to this company are not made by me," he does not run a one-man show. He consults freely and frequently with associates, as often in airplanes, motel rooms, cars and taxicabs as in the home office, a one-floor spread at Manhattan's 380 Madison Avenue. Home is Westport, Connecticut, a one-hour train ride, where he gets to see his wife, three sons and two daughters on weekends and once or twice in midweek. "Those times I like to stop being president and start being a father," he confesses. Other times, he's totally dedicated to trucking. "It's my life," he says.

TROOPING THE LINE of new IH diesels, Seymour spots some patched-up accident damage. With him is Cleveland Manager Bob Lonneville. To save on maintenance, Associated Transport turns over its entire road fleet every three years.

Case history: for the transition from office to territory, a visual bridge

A well-constructed picture story will often include a visual bridge, a transition picture that can carry the reader from one situation to the next. The opener on the final Seymour spread was one such bridge. Until this point, Jim Seymour was a president who didn't stray far from the president's chair. Leaving now for the territory, he was just another figure in a Manhattan crowd . . . and not above carrying his own bag. Two other transition pictures (see left) were quickly discarded; the view on far left because, at this stage, there was no need to show the subject's face; the doorway view because it would have burdened the spread with too many corporate symbols. (Seymour's circled symbol appears also on each of the truck-trailers.) Editors of kept publications tend to overuse such labels. Intended to keep the sponsor or story subject happy, bold logos only jolt the reader and contribute to the unsightliness of the page.

Case history: a summing up

An editor can do a puff piece on an executive or he can probe. Puffery is easily done and easily seen through. The probing story usually involves the taking of pains and the taking of time. It is more than an ego-salver. By examining the problems a man faces, the magazine sheds light on the sector in which he earns his keep. A look at Jim Seymour, in effect, was an inside look at the workings of a modern truck line.

For its study of Seymour, the magazine asked for three shooting days. Three days would catch him in the office and out, would provide a representative slice of his business life. Once coverage began, the photographer let things happen.

Most painful part of the process was the weeding of pictures and their arrangement in spreads. Pictures were assembled in countless combinations. Each combination was tested for unity, coherence, impact. Any picture which failed to say something new about Jim Seymour became a discard, no matter how considerable its other qualities.

Headlines came next, a main head for the opening spread, auxiliary heads for the spreads succeeding. Each head reinforced the pictures which accompanied it.

Final step in the process was the writing of text and captions. Both were written to fit after picture space had been allocated. Instead of preparing an individual copy block for each spread, the writer chose to make his copy continuous. Individual copy blocks would have been preferable. The reader is best served when text and pictures lockstep, when the prose on a spread is specifically relevant to adjacent pictures.

The company publishing the magazine was a truck manufacturer. Not until the final spread did the reader see evidence of the sponsor's involvement. With a bigger story to tell, the editors did not feel the need to inject a product picture on every page. When the trucks did appear, they did so in a low-key way. ("Trooping the line . . . Seymour spots some patched-up accident damage.") The commercial may have been missing, but the implication wasn't. A first-cabin executive usually has equipment to match.

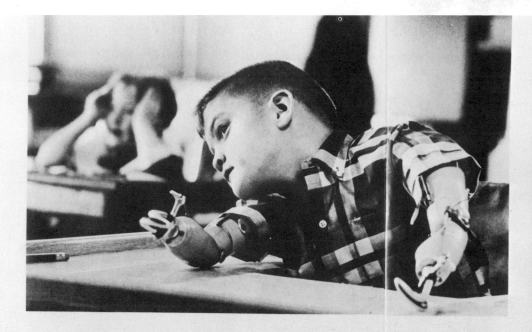

by Kathy McCaughna photos by Angus McDougall

INTENT FIRST-GRADER leaning on desk at left is the same boy shown at bottom of opposite page. At 19 months, Tommy Cook lay on floor, looking at rolling bucket seat that was his first transportation. This fall he enrolled at Shrine School in Memphis. Below, Tom's fiberglass arm goes up along with natural limbs.

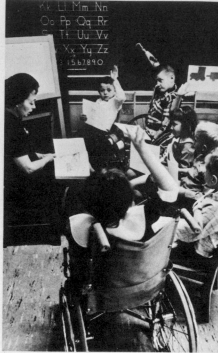

Tommy's a schoolboy now

A progress report on *World's* most memorable story subject

For any child, the first day of school is a milestone. For Tommy Cook, and for the whole Cook family, it was something in the nature of a triumph. It is little wonder so many *World* readers have asked about Tommy in the four years since he first appeared in the magazine. At that time, the youngster was facing a lot of question marks, including whether he ever would be able to attend a school outside an institution.

To summarize Tommy's background: As a result of a genetic accident, he was born with no legs and only short stumps of upper arms. (He is not, as many people assume, a thalidomide victim.) After his mother decided she could not raise a child faced with such monumental problems, Tommy was adopted by Oliver Cook, a machine operator at International Harvester's Memphis Works, and his wife Dorothy. Mrs. Cook is licensed to care for handicapped children and brought Tommy home when he was five weeks old, presumably for a temporary stay. Soon, she and her husband found they could think

of nothing except Tommy and what might lie ahead for him. By the time his mother made her decision, the Cooks had made theirs: they adopted him as soon as possible.

Since then, Tommy's life has been a succession of milestones. He got his first fiberglass arms at 18 months. Next he got a bucket seat platform on ball bearings and soon could propel himself all over the house. At two and a half, he was fitted for his first pair of artificial legs. And now, school. On his first day as a first-grader,

Laying out a picture story, the editor works with highly pliable raw material. Without compromising the photographer's intent, he can shape the material in a variety of ways, grouping pictures this way or that. His aim should be to steer the reader through the story with a minimum of confusion. Demonstrated here and on the two pages succeeding are the ways two editors handled the same set of pictures on an armless, legless boy. Although there were differences in organization, each editor achieved coherence.

The version on these pages appeared in a company magazine. In effect, it was a progress report on Tommy, who had been introduced as a baby after a company employee adopted him. To record a milestone in the boy's life, the magazine went back to cover his first day in school. The story was told in four spreads, the first two concentrating on activities in and around the classroom. The third reintroduced other family members; the fourth brought the reader uptodate on Tommy's accomplishments beyond the classroom. A head on each spread helped support the visual story line.

Tommy Cook

his family circle . . .

and Shorty

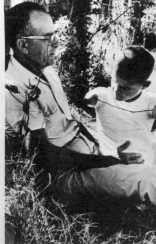

he would like an easier one, "No." Would he like help? "No," again, and soon he found the pieces that made an elephant take shape. By the end of the day, Tom's score was many new friends, several new experiences and one disappointment. Inspired by the slope of the walk in front of the school, Tom had playmates give his wheelchair a push. He was happily speeding down the walk toward the street when teachers put the brakes on the game.

Tom's fearlessness and self-sufficiency are the result, in large part, of his parents' determination to bring him up as normally as possible. His mother remembers the time she overheard Tommy tell a playmate he couldn't do something because he was crippled. "I told him if he ever said he was crippled again, he'd get a spanking." Now, Tom rarely makes excuses. Nor does he need to. Missing limbs or no, he hardly could be more active. Driving from the airport with visitors, he kept up a chatter on the back seat: "When we get home I'll ride my electric car for you. And tomorrow I'll ride Shorty for you." He insisted

FIELD is favorite place for father-son walks. Oliver Cook is International Harvester machine

QUIET TIME, and Tom demonstrates kick with fiberglass leg as classmate watches. He can move slowly on legs, but wheelchair is more practical for all-day use.

TURNING PAGES, drawing with crayons is no problem for Tom. Like his legs, artificial arms are replaced periodically, to keep pace with his growth.

PUZZLE that refuses to take shape momentarily confounds Tommy on second day of school.

Tommy Cook

*I'd rather
do it myself*

Tom stood, in freshly shined loafers, on his latest pair of fiberglass legs. (They are replaced as he grows.) Under his plaid shirt was the shoulder harness that holds on his artificial arms. To no one's surprise, the six-year-old was cool and calm, tho his mother was concerned. Tom had only two worries: that Shorty, his pony, would miss him, and that the cow had not yet found her calf, misplaced somewhere in the pasture behind the Cook's house. In the car on the way to school, Tom told his father:

"I mean it, Daddy, this evening we got to go over the pasture and help the cow find that baby cow." There followed a pause as he considered the plight of the calf. "Poor baby cow," he sighed.

At the Shrine school for handicapped children, Oliver and Dorothy Cook gave Tommy into the keeping of the teacher, Mrs. Jean Smith. It wasn't long before Mrs. Smith saw what a self-sufficient first-grader she had in Tommy. As the first class assignment, she asked each child to

draw a self-portrait. Holding the crayon with his hook, Tom carefully drew a circle, added dots and a line for a mouth. He also printed his name, and when puzzles were given out, handled the pieces adeptly. Noticing that he was stymied by a portion of his picture-puzzle, Mrs. Smith asked if

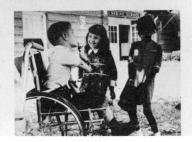

SMILES AND SHYNESS are encountered as Tom socializes in school yard. Extroverted and amazingly poised, youngster is accustomed to meeting strangers.

6

7

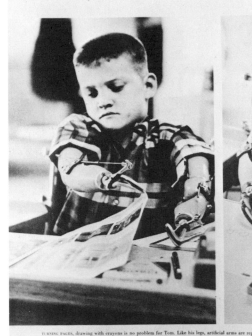

...AN HOLD ON," is his standard line on swing, but mother watches closely.

ROSE TO ROSE, Tom and older brother, Mickey Cook, pause at foot of ladder to tree house Mickey built. In attempt to coax visitors into the branches, Tom folded a question craftily: "We'll talk about it in the tree house."

BUCKET SEAT SADDLE makes it possible for Tommy to ride Shorty, his pony. Only problem is getting Shorty to go as fast as Tom wants. Riding companion is Lisa Phillips, neighbor and Tom's favorite sitter.

9

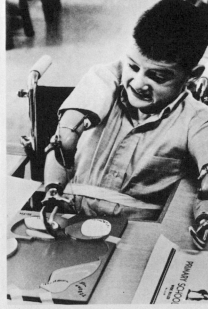

on his own:
imagination,
independence and
derring-do

FACE OF GEESE is one of Tom's few fears. From feed trough, he peers warily.

FLIP from stack of cushions is Tom's idea of good exercise. Another game he invented is fly catching with plastic glasses (bottom picture). It requires fast shoulder action, concentration.

TELEPHONING, Tom dials O, gives number he wants.

OUR EXPRESSION is typical at wash-up time. He can wash face himself using hooks, here turns on water to brush teeth before going to school.

Tommy Cook

on stopping for chocolate donuts, devoured three, asked for a fourth, got a firm parental NO. Next came an offer of his room. "I can sleep in my tree house," he declared with anticipation. The tree house is the work of Mickey Cook, 23, one of the Cook's two older sons. Knowing Tommy would like to be able to climb, he built the back yard tree house as compensation, has made many a trip up the ladder with Tom. "Anything he can't do," says Mickey, "I try to make up to him some way."

Another buddy of Tommy's who operates on the same principle is Memphis businessman George Perkins. Perkins calls Tommy "ol' Tom," takes him fishing and driving, and gave him his first airplane ride. Often, he takes Tom and a playmate on drives to inspect property around Memphis, bouncing over roadless backwoods in a white Cadillac. Scouting is one of Perkins' special interests, and he says, "I want to get ol' Tom in the Scouts." Already, there are plans for him to go along as mascot on a camping jaunt.

For Tom's more distant future, there are more ambitious plans. Like all parents, Oliver and Dorothy Cook are beginning to speculate about their son's future profession. There are, they know, countless fields in which Tom's quick brain would be the factor, and not his fiberglass limbs. A teacher, perhaps? Or why not a lawyer, Dorothy Cook suggests.

And indeed, why not?

10

11

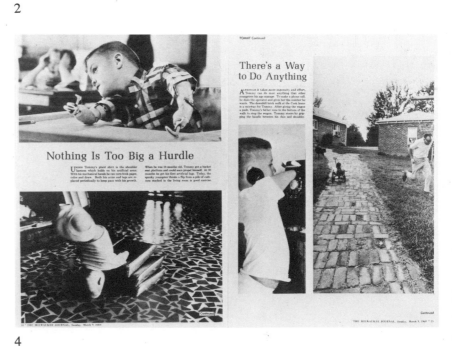

1

2

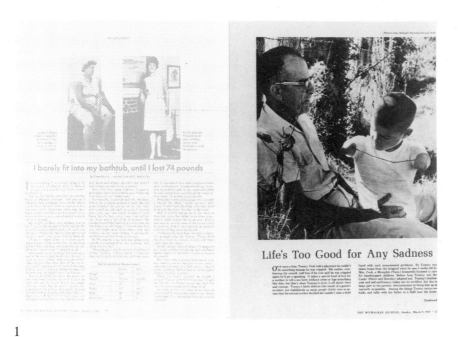

3

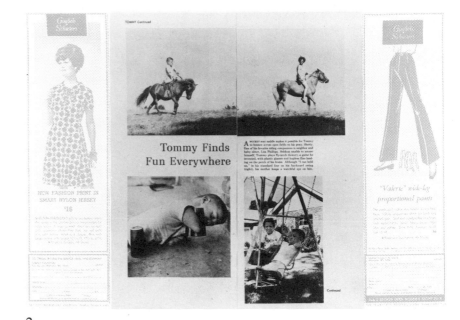

4

A new set of circumstances affected the handling of this version of Tommy's story. Most importantly, it had to compete with ads, all of them distracting, some of them in color. Vying for attention, the editor countered with a big, bold headline on each page. He tried, where possible, to place white space between his editorial pictures and the advertising areas. As often as not, intrusive ads are fatal to the picture story; this one was saved by adroit editing. The story

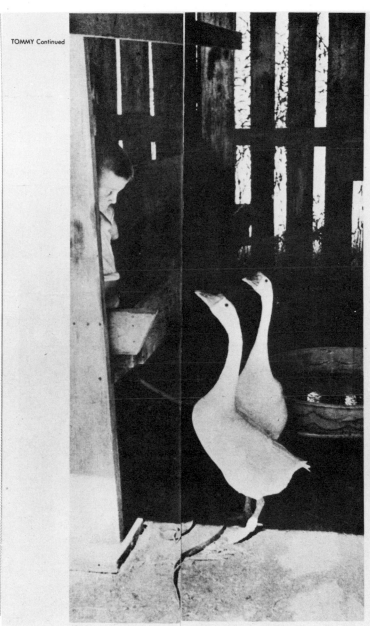

TOMMY Continued

The Future's Bright

TOMMY warily peers at a pair of geese from a safe perch on a feed trough. The big birds are one of his few fears. His older brother, Mickey Cook, gets a good grip on Tommy before carrying him up a ladder to a tree house he built for the youngster. Mickey, 23, is one of the Cook's two older sons. Like all parents, Oliver and Dorothy Cook are beginning to speculate about their youngest son's future. There are, they know, countless fields in which Tommy's quick brain would be more important than his fiberglass limbs.

END

5

appeared in a newspaper's Sunday magazine whose readers had no prior introduction to Tommy. For new emphasis, *Milwaukee Journal* Picture Editor George Lockwood led off with a warm scene showing father and son, then moved to pictures of the boy at play. School received less attention, coming through now as Tommy's "newest challenge." Picture arrangement was logical, with straightforward heads reinforcing the editor's rationale. Only on the concluding page, where the pictures appeared to lack editorial unity, did picture use require verbal acrobatics on the part of the writer. Typographically, there were essential differences between the two Tommy stories. In this version, each page was a unit unto itself. Each carried a complete text block, with caption material incorporated in the text. In the company magazine, unbroken by ads, text ran in unbroken sequence from spread to spread.

A company magazine in the U.S. told the story of a lady logger (above) in six pages. *America Illustrated,* the Russian language magazine published by the U.S. Information Agency, borrowed the pictures and told the same story in four pages. Did the first editor squander space? Not necessarily. Did the second editor shortchange his readers? Again, not necessarily. Picture-story editing is no formula or sliderule proposition. There are few categorical answers. How many spreads to allot to a story, which pictures to drop or emphasize are matters of editorial judgment and taste.

In the case of the lady logger, Editor A felt that strikingly different views of his subject justified a two-page introduction. If his opener had stopper quality, if it drew the reader into the story, the space was profitably expended. Editor B felt that two clearly defined spreads were sufficient to contrast life in the woods and activity at home. If he caught the essence of the story and enough detail his coverage was ample.

With the two versions in view, it might be profitable to analyze the pictures used and those not used, to compare picture size, prominence and arrangement. Did Editor A err in mixing logging and homemaking on his third spread? Did Editor B, on his opening spread, use two truck pictures too similar in appearance? Did he miss a significant angle by not showing the subject's easy camaraderie with her fellow-loggers? Or was he concentrating on areas of more interest to his Russian readers? Second-guessing is part and parcel of picture editing. Indeed, conscientious editors are their own best second-guessers. The flawless layout is a rarity.

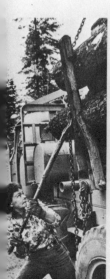

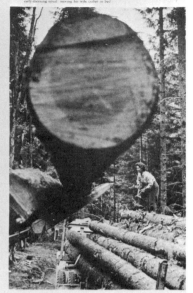

AT ELK LUMBER COMPANY MILL, a scaler checks a load, a truck driver checks a coiffure.

AT MEDFORD IH STORE, where the coffee is always "on" for customers, Mickey Cooper shares a merry moment with Walt Froeber. Says the lady truck operator: "We used to do our own maintenance until we found Walt. We can trust him." Says Froeber: "She may not be a mechanic, but she knows where trouble lies."

IN UNSCHEDULED STOP, the trucker turns homemaker, buys fruit at roadside stand.

WAREHOUSE AND WEDDING CAKES churn a lady logger. Celebration cakes for the community are her specialties. Her six-timer: granddaughter, Lisa.

SECOND WOMAN DRIVER: A 110-board-foot of fir.

LADY LOGGER

truck driver's job, but the 50-pound weight is too much for me. I could do it if there was a three-foot stump around to stand on. But I'm not looking for that stump."

Among the functions she handles with no help from Al is the purchase of her trucks. Her big V-200 is her second International and few trucks get better care. "She doesn't tell me what to do," explains Walt Froeber, service department foreman at the Medford (Oregon) IH store. "She just tells me what's happening, the sounds it is making or the way the indicator is acting up. But she knows more about trucks than she lets on. She treats me implicitly and I guess my attitude toward her is naturally affected by this."

In his respect for Mickey Cooper, the lady logger, truck expert Froeber joins ranks with a small army of fallers, skinners, scalers and drivers who work the woods of southwest Oregon.

LIGHT LUNCH (half a sandwich, considerable coffee) and small talk fill noontime break. Lunchtime companions include her husband, Al (on her right), and their crew of fallers and skinners.

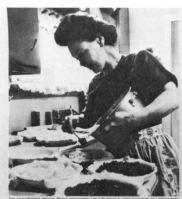

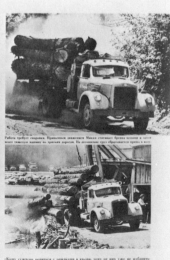

РУЖЕНИЦА ЕСОВ

ФОТО ТУДА СПАГЕЛА

«Кому суждено родиться с шишками в крови, тот от них уже не избавится, — говорит Микки Купер, миниатюрная женщина 44 лет. Несмотря на свой возраст она уже бабушка, но ею не мешает ей работать на лесозаготовках в лесах Орегон. Карьеру свою Микки начала в 16 лет, поступив в один из крупных лесопильных заводов...

Сейчас Микки быть строгим, а все ценит Ал.

Энергичная Микки легко справляется с делом и в лесу и дома

Друзья Микки неизменно отзываются о Микки с похвалой и поражаются, с каким успехом она выполняет обе роли. Микки улыбается: «Да, я, пожалуй, не только лесоруб, но и я не только домашняя хозяйка...

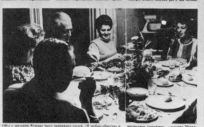

В молодости дни Микки — отличный день.

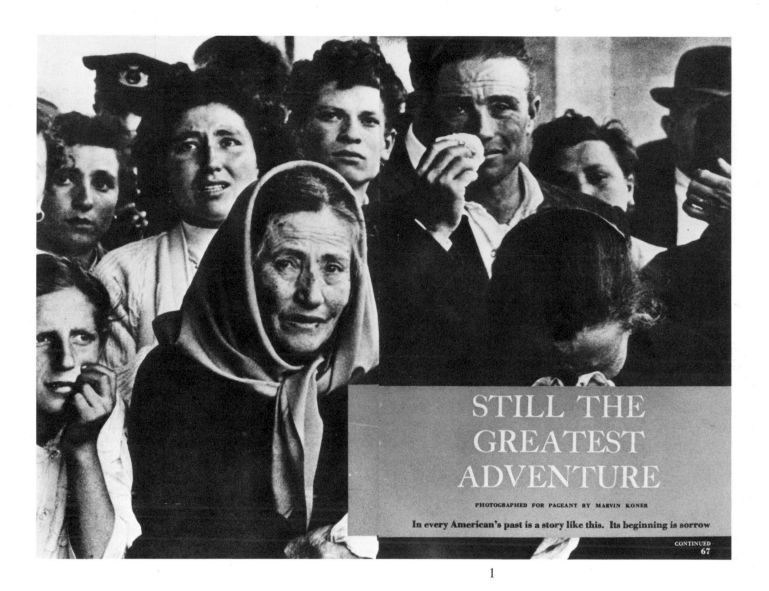

STILL THE
GREATEST
ADVENTURE

PHOTOGRAPHED FOR PAGEANT BY MARVIN KONER

In every American's past is a story like this. Its beginning is sorrow

CONTINUED
67

1

Picture story:

*the story of Carmela
as Pageant told it*

Sorrow on the docks at Naples. Emotional farewells as dear friends and near of kin leave the old country for the new. An American photographer observing the scene, a picture story taking shape in his mind. After a query, an assignment from the editors of *Pageant.* In due time, the delivery of 90 photographs, each revealing the depth of Marvin Koner's feeling about the emigration to America of Carmela De Maria and her children. Sey Chassler, managing editor of *Pageant* when Carmela's story appeared, defines a picture story as "creative story telling." More than a layout, more than a record of what there is to be photographed, he calls it "a synthesis of what the brain understands, sees, feels, reacts to." On these two pages, reprinted from *Pageant,* is one synthesis of Carmela's adventure. On the next spread is another.

TEXT BY LEONARD GROSS

■ FOR CARMELA DE MARIA, who had known the pragmatics of poverty for all her 35 years, Saturday, April 27, 1957, was a day naked of reality. For more centuries than memory could summon, her family had adhered to a lush farming plain in southern Italy, near the Adriatic. But this day she was going to America for the rest of her life.

Her story is ours—the 320,000 new Americans who came in 1956, the many millions who came from the 17th century onward to spawn us all. Today our immigration laws are not perfect. Few will say they are. But some still come. And this is the adventure of one who did.

Carmela's husband, Leonardo, an $800-a-year farmer in Italy, had gone to America two years before, become a $3,500-a-year laborer and saved passage money for her and the three children. He waited now among a great family in Orange, N. J., the progeny of five aunts who had emigrated 60 years before. And the excited family was planning a great welcome.

But happiness this day was like a sin. Carmela could feel only the swelling pain of parting. *Her* family was here, in sunny Lucera, and this day would be the last she would ever see her mother.

Her mother came, a tiny woman wearing a shawl. Her in-laws came, the De Marias, who had once lived in America, but had returned to spend their last years in Italy. Aunts, uncles, cousins and close friends came. A dinner was served, a dish of lamb, scrambled eggs and chopped chicory greens. Then they all sat in the stripped room and waited. A few minutes before ten, it happened.

68

Carmela and Lucia take a final walk

RISTORANTE

Carmela's Lucera is sunny, time moves slowly, diversions are few

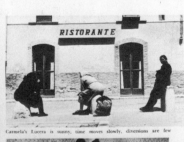

A farewell dinner: lamb, eggs and chopped greens for twenty

A final memory of home: her mother holding bread to her heart

2

100

In Naples, she sees her ship

The numbing pain

Carmela had sat numbly through the evening. Now she began to rock and to moan softly; then her head went to her hands, and the first tears came. Then her mother began, and then the others, until they all sobbed. Across the street, a Victrola blared rock and roll.

View of Vesuvius overcomes Michele
CONTINUED
71

3

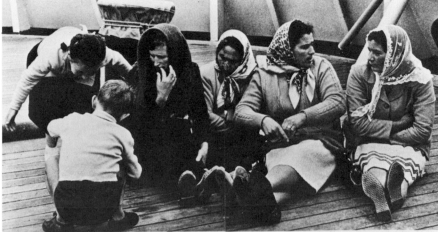

Ocean liners are faster and sleeker—immigrants unchanging. They huddle and hope

At farewell dinner before New York arrival she donned festive cap, but ate quietly

The numbing wait

Carmela's ship was the *USS Constitution*; its impact was instantly and overpoweringly American. There were other Italian emigrants aboard, 215 of them going to Canada, another 45 to the United States. But the food was strange, the language of the crew incomprehensible. While the children raced through tourist class, Carmela moped. Then, as her body stabilized to the sea, so her thinking adjusted to the future. On the seventh day out, she smiled.

72

4

est clothes, children examine New York skyline

e numbing joy

n landing day, Michele, 12, Francesco, 8, Lucia, 4, raced early to the railing. As the *stitution* docked they looked for their father, m Lucia did not even remember; for a long they did not see him. At last, there he was, all figure so distracted he had not thought to close to the dock rail. When Carmela and three children were at last on the pier, he d her passionately but self-consciously, then upon the clamorous children. Soon, they all speeding home together.

anxious moment when documents are scrutinized

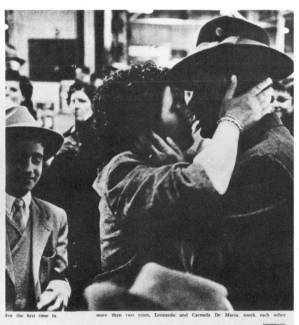

For the first time in more than two years, Leonardo and Carmela De Maria, touch each other
CONTINUED
75

5

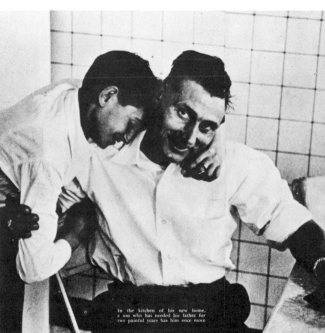

A festival in Orange: food, tears and a prayer for success

All the way to Orange, as the children gaped at the new world, Leonardo and Carmela looked at each other. Even at the new home, furnished by Leonardo and crowded now by strange family, Carmela was subdued. But the children could not get over the number of rooms. In Italy, there had been one, and one bed; here there were five rooms, and beds for everyone. Nor could they comprehend a young cousin who was wearing toreador pants with a zipper in the back. They decided she was crazy.

Now came the welcoming dinner —one of its ingredients the dish of lamb, greens and scrambled eggs. Then Carmela passed out cheeses and olive oil she had brought as gifts from Italy.

And then came the crowds. Several hundred Italian-Americans shook hands, asked about families still "on the other side," shed tears and wished *Buona fortuna*. At last there was sleep, and with it, the sweet dream of more. ■■

In the kitchen of his new home, a son who has needed his father for two painful years has him once more

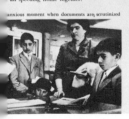

Mammoth dinner preceded open house

77

6

From 90 story-telling images, *Pageant* editors picked 15, assembled them on a dozen pocket-sized pages. As is obvious, the magazine's restricted format does not rule out good picture stories. It does present problems. Case in point: wanting maximum display for the emotional opening picture, the editors ran it across two full pages, bleeding top and bottom, left and right. With no space left for a headline, they put a panel over the photograph. It was an unfortunate intrusion, since it covered the figure of a weeping woman. There are other challenges: captions under small pictures have to be brief, almost literal. Details and amplification are left to the text. This treatment of Carmela's story spans more time and miles than the version next in view, in which Editor Chassler and Photographer Koner rework their material for a different audience and, in the process, reuse only one picture appearing in *Pageant*.

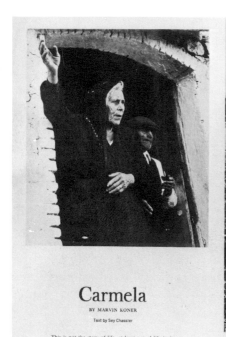

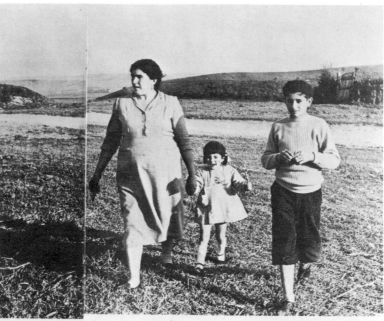

Carmela

BY MARVIN KONER

Text by Sey Chassler

This is not the story of life, at least not of life in its entirety. But in many ways it will do, as a flame does on occasion for the sun. It will throw a small light where a large one might blanch the image and blind the eye to detail. This is a story about an episode in the life of Carmela De Maria.

Carmela De Maria. ⁷She has lived all her life in Lucera on the plains of southern Italy; all of her life and all of the lives before her, of ancestors without number, through years without number. But tomorrow she will leave Lucera, she and Michele and little Lucia. Her husband's mother reaches out in farewell as she had reached before — two years before—to Leonardo, when he sailed across the seas to begin a new life in America. Leonardo: the son departed, the husband waiting

1

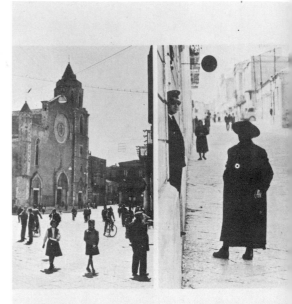

There are two strands to life: One a succession of joys small and large, the other a succession of sorrows. There are times when they make a knot so entwined that they are indistinguishable. For Carmela life during this day in Lucera is such a knot. The strand of small joys has in it her beloved church and her piazza . . .

. . . and a small street leading upward to the su Sometimes quiet. Sometimes not so quiet. Son times clean. Sometimes not so clean. Sometime prosperous. And sometimes — not so prospero But after all, it is only a street, and what can y expect of a street?

2

Carmela's story: stripped to the emotions

Opening differently and ending sooner, this is the way Carmela's story was retold in *Infinity,* publication of the American Society of Magazine Photographers. Says Sey Chassler: "Here it is stripped down to a distillation of the emotions involved. And the text is designed to follow the pictures—not to tell what the *events* are but to direct the reader into the pictures, to provide a kind of sympathetic frame through which the picture may be viewed properly." This distinction is evident in the story's closer: "But on the ship. On the ship there is only a small knot, joy and sorrow entwined. Carmela, Lucia, Michele. And in the distance, across the western seas: Leonardo De Maria, the husband waiting." In *Pageant's* version, the same picture was captioned: "View of Vesuvius overcomes Michele."

Captions reported feelings, not just events. A pair of samples:
"The farewell supper. All a man—a brother—can do is feign levity." "But a woman can do what must be done, without words, without pretense."

4

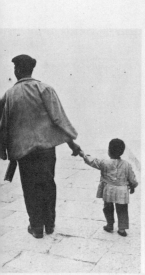

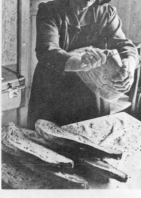

Everything. And nothing. Images of a father and son. Recollections. Memories. And as one watches, the strand of remembered joys in the knot slowly...

. . . becomes the strand of sorrow. On one street, behind one door, on this one day, Carmela's mother slices bread for the farewell supper.

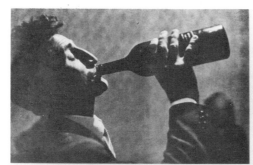

The farewell supper. All a man—a brother—can do is feign levity.

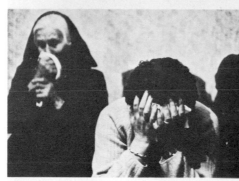

But a woman can do what must be done without words, without pretense.

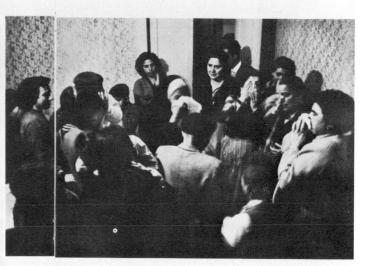

Carmela's farewell. Her friends, her family, Leonardo's family in a sparse room, by a spare light, the voices like waves, the tears like prayers, the touch of hand on hand like promises—farewell.

7

8

9

3

It is tomorrow. On the dock at Napoli are a thousand faces. And a thousand farewells for others. From Foggia and Gravina. From Santa Maria and Alta Mura. From Benevento and Caserta. From Salerno, Potenza, Eboli—and Lucera.

But on the ship. On the ship there is only a small knot, joy and sorrow entwined. Carmela. Lucia. Michele. And in the distance, across the western seas: Leonardo De Maria, the husband waiting.

12

5

Multi-subject

Single subject

THE NEWSPAPER PICTURE PAGE

It works best when
a single subject
is explored in depth

The picture page in many newspapers is a catchall for miscellaneous pictures. Subject matter runs largely to froth haphazardly arranged in layout. Esthetically, the smorgasbord page is rarely attractive. "Something for everyone" is the rationale for this grouping of sundry pictures. Unfortunately, divergent pictures juxtaposed this way tend to compete with one another for reader attention. Unrelated pictures are best used on pages throughout the paper. The newspaper picture page communicates best when a *single* subject is explored in depth. In layout, however, even the single-subject page tends to be predictable. Formula editing is too often the rule. Rigidity is the inevitable result. There is a lack of emphasis, a sameness of picture size, not enough openness. Little effort goes into making a layout "read". But there are heartening indications of change. In small offset dailies especially, but also in a handful of metropolitan papers, there has emerged a new breed of picture-conscious newsmen. These editors have succeeded in adapting the principles of good magazine layout to the vertical format of the newspaper page. In the words of one of them: "We've come to the realization that complex picture-and-word combinations spread over a full page require concentrated, intuitive attention." There is more willingness, too, to let cameras do what they can do surpassingly well: explore problems; motivate readers to act and react. If picture pages are to excel, the editor must **graduate** from single-picture thinking; editor **and** photographer *together* must plan assignments and think pictures; the photographer must be perceptive and must have time to probe. Pictures must be edited for variety and impact. And the page must "read."

A Day with the Amish

Dawn comes to an Amish household, where a gentle people follow an agrarian way of life, cherishing a cohesive family and community and practicing their religion devoutly.

A young girl heads for school on her bicycle. She attends a one-room Amish school. However, some children attend public schools in Nappanee, Ind., near the Amish community.

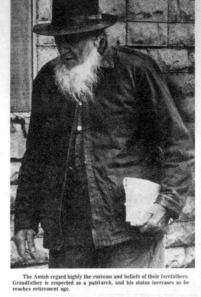

The Amish regard highly the customs and beliefs of their forefathers. Grandfather is respected as a patriarch, and his status increases as he reaches retirement age.

Physical labor is part of the Amish life, and modern conveniences generally are shunned in favor of the old ways.

The horse provides transportation, and the young learn early how to care for the animals.

A shopping trip into Nappanee provides excitement for the entire family, altho modern clothes are not on the shopping list.

The modern world of cars and electrical appliances has passed the Amish by. To them, the past still holds strength.

At the end of the day, the Amish return home, to their life built on hopes and hard work, with their strong attachment to the soil and the Bible to sustain them.

"A day with . . ." lacks a point of view

Literally as well as figuratively, this picture page has whiskers on it. As a story approach, "A day with . . ." is a cop out, editorially as well as photographically. By failing to go beyond simple chronology, the cameraman returned with a set of literal pictures. By opening with a "dawn" photo and closing with a scene at nightfall, the editor also took the easy way. The pictures that fall in between do little to reveal an editorial point of view. No picture dominates. Captions are largely hole-fillers, inserted into ungainly patches of white space. Could the page have been saved? A more specific headline would have helped, plus a brief text block to give direction to the reader. One or two photos could have been eliminated, permitting more effective sizing. For impact and ease of reading, compare this with the treatment at right.

On the Amish page at right everything works. The photographer did a better job of seeing. The editor did a better job of implementing. This is first-rate material forcefully used. A dominant photo sets the scene and a tightly cropped vertical contributes variety. Three pictures stacked vertically at the lower right neatly balance the narrow view at the upper left. The interrelationship of the three pictures—each deals with non-mechanical power—permits a single caption and the narrowest of picture spacing. Besides its pleasing balance, the page achieves excellent interplay between words and pictures. To be fair, it appeared in a weekly, not a daily. But deadlines should not be blamed for non-timely picture pages that miss the mark. A better policy is to polish now, publish later. Also of note: this one is a picture essay; the other's a picture group.

No matter the hardships of hills and chills, Amish children learn early that they will walk to school.

An Amish lad and his chores: Having lined up milk cans for morning, he carries logs cut in summer inside his house to fuel wood stoves used for heating and cooking.

A Simple And Uncommon Grace

Amish Fascinate Modern Society

With a Life Almost Forgotten

The Amish, a segment of Protestant Mennonites who number about 50,000 in North America, want to keep their life simple —and unbothered by the modern world.

But their life thus presents an irresistible temptation to tourists, sociologists, and, most of all, photographers.

Some photo-journalists go so far as to invade the privacy of the Amish. That was not the aim of photographer Merrill Matthews, who recorded these scenes— seemingly of an earlier day in America—last month in the Conewango Valley of western New York state, near Buffalo. The colony, which began in 1949 with 4 families, now numbers about 150 families.

Call the life of the Amish austere, or serene, or whatever, these photos do provide a charm and grace not easily found in this day.

Though religious strictures bar engines, human and animal power move a variety of vehicles.

An Amish home is a place of shelter, work, and worship. The clothes hung out are all hand-washed and sun-dried.

Depending on mood, layout may be relaxed or formal

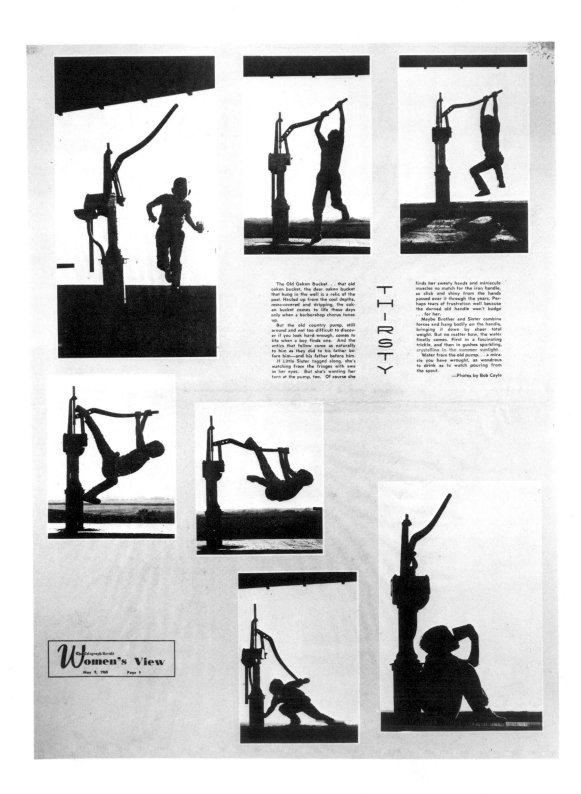

The Old Oaken Bucket... that old oaken bucket, the dear oaken bucket that hung in the well is a relic of the past. Hauled up from the cool depths, moss-covered and dripping, the oaken bucket comes to life these days only when a barbershop chorus tunes up.

But the old country pump, still around and not too difficult to discover if you look hard enough, comes to life when a boy finds one. And the antics that follow come as naturally to him as they did to his father before him—and his father before him.

If Little Sister tagged along, she's watching from the fringes with awe in her eyes. But she's wanting her turn at the pump, too. Of course she

finds her sweaty hands and miniscule muscles no match for the iron handle, so slick and shiny from the hands passed over it through the years. Perhaps tears of frustration well because the darned old handle won't budge ... for her.

Maybe Brother and Sister combine forces and hang bodily on the handle, bringing it down by sheer total weight. But no matter how, the water finally comes. First in a fascinating trickle, and then in gushes sparkling, crystalline in the summer sunlight.

Water from the old pump... a miracle you have wrought, as wondrous to drink as to watch pouring from the spout.

—Photos by Bob Coyle

T-H-I-R-S-T-Y

The Telegraph-Herald
Women's View
May 9, 1965 Page 9

Different as day and night, but each of them highly effective, are these pages from the Dubuque *Telegraph-Herald*. One was a feature; the other, breaking news. One is refreshingly open; the other, formally balanced. In each case, a screened background reflects the tone of the page: light gray for the light-hearted; solid black for the somber. To quarrel with the cropping might appear to be carping, in view of the overall success of the sequence at left. But refinements would have helped. It was logical, for example, to include the roof of the shelter in the first three photos. But after moving in close for the action, it was a mistake to permit the roof to reappear in the next-to-last picture. In the photo at top right, too much foreground remains. With tighter, more consistent cropping, the boy's figure would not have fluctuated in size. Until the final silhouette (which is a bit too pat and posey), the layout is candidly honest. The page is anything but second-rate, despite this second-guessing.

No exception can be taken with the cropping on the page at right. Despite the layout's rigidity, the picture content fits the shapes. Consider the narrow verticals: two closeups tightly cropped; two longer views, which include arms almost to the elbows. All reflect good editorial judgment. The photo of the coffin and mourner at the top of the page needs to be there. It explains the tears and eliminates the need for words. But it doesn't need to be bigger than it is. Size is wisely reserved for pictures stronger in emotional impact. A word about the center photo, around which the layout revolves. Normally it is poor policy to burden a photo with this much type. This time it works, possibly because the photo is symbolic, possibly because the quote is so highly appropriate. As a general comment, much thought went into the two layouts reproduced here. Pages like these won a picture-editor-of-the-year award for the *Telegraph-Herald's* James A. Geladas.

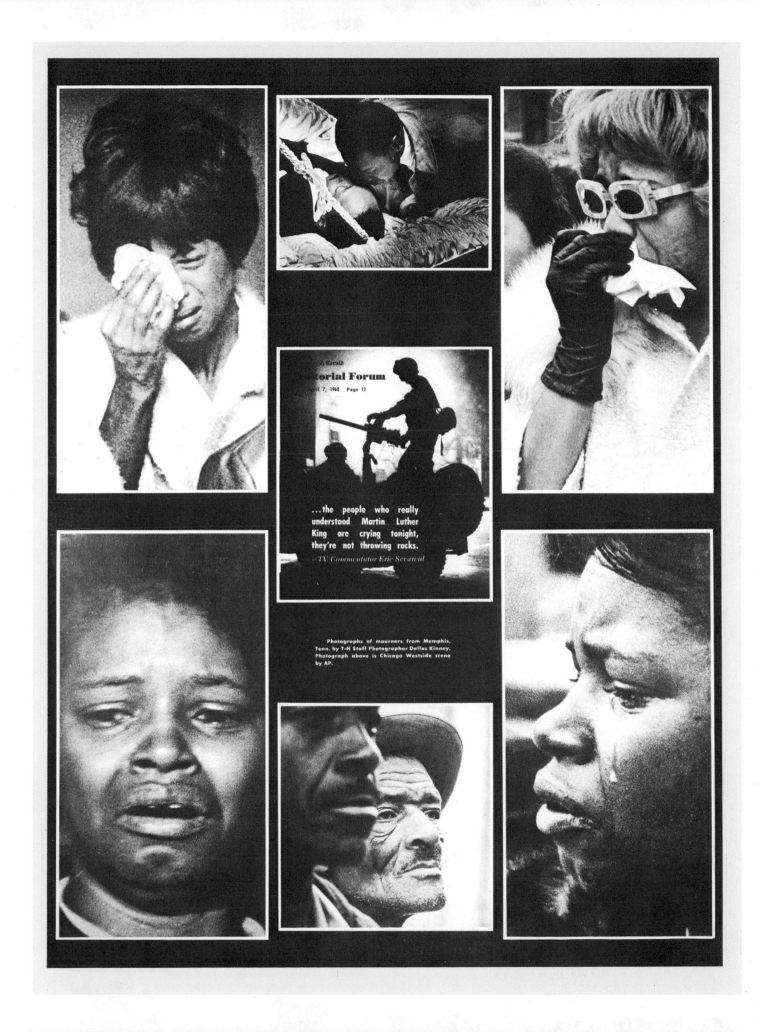

...the people who really understood Martin Luther King are crying tonight, they're not throwing rocks.

— *TV Commentator Eric Sevareid*

Photographs of mourners from Memphis, Tenn. by T-H Staff Photographer Dallas Kinney. Photograph above is Chicago Westside scene by AP.

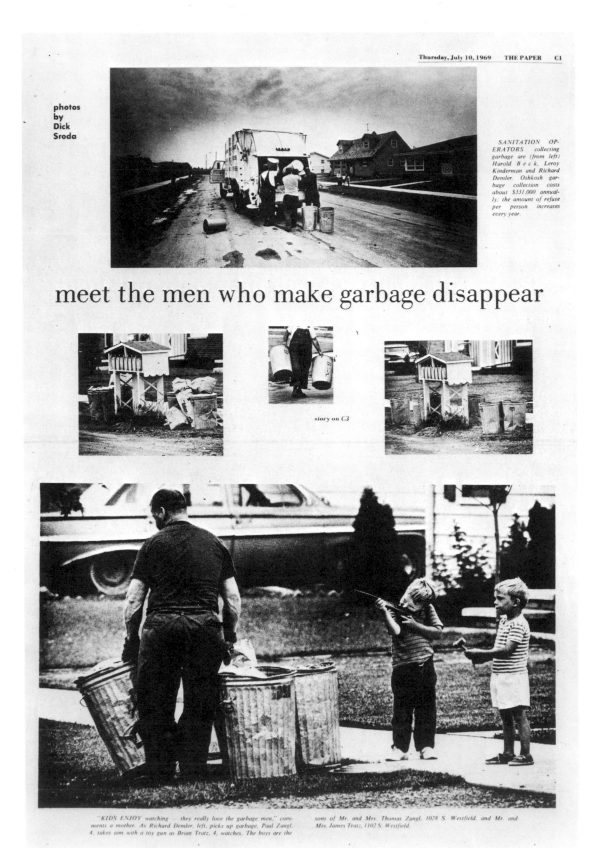

photos by Dick Sroda

SANITATION OPERATORS collecting garbage are (from left) Harold Beck, Leroy Kinderman and Richard Denler. Oshkosh garbage collection costs about $331,000 annually; the amount of refuse per person increases every year.

meet the men who make garbage disappear

story on C3

"KIDS ENJOY watching — they really love the garbage men," comments a mother. As Richard Denler, left, picks up garbage, Paul Zangl, 4, takes aim with a toy gun as Brian Tratz, 4, watches. The boys are the sons of Mr. and Mrs. Thomas Zangl, 1028 S. Westfield, and Mr. and Mrs. James Tratz, 1102 S. Westfield.

A garbageman on camera is a rarity. Unless, that is, he plies his trade in a small city blessed with a picture-oriented daily. Oshkosh, until 1970, was such a city and *The Paper* was such a paper. In its day, *The Paper* succeeded in showing, warmly and believably, how ordinary people live and work. Its cameramen clothed the commonplace with new meaning and charm. "Communicating in a small town with high-level photography" was the way Dick Sroda described it. Sroda was one chief photographer who did his own layouts. On the picture page he "packaged" his pictures through creative use of white space. He kept words to a minimum. Words were saved for the full-fledged text piece normally appearing on a page adjoining. "Meet the men who make garbage disappear" is imaginative and eye-catching, in the best Sroda tradition. A typically deft touch is the pairing under the headline, contrasting overflowing and empty garbage cans. Typically, too, the picture with the greatest human interest gets the biggest play.

A governor on camera is usually all smiles. He will be photographed cutting ribbons, signing bills, greeting Miss Sweet Corn. His lonely hours are rarely recorded. A noteworthy exception is this picture page from *The Courier-Journal* in Louisville. Photography pulls the reader inside the inner circle, brings fresh insight into the cares and emotions of the man who governs. It also conveys a feeling for the setting in which he works. The page comes off for several reasons. Photographer Bill Luster was perceptive, of course, but he was also unobtrusive. The governor, as a result, was comfortable. He was always himself. Good shooting was followed by good picture selection, good cropping, good sizing. The layout was horizontal and remarkably clean; its meaning clear enough to be grasped at a glance. From the opening view of the pensive governor, the reader was led adroitly to the effective finale at the end of the day. Perceptive shooting, intelligent handling made this one a winner.

A new problem provokes an arm-waving discussion between the governor and two aides, Jim Watson (left) and Fred Karem.

Whether pacing the floor of his office or going over sheets of statistics, Governor Nunn's day is filled with the "homework" for decisions.

A Governor's Burden . . .

These are hectic days for Kentucky Gov. Louie B. Nunn. Normal days for the Commonwealth's chief executive are busy, but with the legislature in session the tempo quickens. The moments for relaxation are rare as the governor moves through a schedule of committee meetings, private discussions with aides, press conferences, public appearances and legislative lobbying for a variety of bills. The heaviest burden of office comes at the time of final decisions. Advice and counsel given, the governor frequently retires to his office to arrive at a final judgment. These are the lonely times for a chief executive. The responsibility cannot be shared. Right or wrong, the decisions—and burdens—are his. . . .

. . . Lonely Days of Final Decisions

The burden of responsibility weighs heavily on the governor as he wrestles with a decision in the privacy of his office. But there are light moments, too, and a laugh at an aide's anecdote relieves some tension. In the seclusion of a living room in the Executive Mansion, Nunn is able to prop his feet up and read the day's news— some of which he helped to make. His reading is rarely for pleasure, however, for what he reads will affect his coming days as chief executive.

Staff Photography
by
BILL LUSTER

111

Sailors skirt pilings.

Fox River
A quest for beauty in Oshkosh

CABLES DO NOT ANCHOR

Nothing to latch onto.

Dog: Braver than most men.

Fish don't commit suicide!

PRIVATE PROPERTY
NO TRESPASSING

Photos by Dick Sroda

One of many such signs.

It is a paradox to be sure, but there are times when a photographer's good eye and the quality of his pictures can actually defeat his purpose. The photographer in Oshkosh was looking for evidence of ugliness along the Fox River. Yet the pictures, the larger pictures especially, are really quite pretty. Ugliness along the shoreline (top) was concealed or softened by the picture's mood. Far from being repugnant, the "Do Not Anchor" scene has a charm reminiscent of New England fishing towns, Two pictures do repel: the view of the dog and debris; the close-up of a dead fish. These pictures say "pollution" but they receive subordinate display. Overall the page says "picturesque." Explicit words would have helped reinforce the editorial intent. But the captions are cryptic and the headline is an attempt at irony. It is easy to misread this page.

There is no misreading the page at right. This treatment puts no burden on the reader. Page organization is tighter and the message is unmistakable. Harsh closeups of junk and debris affront the eye in "Look around Flint." And while the pictures lack captions, the text bristles with pointed words of the photographer, Barry Edmonds: "Every main approach to the city is glutted with debris . . . main arteries are lined with junkyards overflowing with smashed and battered hulks of castoff cars . . . vacant stores and empty storefronts . . . peeling paint, old posters . . . gutters filled with broken glass, squashed beer cans . . . broken automobiles parked in mud-rutted yards . . . " Technically, the Oshkosh and the Flint pages are first-rate. Editorially, only the Flint *Journal* makes its point perfectly clear.

Look Around Flint

. . . and see what Journal Photographer Barry Edmonds observed recently through his camera lens. Said Edmonds: "Every main approach to the city is glutted with debris . . . main arteries are lined with junkyards overflowing with smashed and battered hulks of castoff cars . . . vacant stores and empty store fronts . . . peeling paint, old posters . . . gutters filled with broken glass, squashed beer cans . . . broken automobiles parked in mud rutted yards . . ."

Now look again at the pictures on this page, and remember that this is the city in which we live.

THE DAY LOUNGE is furnished in reproductions of early American furniture, as the upstairs lounge and the suite.

ZENO GOOCH relaxes in the bedroom of the suite.

THE PARLOR of the Nursing Home's only suite boasts excellent reproductions of early American antiques.

ELLERY waves from his bed, where he was watching a television program. The T. V. set sits on an elevated rack above the lavatory area.

THIS EMPTY ROOM indicates the amount of space in each bright, colorfully decorated room. The television set is on an elevated rack above the lavatory.

Hospital funds subsidize home

Continued from Page 1

ROOMMATES. Mr. B. Wright (sitting) and Della Crolev share a room.

MR. AND MRS. DUDLEY STEPHENS are the only married couple staying at the LaFollette Nursing Home.

Tri-county CAC
representative election

THE MORNING TRAYS are lined up in the kitchen and serving area each evening for the next day's breakfast.

IF YOU DON'T LIKE OUR COPS, CALL A YIPPIE NEXT TIME YOU NEED HELP

This Newspaper is more interested in this community than any other publication in the world

STORIES, TEXT

NEWS EDITOR

Concededly the cards are stacked here. While each picture page deals with a nursing home, the mismatch is obvious. The version on the left appeared in a small weekly. It was the product of a youngster new on the job and inexperienced behind a camera. The coverage on the right was the work of Barry Edmonds, an award-winning professional. It appeared in the picture-conscious Flint *Journal.* Though it is unfair to compare them, the pages present a powerful object-lesson. Arrayed this way, they exemplify the sharp distinction between the perfunctory and the gutsy, between the record picture and the telling picture. The disheartening truth is that the unprofessional photos on the left, displayed without benefit of intelligent cropping or sizing, are more representative of newspaper picture use than the highly effective treatment at right.

Of course, Photographer Edmonds had a rather special point of view. His point was that *this* institution was not a particularly pleasant place that it was, in fact, a lonely, rather desperate place . . . where the quiet was disquieting. He achieved impact by concentrating on people rather than facilities. While the camera-conscious subjects on the left pose for pictures, the old people on the right, totally without camera-awareness, go about their business of living . . . and dying.

Winchester . . . Where the Quiet Is Disquieting

The visitor to Winchester Hospital walks uneasily down empty corridors, footsteps echoing hollowly in the eerie emptiness where hope has fled.

Skeleton crews flit through bare halls but the hustle and bustle of the past is gone. Perhaps it disappeared when the recent cutback in funds caused much of the staff to be dismissed and others to quit.

What remains is the overwhelming quiet—the disquieting quiet. The patients remain; the crippled, the senile, the wasted, the dying . . .

Here lies a woman curled in the fetal position, gnarled hand pathetically clutching a much-fondled doll. Behind her, on the bed, their unblinking eyes staring upward, sprawl three naked dolls . . .

There a man down on all fours scrabbles in seemingly aimless fashion. "Where am I," he asks. "Where am I?" But the gleaming hall is empty and there is no answer . . .

Other vignettes catch the visitor's eye: the apprehensive stare of a woman, her fists clenched to her mouth; the sight of an ambulatory patient helping one confined to a wheel chair; a dejected, graying figure slumped in a chair . . .

And a financially-troubled hospital desperately tries to keep its head above water and hopes for a miracle that will keep its patients alive.

Journal Photos By Barry Edmonds

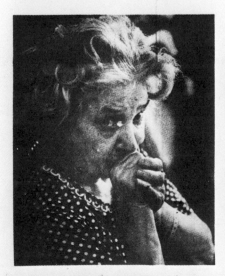

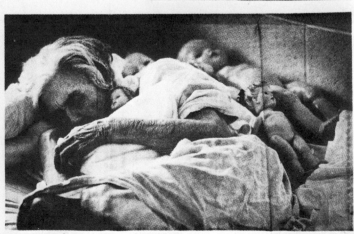

115

The newspaper picture page

Double-truck to double the impact

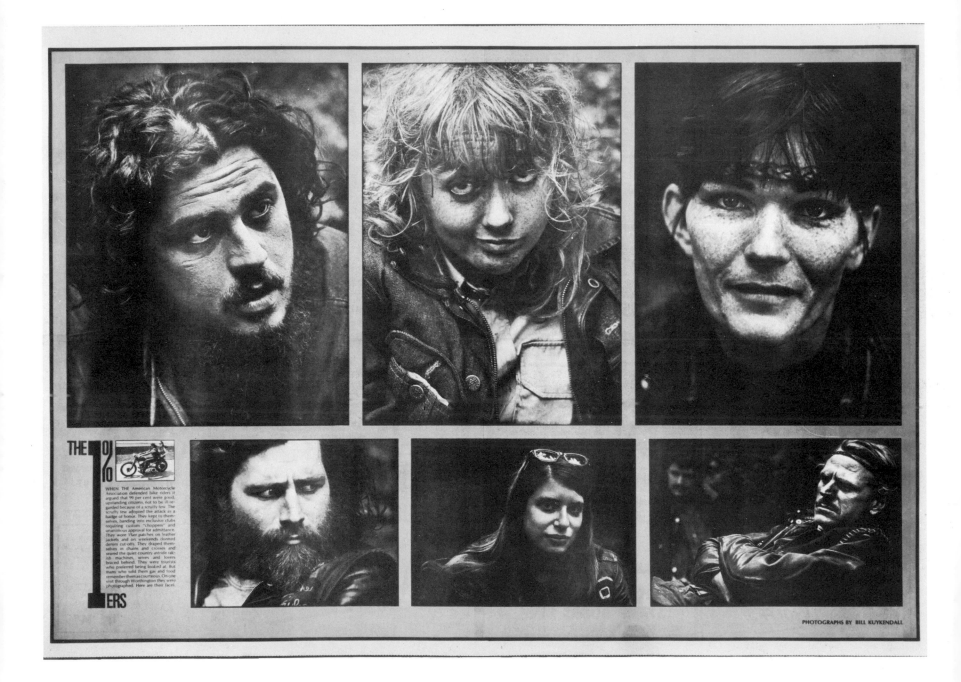

PHOTOGRAPHS BY BILL KUYKENDALL

In the area of picture use, no big-city paper anywhere out-performs the Daily Globe of Worthington, Minn., a community of 10,000. Behind pages like these are a management which encourages innovation and a photo editor named Bill Kuykendall.

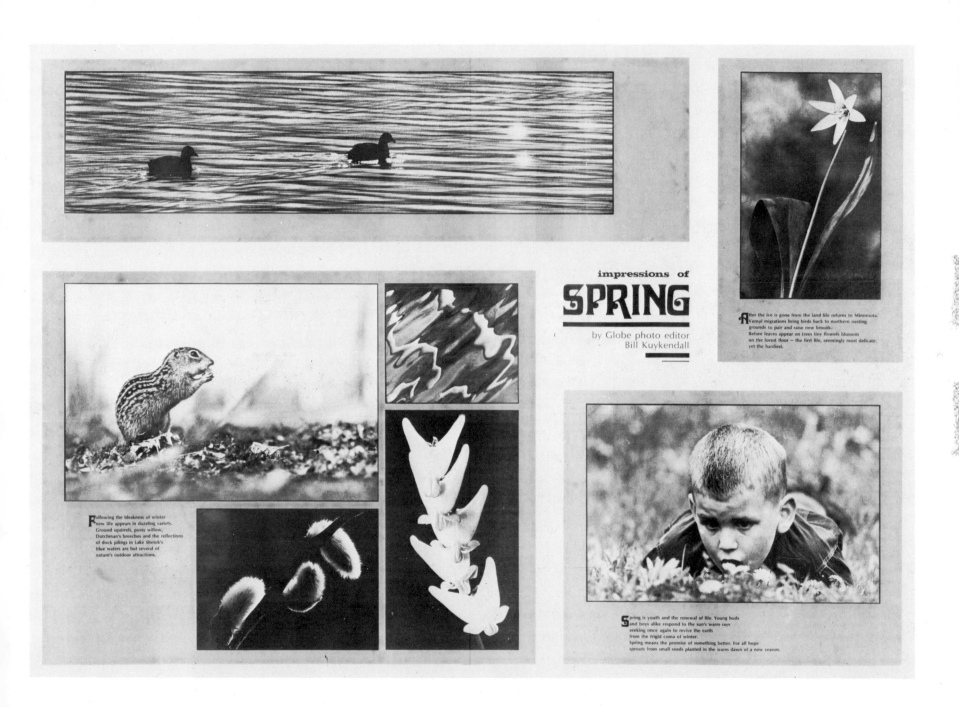

impressions of
SPRING

by Globe photo editor
Bill Kuykendall

After the ice is gone from the land life returns to Minnesota. Vernal migrations bring birds back to northern nesting grounds to pair and raise new broods.
Before leaves appear on trees tiny flowers blossom on the forest floor — the first life, seemingly most delicate, yet the hardiest.

Following the bleakness of winter new life appears in dazzling variety. Ground squirrels, pussy willow, Dutchman's breeches and the reflections of dock pilings in Lake Shetek's blue waters are but several of nature's outdoor attractions.

Spring is youth and the renewal of life. Young buds and boys alike respond to the sun's warm rays seeking once again to revive the earth from the frigid coma of winter.
Spring means the promise of something better. For all hope sprouts from small seeds planted in the warm dawn of a new season.

"Layout," observes Bill Kuykendall, "is the critical step over which most newspapers still trip." As is evident here, Kuykendall has a sure-footed way with words and images on the printed page. He also has freedom. He shoots, writes, prints, lays out and pastes. A serious student of "story packaging," he draws ideas from magazine make-up and advertising. In the center of his paper, he will lay out his story in the manner of a magazine *spread,* regarding two pages as a single unit, disregarding gutters. Deserving pictures get eye-stopper display. The three powerful portraits at the top of the spread at left were 13 inches deep. Offset reproduction lets him achieve unusual graphic effects, as in his spread on spring. In effect it permits layouts within layouts. Words and pictures are closely integrated and always in careful balance. Picture pages are laid out as far in advance of publication as possible and the esthetic payoff is obvious. Another payoff: a circulation improbably large.

Machinery salesman

Happiness may be a signature on a dotted line...

...but oh the agony of sweating out the decision to buy!

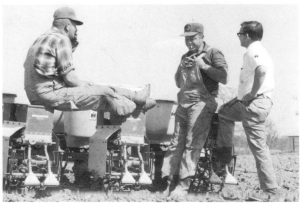

fold

When space is short, discipline is strong. But tight space is rarely a factor on picture pages of conventional size. Free of sizing restrictions, the unfettered editor will often produce loose and sprawling layouts, with pictures extravagantly large. Viewed from a distance, the effect may be impressive. Unfortunately, pages aren't read that way. At arm's length, the images may be too huge to be quickly comprehensible. One answer—as these mockups suggest—is to put the picture page in a new perspective, to regard it as the equivalent of two magazine spreads, one spread above the fold and one below. Complete with appropriate head and text, each half-page would complement and reinforce the other, just as magazine spreads do. Allocating his space this way, the editor will find himself arranging and consolidating his material in a more meaningful manner.

Admittedly, the two-part picture page involves the taking of time and pains. Carefully structured, it is not a layout easily thrown together under tight deadline pressure. But again, it need run on no specific day. Certainly, it would require more interchange between photographer and editor than is now the rule. This is a plus. Editors become better editors and photographers better photographers as mutual understanding deepens. Without question, photographers would have to dig deeper; subject matter would have to be more substantive. This is another plus. The picture page should be more than an ego trip for the photographer, more than a showcase for his virtuosity. Picture pages should have something to say. Themes should have strong visual potential. Given vital subjects, gutsy pictures and meaningful display, picture pages can be movers and shakers.

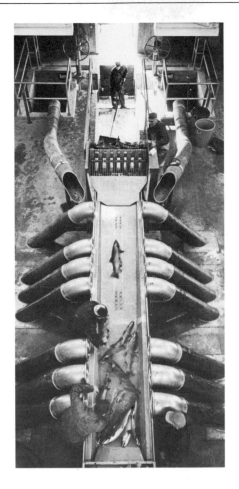

FISH STORY

Some fast physicals
for sedated salmon

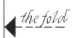

the fold

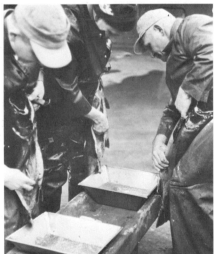

Eggs by the millions

Helping hand in the
spawning process

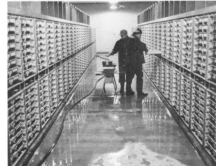

When Nikita Khrushchev visited an Iowa farm, cameramen descended on Coon Rapids in force. Most of them got the same routine view of the premier in a feedlot. By not following the crowd, one lensman got something additional: the essential scene plus a pyramid of photographers.

THE PHOTOGRAPHER

Technique is
only the
beginning

The photojournalist belongs to a special breed. He has the instincts of a newsman, but he also has the compulsive desire to share his pictures with others. Like the doctor and the psychiatrist, the editorial photographer often probes the privacy of his subject's life. Unlike the confidential findings of medical men, *his* visual records are arrayed for all to see. This presents challenges. Before a camera can do any meaningful probing, the cameraman must be totally accepted. Genuine respect for his subject is the best avenue to acceptance. Faked feelings on the part of the photographer are often subliminally detected. A wary camera subject is a poor camera subject. The best photojournalists are comfortable in all strata of society and on both sides of the generation gap. Blessed with good taste, unhandicapped by eccentric behavior or attire, they quietly establish rapport. They are aware that during the social amenities of getting acquainted, the story subject is apt to assume the role of host. They know also that as long as the guest-host relationship continues, superficial pictures will result. So they subtly withdraw, do less talking and become sympathetic observers as the subject goes back to living his own life.

Photo *thinking* is what this section is about. As such, it involves the editor as well as the cameraman. It has little to do with lenses and lighting, with nuts and bolts of equipment. Literature on these subjects abounds. Important though it is, photographic technique is only a beginning, a necessary first step, in this business of communicating with a camera. The personal quality of thinking, feeling and seeing is what distinguishes one photographer from another.

The Photographer

Executive in studio light (top) is same executive who comes alive in available light above. Retouching in studio portrait has removed wrinkles and character; large area of suit contributes little to understanding the man.

Portraits:

honesty . . . or little white lies?

Like ancient Greek sculpture, the formal studio portrait is an idealization, a little white lie rather than an honest likeness. Its purpose is to flatter the subject by picturing him as he would like to look. It is usually a head-and-shoulders' view, complete with breast-pocket handkerchief. The subject's expression may be serious or non-committal. There may be a faint trace of a smile, but never a true smile. The eyes are brightened, the complexion smoothed. A retoucher's pencil has removed worry-wrinkles and smile-lines, crow's feet, neck folds and blemishes. Only the eyes, nose and mouth are in focus. Thus the cosmetic portrait presents a mask rather than the man. It belongs in a frame on a wall or mantle but not in magazines or newspapers.

The journalistic portrait, on the other hand, tells the reader something about the subject's character and personality. It catches him reacting to an idea, expressing an opinion, active rather than passive. Because he is not posing, he will not have a self-conscious or vacuous look. The journalistic portrait may be critical of the man, but it will be honest. His close friends should be able to recognize in the portrait characteristic qualities they know are basic.

Since no single portrait can reveal the whole truth about anyone, editors often prefer to use several views, each revealing one more facet of the subject's personality.

Any portrait is necessarily the result of interaction between the photographer and his subject. The more a photographer understands his subject, puts him at ease and elicits natural expressions, the better will be his portrait. The psychological key to portraiture is rapport. Both subject and photographer contribute to the visual statement.

On the technical side, a photographer should master formal portrait lighting even though he prefers available light. It will sharpen his appreciation of the ways light can change the mood and structure of the face and enable him to modify available light to do a better job. Uses of mainlight, fill-in light, accent light and background light are thoroughly covered in books on portraiture and will not be dealt with here. But their intensity, direction and quality reveal the technical skill of the photographer.

Longer than normal lenses have two principal advantages: they permit a large head size without danger of distorting the features; they allow the subject to feel less self-conscious than he would if the camera were thrust close to his face. Focal lengths from 85mm to 135mm are often used on 35mm cameras.

Though a small camera is less disconcerting than a formidable studio camera, it has one disadvantage. When he holds it to his face, the photographer loses direct eye-contact with the subject. Normal conversation is disrupted. The photographer working alone might try placing the camera on a tripod. Sitting beside it, he can converse in a natural direct manner. Or he can invite a friend of the subject to engage him in conversation. This frees the photographer to shoot from several positions while the conversation continues.

But the best way of all is to make informal portraits while the subject is going about his business. Soon he will be unaware of the camera's click and meaningful portraits will result.

The difference a mood makes. Engrossed in decision-making, the executive is, in turn, skeptical, elated, thoughtful. Views reveal three facets of subject's personality and offer evidence that single picture can seldom be definitive.

123

The Photographer

Eyeglasses in portraits:

a problem . . . or a prop?

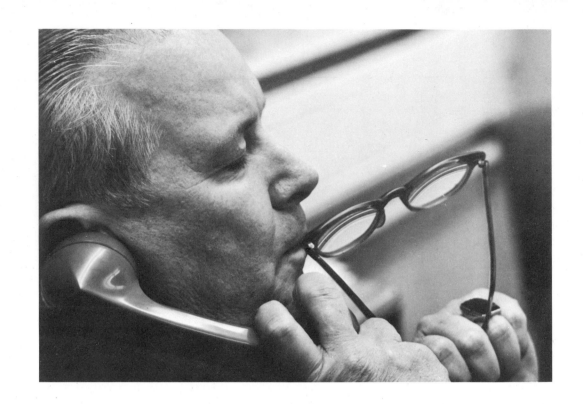

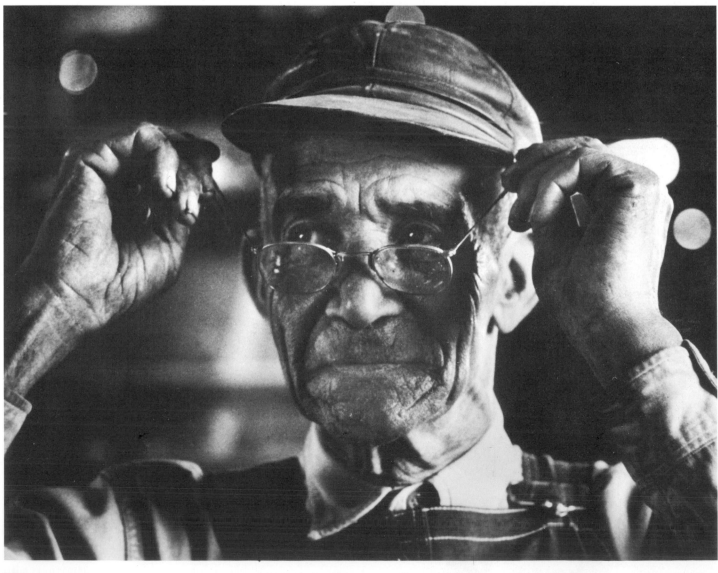

On three counts at least, eyeglasses worn by his subject can complicate life for the journalistic photographer. The lenses will often reflect hot spots. Some will veil the wearer's eyes. Frames of the glasses will cast distracting shadows. Asking the nearsighted person to remove his glasses for a portrait is not the answer. He will feel uncomfortable and he will look unnatural. Besides, marks made by the nose pads will be all too evident. To resort to lensless frames, as some photographers do, is patently dishonest.

A downward tilt of the head will usually get rid of eyeglass reflections. But directing the subject to lower his head could make him self-conscious; naturalness might evaporate. The best way to handle the reflection problem is to look for the source. In available-light situations, adjusting drapes or drawing blinds might be a remedy. A lighted lamp might have to be moved or turned out. While he ponders the solution, the photographer should continue shooting, even though he may make a few unusable pictures. It is better to waste film than to betray hesitancy and make the subject uneasy.

There are ways to shoot around the problem. If the subject has a good profile, the camera can catch the eye behind the glasses and under the bow. Catching him in the act of putting on glasses or taking them off can be effective, too. But portrait photography is best served when a man's glasses are an adjunct to his personality, when he uses them to doodle, to nibble, to gesture as well as to see. No longer a liability, glasses now expand the portrait possibilities.

Closed eyes and strong hands holding conventional props (left) contribute to an unconventional portrait by Ted Rozumalski. Rarely can such a portrait be posed. So it is with his portrayal of the factory worker affixing his glasses; here is honest directness that communicates. Rimless glasses (below) and heavy frames (right) are personality extensions of a country banker and photographer Ansel Adams.

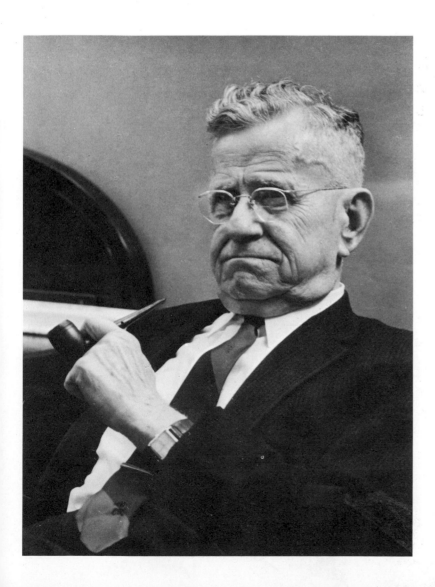

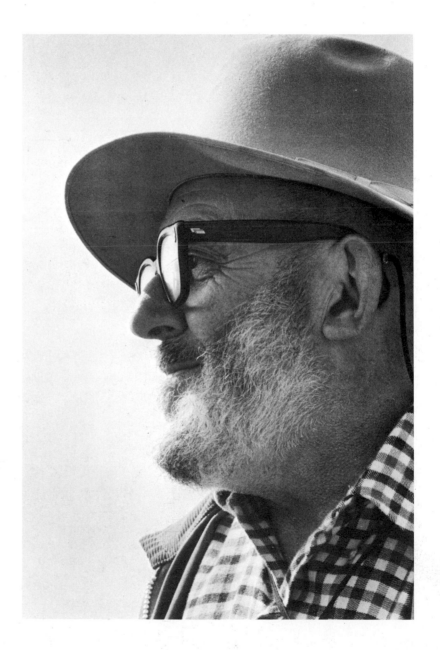

Hands in portraits:

idle . . . or integral?

Yesterday's "please-the-sitter" portraits are being phased out. Sharp editors now demand portraits that command a second look. Some of the more telling examples emerge not from "portrait" sessions but from candid coverage of a man's day-to-day activities. Things begin to happen. Gestures come naturally. In time, portraiture is no longer on the subject's mind. Nor on the photographer's. The latter is mainly interested in strong pictures. He is alert for significant mannerisms, for expressive hands that cup the chin, rumple the hair or help his subject express his thoughts. As the hands move, they may hide facial features but they don't detract. In a journalistic portrait, half a face may reveal more than the whole.

Passive hands, self-consciously folded, contribute little in formal portrait at left. Inventor's face and hands (below) reveal with transparent clarity the particular talents that resulted in more than 60 patents: creativity, drive, imagination, expression and warmth.

M. Leon Lopez

Backgrounds in portraits:

will face say enough . . .

or will background say more?

The significant portrait reflects more than facial architecture. It reveals inner strength and character. The value a man places upon himself will, in subtle ways, show through the facade. But experience and environment also mold the man. And, to a degree, these important influences can be visually recorded. With or without symbols or props, a valid background can quickly identify the subject's work or his interests. It adds a new dimension. The environmental portrait has another plus: in familiar surroundings, the subject is more likely to be himself.

Using this technique, the photographer is doing nothing novel, of course. In a much earlier era, Flemish painters effectively used the background of their portraits to establish the atmosphere in which their subjects lived. Whether a craftsman works with canvas or film, Old Masters continue to be good teachers.

Too often in journalism the group picture prevaricates. It is a put-on. Purely for the camera's benefit, the subjects will pretend to read, pretend to examine. This is play-acting and it fools no one. Both photographer and editor underestimate reader-perception when they try passing off pretense for the real thing. The best approach to group portraiture is usually the straightforward approach. There is nothing wrong with the honest look of people having their picture taken.

But it will be necessary at times for the photographer to turn director, to pose his group for

First picture of executive team fails because simulated conversation is obviously staged. Group would not sit this way to chat if camera were not there. Second picture, with subjects looking at camera, is more acceptable because no subterfuge is implied. Robert McCullough's final picture (below) is a success on all counts: low camera angle is effective; both foreground and background enhance; composition is improved; postures are better; expressions are warm, alert.

good composition and comfortable positions. To be valid, his portrait should do more than show what the individuals look like. It should reveal the common bond or distinctive relationship among them.

There are also times for the "snapshot" approach. Using this technique, the photographer records rather than manipulates. He permits each subject to choose his own pose and expression. The hands-off method will catch the image each man wants to project and may also reveal personality traits of which he is not aware. It can be more significant, more honest than the manipulative approach. Largely because of the uncontrived snapshot approach, early-day portraiture has retained lasting value and charm.

In "snapshot" approach (right), the photographer merely records. He says, in effect: "Let me take your picture." Members of group assume own poses and portrait has honest directness.

In posed protrait, the photographer interprets. To portray seven brothers who build trucks, he sets up straightforward picture with an appropriate symbol and setting.

Summary pictures: the setup that wraps it up

Sooner or later in every story coverage, photographer and editor have to face up to the question of the lead picture. Most times it's no great problem. Candid shooting often produces strong candidates in quantity. But some stories present complications. There are instances where no one candid picture will say enough. The answer is the setup picture that provides a visual summary. It has to be contrived because it juxtaposes story elements that normally would not appear together. There is no attempt to fool anybody; the reader immediately realizes that fabrication has taken place. But if the picture works, his attention will be flagged and he will be impressed by the scope of the presentation. The summary picture succeeds when the idea is valid and unique and when the photographer is able to visually express it. Unless rich in promise, ambitious setups are unwise.

Summary pictures at left were contrived to show variety of special-purpose trucks used in poultry industry. Compare them for composition and reader appeal. Lower picture made arresting story opener. Headline: "A Tyson chick and the trucks in her life."

Size and scope of corporation's photo center (right) were too much for conventional coverage to grasp. Candid coverage of dentist-farmer (above) could catch him in one role only. Setup picture brought his two roles together: "Dentist who developed Crest breaks ground in brand new field."

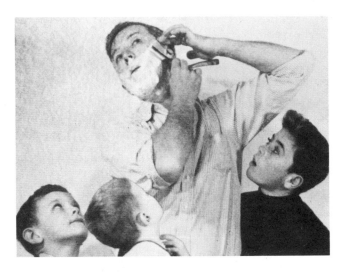

Little shavers (top) become ham actors taking their cues from photographer's stage directions. Picture is patently phony. Uncontrived scene at right has naturalness, believability.

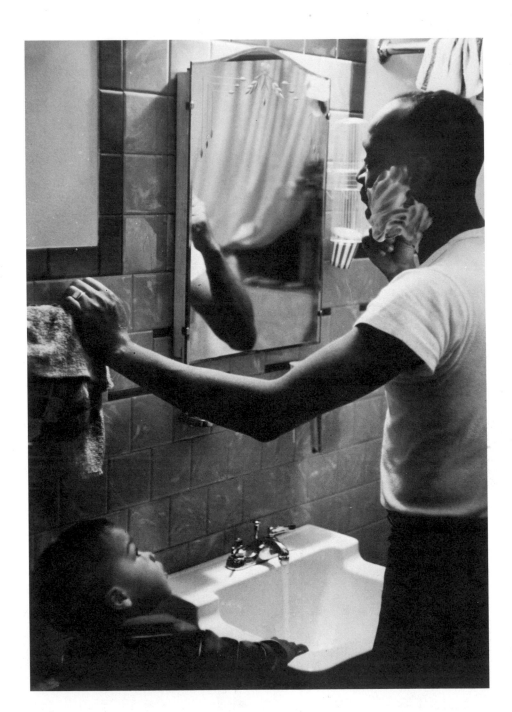

People pretending to read (upper left) should be prime candidates for banishment from printed page. Same fate should befall people pretending to paint. As sharp eyes will discern, brush is dry.

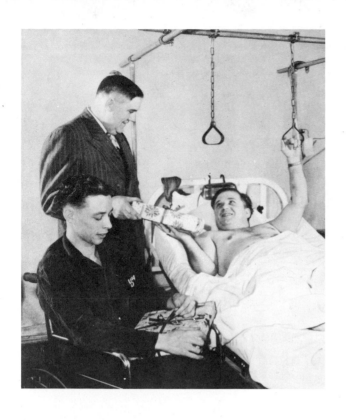

Life as cameras record it is often a mechanical counterfeit of life as it's actually lived. Real life has spontaneity, flavor, warmth. As represented on the printed page, life is often wooden and sterile. "Stop living and start posing," the photographer says in effect. And he squeezes out most of the warmth. The photographer who makes a practice of posing his subjects may not commit a breach of ethics but his effectiveness is questionable. Credibility suffers because few people are convincing actors. The more direction they receive, the more self-conscious they become.

Some photographers sidestep honest coverage for reasons of expediency: the situation was not as represented so one had to be set up; there wasn't time to wait for the real thing to happen. Others follow shooting scripts prepared by heavy-handed editors or art directors.

Whatever the excuse, too many pictures continue to lack believability. Too many photographers still exhort their subjects to: "hold it", "point", "say cheese." Until the man with the camera shows a greater desire to let things happen naturally the printed page will continue to languish.

Hoked-up hospital photo at left has little to recommend it. Faulty posing divides center of interest; desire to show three faces has led photographer into the posing trap. Picture below, unposed in available light, rings true.

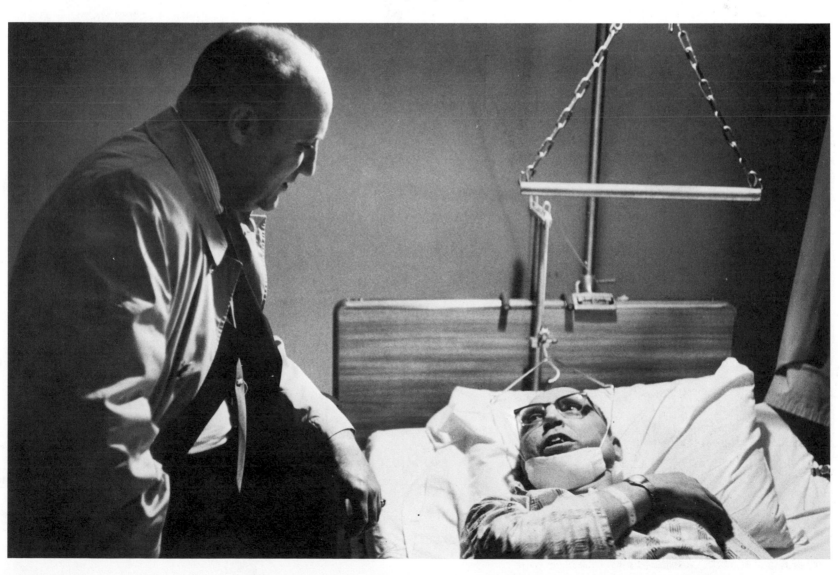

The Photographer

Photo clichés: shoot them if you must, save them if you can

"That's not me!" "Oh, yes it is." "Let me have another look at that." Examining old photographs of themselves, men in scene at right are genuinely interested. In photo above, interest is obviously feigned. Photographer jammed too many men together, told them where to look. Picture at right would have been made even better with attention to detail. Retouching could have removed clothes tree horns from head of man at right. Lower camera angle could have done the same.

The photo cliché is a picture idea that has become trite. Its effectiveness has been diluted through overuse. Presentations of checks and plaques, of trophies and certificates, of keys to cars and cities are prominent in the catalogue of clichés. So are ground-breakings and ribbon-cuttings, new officers beaming and new beauty queens crying. The list is as long as the pictures are old and tired.

The cliché is propagated by the editor who can't say "no" when well-meaning groups request recognition or publicity. It is perpetuated by the photographer who is content to cover the cliché situation in the same old hackneyed way. Complacency is the culprit here. The photographer convinces himself that an investment of creativity would bring him small return. He responds to the trite assignment with uninspired effort.

To the self-respecting photographer, the cliché situation is a challenge. He will strive to find a fresh approach. Seeking spontaneity, he will record a presentation as it actually happens. He will be alert for the unexpected, the faux pas, the reactions of onlookers. If other photographers pose the presentation, he will step back and record the scene. While cameras up front are trained on the spurious, his own lens will catch an honest happening.

If the picture must be posed, he will pose it honestly. He will avoid any reenactment of the handoff. By employing the skills of informal portraiture, with good composition and effective camera angle, he can make the unpromising palatable. Even memorable.

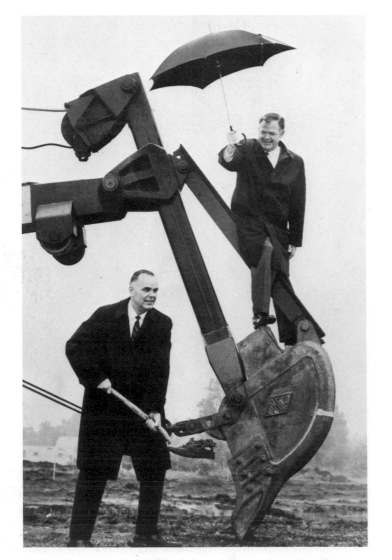

Gilded shovels, earthmovers and architects' drawings are standard props for the ground-breaking picture (top left). Turning rain to his advantage, a photographer with a flair broke new ground with cooperative subjects and an incongruous prop. Compare the pictures for composition, reader interest.

Jane Sisson

Mixture of interest and apathy in audience contribute candor to presentation photo at right. Honesty makes picture superior by far to stilted check-passing (above) enacted solely for camera.

"*Side glance.*" *Robert Doisneau anticipated moment of discovery and captured it. He waited unobtrusively behind an art gallery display window for reactions to the nude painting. Doisneau, who finds gentle humor in Paris and its people, has said: "The marvels of daily life are exciting; no movie director can arrange the unexpected that you find in the street.*"

Fleeting scenes: a hand quick as an eye

No photographer who truly cares can forget a great picture that got away. If he's ever had a near miss in a now-or-never situation, he will have total and painful recall. But he will not help his batting average by stewing over lost opportunities. The wise photographer will do what he can to sharpen his faculties. He will try to do a better job of seeing. He will try to broaden his comprehension, to understand more clearly the inner nature of people. The better he perceives and the more he comprehends, the more likely he is to anticipate.

Until a picture can be made by winking one's eye, anticipation will have to involve some mechanical preparation. It may mean pre-setting shutter speed and lens aperture, then zone-focusing for the depth of field available at the selected f-stop. When the telling moment comes—if it comes—seeing and shooting will be simultaneous. The hand will be as quick as the eye.

Preserved on these pages are three memorable, fleeting moments. Three photographers perceived and were prepared. Each picture makes a unique statement about human nature. Interplayed in a single layout, their impact increases. The recurring female figure reinforces what each picture says alone.

© *National Geographic Society*

"Interested listener." Winfield Parks' prize-winning photo was completely unposed. Indeed, it was one of only two exposures he was able to make before impromptu conference broke up. As an added indication of his technical skill, picture was originally made in color.

"Cautious critics." Her practice of carrying a camera to women's club meetings paid off handsomely for Joan Liffring Zug. This occasion was an art-lecture tea. She recalls: "At one end of the room was this great nude with four ladies. Unaware of the camera on my lap, next to purse, one of them kept looking back. The second time she did it, I got the shot. It seems to summarize art-gallery events in one grand finale."

**Equal partners though they are, it is imperative
that pictures fall into place first and words later**

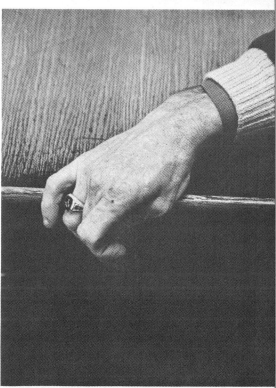

THE MAN TALKS STRAIGHT, gestures for emphasis with a finely sharpened pencil. He is Bob Heim, East Moline interviewer and his job is to sort out employment applicants like Harold Parson. For Parson, it's a time for calmness and confidence, but a nervously twitching thumb tells another story.

NEW HIRE / *among the hurdles: high-tension interview, old hand injury, "catchy" test*

THE QUESTIONS were sharp and to the point. "What are your physical disabilities?" "Do you have assembly line experience?" Interviewer Bob Heim's analysis of the job opening was also frank. "It's good work, but it's hard work, too . . . Our stations are timed. You might get a little nervous at first but there'll be someone to help you." Through it all, Harold Parson answered the questions directly ("I injured my hand in the service but it's okay now, has been for years . . . Yes, I've got six months' assembly experience.")

To the casual eye, the job applicant seemed calm, confident. But hidden from view, a rhythmic lifting and lowering of the left foot, a persistently twitching thumb and a steady clinching, then relaxing of a moist left hand told otherwise. Then, the good news. Barring failure of a pre-employment medical exam or an intelligence test labeled "catchy but not overly tough" by Interviewer Ron Mason, Parson would start work the following morning. He did well on both, really had "something to tell the wife tonight."

1

Wedding the visual
to the verbal;
the impact of words

The mating of pictures and words—the right words locking step with the right pictures—is what good photojournalism is all about. If the marriage is to work, neither should be subordinate to the other. Equal partners though they are, it is imperative that pictures fall into place first and words later. It is no coincidence that the page with visual impact usually has verbal impact also; good words are often a consequence of good pictures. The writer is best served when he sits in on deliberations over picture selection, when he helps hammer out the headlines and auxiliary heads. All this behind him, he will have the story line in firm grasp before he commits a word of text to paper. He will not meander. If he is allotted slightly less space than he feels he needs, he may write more effectively. The discipline is demanding, but the words that emerge tend to be more crisp and cogent.

The
Stoppers

In 21 years Mr. X had smoked an average of two packs a day, 700 packs a year, more than 300,000 cigarettes in all. He had smoked through 1,000 days, spent more than $5,000, left an ash 15 miles long. So, he decided to quit. It wasn't easy. But now he smiles a lot.

Three years ago he was a city boy,
fresh from the campus, without land or capital

LOOK WHAT'S HAPPENED TO ELTON UPSHAW!

The photojournalist not only tells his story visually but quickly. He rarely dawdles. His captions are fact-packed, concise. He writes his text succinctly, getting maximum mileage from limited space. Only in his headline-writing is he free of the pressure for brevity. Space is no over-riding factor here. The editor need not think in terms of one-column or two-column heads. Flexibility is imperative. A head may take the form of a long and leisurely sentence . . . or a single word . . . or anything in between.

In some editing circles, there is a tendency to deprecate the label head. Contest judges impose penalties whenever headlines appear without verbs. Use "action" heads, they implore, unaware apparently that many of picture journalism's memorable stories did quite well without them. "Maine Winter", "Country Doctor" and "Spanish Village" come immediately to mind. What's wrong with too many headlines is not the lack of the verb, but the absence of precision. "A better way!" a headline will proclaim, with no lead-in or subhead for elaboration. "An Important Step", another will assert, without a word of amplification. Obviously (see left), the label head needs help.

With or without a verb, the headline needs to be specific. It should intrigue but never overstate. In photojournalism it should relate, of course, to the pictures. In effect, it should serve as a road sign guiding the reader down a visual story line.

Matching the mood of the pictures, the head may be solemn or flippant but not extremely so. The prosaic head won't grab. The head too clever may not communicate.

"A head may take the form of a long and leisurely sentence . . . or a single word . . . or anything in between."

On each new spread of a picture story or picture essay, the professional editor will select pictures that make a single statement, a single point. Then he will write an auxiliary head to make his meaning unmistakable. As *Life* magazine uses them, auxiliary heads are models of simplicity. After its opener on END OF A COMPANY TOWN, *Life's* succeeding heads were:

> Most workers will stick it out to the end
> The company built and ran everything
> "We've been riding the gravy train for a long time"
> The simple life of the valley will be hard to leave.

The auxiliary head will often take the form of a telling quote. It should enable the page-flipper to absorb at a glance the essence of the spread. But if it truly works, the auxiliary head will beguile as it interprets; it will try to make a reader out of a looker. In style and stance, it should share a family resemblance with auxiliary heads that precede and follow. Working together, auxiliary heads provide the necessary cohesion for the long picture story or essay.

"A family resemblance with auxiliary heads that precede and follow."

EDDIE

Spring can be a tender shoot
pushing through the earth
or a small boy
bursting through a door

EDDIE
a king of the hill . . . deposed

EDDIE
a sprayer of water . . . dehosed

"Cohesion for the long picture story or essay"

HOW JUSTICE WORKS: The People vs Donald Payne

> THE DEFENDANT: "Too much happening"
> THE VICTIM: "They're chasing me out"
> THE COPS: "It's never going to stop"
> THE JAIL: "You'll always have the hole"
> THE DEFENDER: "It's the wild west"
> THE TRIAL: "Let's get rid of this case"
> PRISON AND BEYOND: "I'm on my way home"

RUSSIAN AGRICULTURE: Blunders in the breadbasket

> MONTANA VS KAZAKHSTAN:
> Look Ivan, fewer hands!

> MONTANA AND KAZAKHSTAN:
> two schools of thought on kids and cows

> MONTANA AND KAZAKHSTAN:
> matching horizons, worlds apart

For mosquito foes
in Orange County, California
the assault is amphibious
THE FIGHT ON BITES

BITE FIGHTERS
strategy of battle:
hit 'em before they hatch

BITE FIGHTERS
Nick Blair's mission:
search and destroy

Pages with strong pictures are likely to be alive with bright words. Evidence suggests that the editor with picture awareness is also the editor whose words are on key. He will not settle for stuffiness. He will have room only for warm and engaging words, person-to-person words, dead-on-target words. The writer in picture journalism has the advantage of knowing where he is going. He has a photo layout to light the way. Deftly, crisply, he will write with a pace that pulls the reader along. He will not drag even while weaving in background and explanation. He will not pause to preach even if he writes for a special-interest publication. He will sell softly, not blatantly, and he will hold his reader. His first obligation is to his reader.

He will not generalize and he will avoid abstractions. He will reduce complexities to something approaching bite-size. He will develop a good narrative style, with a leavening of grace and wit; functional writing need not be clumsy writing. His pace may be swift but he won't try to say it all in his lead. His block of copy must build . . . up to a final climatic sentence . . . which may have the kick of a mule.

Or a light-hearted twist.

" . . . a pace that pulls the reader along . . . "

By catching a green light at Randolph and Michigan, Angie Syrigas can count on sprinting into the office 45 seconds before the starting bell. At noon, she hovers long enough for cottage cheese, an apple, a banana and a glass of milk. Then she hurries off to shop. "Even if I don't buy, I look," she explains. Claims her husband: "It's against Angie's religion to come home empty-handed." Back home in the evening, she changes "into something glamorous," prepares dinner, sails into housework. ("I hate to clean house, but I hate dirt more.") A talented lyric soprano, she may have to rush off to a singing engagement or out for an evening of fund-raising—for a stained-glass window in the new church, for a Greek hospital needing sheets. "I go very hard," Angie admits. "I go on nervous energy. Finally, I practically collapse." —G.D.H.

" . . . he will not drag even while weaving in background . . . "

To make his name a household word all Henry M. Stanley had to do was penetrate the African bush and find a Dr. Livingston. Today, a century later, it's a simple matter to find African Missionary Paul Teasdale, although rigors remain. Teasdale's mission is at Gatab, in the remote reaches of northern Kenya. To get there from Nairobi, the visitor has two unsatisfactory choices. He can travel by land for two back-breaking days or he can take a hairy flight in a small plane, touching down nervously on a spectacular airstrip rimmed by mountain canyons. Identifying the missionary is easy: he's the dust-caked tractor operator carving a new landing field at a lower altitude, hacking it out of scrubland bristling with thorn bush —G.D.H.

Time was when winter put the Alaskan Eskimo out of business. Came the darkening days of November, his cycle of hunting and fishing ended and he prepared to hole in. His abode was not the igloo (a Canadian invention) but a sod house, partially underground, with a small domed ceiling and a smoke stack in the center. For heat and light he burned seal blubber in a shallow lamp made of pottery. The sod houses are gone now. In Barrow, at least, they have been replaced by frame buildings whose brightly lit interiors help offset the Arctic gloom. Barrow sits on permafrost 600 feet deep and doesn't see the sun from mid-November until late January. Its warmest month has a mean temperature of 39 degrees and it knows at least 170 subzero days a year. But so taken with electricity are Barrow's 2,000 Eskimos that the sale of a refrigerator is no longer Mission Impossible. Power came to Barrow in the hold of a supply ship that arrives every August when ice breaks up in the harbor. When a pair of turbine-powered generator sets were lightered ashore last summer, bright lights for Barrow were assured . . . —G.D.H.

" . . . he will sell softly, not blatantly . . . "

At six foot five, William E. Callahan may stand tall in a crowd, but he comes up only to the door handle of one of his new heavy-duty trucks. And when he sees one of these gleaming giants at the end of the assembly line, the door handle is precisely what Callahan reaches for. He opens the door and slams it shut, listening to the sound. He reopens the door and pulls down on it with both hands. He examines the seals and the finish, kneels to inspect the weld on the aluminum threshold. He stands and tugs mightily on the rear-view mirror. He questions the driver about everything from seat adjustment to the pressure-sensitive decals on the instrument panel. In the process, the executive vice president will: show assemblers that somebody upstairs "is looking at all those dagnab *little* things;" assure himself that the truck will be delivered nuisance-free; make doubly sure that the left-hand door is built "hell for strong." Explains Callahan: "You wouldn't think a cab door or mirror were designed to have a 250-pound fellow put all of his weight on it, but the cold hard facts are that a truck driver does exactly that. You can put handles all over the place, but you watch him and he's on the door or the mirror"—G.D.H.

" . . . a leavening of wit . . . "

Joe Uildricks rang 40 doorbells one evening this fall. By election day he saw almost every one of the 512 registered voters in his precinct at least three times. "I try to hit all the Democrats first, then hit the Republicans and see if I can't swing a few more," Joe says. "When they slam the door in your face, you know what they are." Despite an occasional door in the face, Joe tries to remain helpful and available to voters of any political stripe. His vote-getting arsenal includes a garage full of tools that he regularly lends to anyone in the precinct.

Joe's a pro who knows his territory. When he turns in his estimate before the election he always comes within three or four votes of the final count. Usually he's beaten about three to one, but he has a plan to improve his vote. A solidly Republican segment of his precinct is separated from the polling place by railroad tracks, with only two places to cross. "I'm fighting to get 'em taken away from me," Joe says, "so they won't have to cross the tracks . . . "—M. Leon Lopez

Tape it to keep the sizzle

Keep it warm. Keep it simple. Where text is concerned, these two guidelines will serve as well as any. Tell a story through people and interest is heightened. Tell it through one person and the appeal increases. But the printed page will not have warm humanity until story subjects come truly alive. They must talk like people talk and not like frozen assets. Every quote must have an honest ring. The best tool for nailing down authentic quotes is the compact tape recorder. To get a man's words on tape is to get all the flavor locked in. The note-taking reporter will catch the meaning but he may miss the colorful turn of phrase. He will come back with the meat, rarely the sizzle.

The small, light-weight recorder can bring to prose the same realism, the same believability the 35-millimeter camera has brought to pictures. But just as the small camera means more proof sheets to cull, the recorder means more information to sift. Indeed it may take three hours or more to transcribe one hour of tape. Wealth of detail is one payoff. Human warmth is another. Consider these words, directly off tape, of a factory worker whose son had just played his final game of college basketball: "I was at the game when Joe scored the 40 points —he got a big hand after he did it—and my wife—talking about wives—she was crying. Sitting down and crying. She couldn't get up. I nudged her and said, 'That kid's better than a movie.' She said, 'You got a handkerchief, Joe? Let me have your handkerchief.' "

" . . . not like frozen assets . . . "

"*Man*, we gotta *roll*!" That's Elton Upshaw talking, as always in capitals and exclamation points. Tearing over back roads, gravel hitting the car like buckshot, Upshaw sings along as the car radio blares "King of the Road." He slows down only when he passes one of his fields. "Boy, that little cotton's pretty for it to be so damn cold." At another field: "That's just a beautiful little cut of cotton. I really like to see those little things comin' up. Hot dog! I didn't realize I was such a good farmer."

As a farmer, Upshaw is a city slicker. He grew up in Monroe, Louisiana, a town boy whose father is a college professor. Operating on sheer nerve and borrowed money, he launched his farming career three years ago, renting 511 acres. Today—at 26— he leases 1,800 acres, has close to $80,000
—Kathy McCaughna

Happiness to Sam Bibbs is a beautiful trade-in. This is a man who can get lyrical about a used truck. His voice, deep and resonant, purrs like a finely tuned engine when he intones the virtues of a good, reconditioned rig: "Nice clean cab; nice red color; clean new recaps; 190 horses. Best deal you could hope to make, sir. The *very* best deal." Always Bibbs is quick with a quip: "You heard we had a '69 model with 90,000 miles on it? Man, a '69 would have to be sick lazy or in jail to have only 90,000 miles. This rig's got 200,000! It's been up and down the road a few times but it's beautiful." Sam Bibbs works in Indianapolis in a place called . . . —G.D.H.

" . . . with all the flavor locked in . . . "

Bob Shupe drove 60 miles on March 4. He made eight calls and talked to two customers at the store. Right after lunch, Shupe went up to Ursa to see Glenn Nuegge about trading for a baler in partnership with his brother, Orville. Glenn's wife, Martha, came out to meet him when she heard the dog bark. Bob spoke first:

"What you got the boss doing?"

"Well, he's sowing clover seed."

"What's he doing sowing clover seed—muddy as it is?"

"Well, I tell you he looked like a mud turtle. But he's sowing clover seed."

"What's Orville and Glenn decided on that baler?"

"You go over and see Orville. Have you been over there?"

"No, I haven't."

"Well, he's got all the statistics and I think when you get over there, you'll get your answer."

"Well, is he tough today?"

"I don't know how tough he's going to be but I think he knows all the answers."

"Well, I tell you. I'll go over there to Orville's and whatever he does is O.K."

"That's right."

"Well, thank you a lot, Martha."

Shupe found Orville preparing to go into his fields with fertilizer. They passed the time of day before Bob got down to business.

"I stopped over at Glenn's. Martha said you had all the answers."

"Yes sir. Well, I don't know many answers—like the fella says."

"Well, if you go ahead and trade balers with us now, it'll help us get rid of the used one."

"We just kind of thought, by golly, we'd have this one fixed."

"Well, you want us to pick it up, then?"

"I believe so."

"We can pick it up any time. That's all right with us if you want to fix it and don't want to trade. And while we've got it down there fixing it, you might take a notion to trade. Now let's get back on that tractor deal . . . "—Wendell F. Overman

"THOSE SHEARS WILL CUT into that steel like butter." Among dignitaries who have witnessed Hammond's lively demonstrations: India's Nehru, Turkish President Bayar.

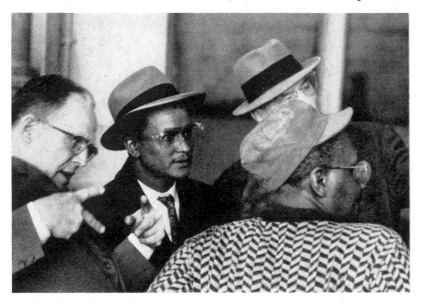

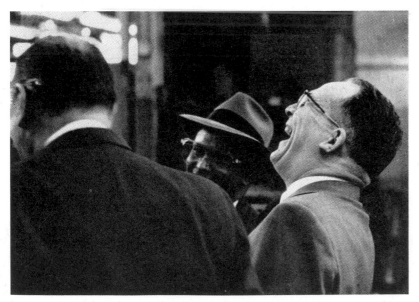

WRY PUN SETS OFF HAMMOND ROAR. But, before long, conversation will return to tractors. Explains Hammond: "I've got this one chance at them. Every minute counts."

Deceptively simple, often devilishly difficult to write, words in captions are a breed apart. And they require far more attention than editors generally give. Turning from text to captions, the writer must make adjustments in style as well as pace. Because opening words usually get typographical emphasis, he must concentrate on a colorful, attention-grabbing start. He should keep his sentences short, direct. He may have to compress by eliminating articles, conjunctions. Often as not, he will explain "what" first, "why" or "how" later. Always, he will keep the picture in view as he writes. If a meaningful detail is inconspicuous, he will point it out. If a picture is subject to misinterpretation, he will quickly clarify. He will give each picture the help it cries for. He will not waste words on the self-evident. He knows why the caption is there. It is there specifically to serve the picture, to lure the reader back for a second, more appreciative look.

The right words can make a picture more vivid. The right caption will say more than the reader could perceive by himself. As an example of a caption that serves neither picture nor reader, consider this: *Heavy granite is lowered gently to sidewalk by workmen.* The caption improves immeasurably with the insertion of detail and imagery: *Six-ton granite slab—as heavy as three automobiles—was one of 14 removed by quitting time.*

Nor is there any excuse for the caption that contradicts the picture. As a minimum requirement, caption and picture should speak with one voice. If, as an example, the Happy Homemakers are obviously posing for a picture, there's no point in writing: *the ladies are shown here planning their autumn bake-sale.* To pass off posers as planners may seem a harmless distortion but it is one more chink in picture journalism's credibility.

Captions have multiple roles. One of them is to move the story along. Adroit use of transitional material will do the job, especially when a single caption serves a pair of pictures or a picture sequence. Captions serve also as repositories for incidental nuggets too choice to leave out but perhaps not appropriate in the text. Such tidbits should be woven in after the essentials are dealt with, space permitting.

Caption material is best presented in small doses. Long captions are difficult to read and often unsightly. Unsightly, too, are widows of one or two words. Squared-off captions, of course, provide the ultimate in neatness, but there is something to be said for captions less rigid. Captions set flush left or flush right with lines of unequal length can be pleasingly effective. And the writer is spared the problem of concocting, for each and every caption, an exact count of letters and spaces.

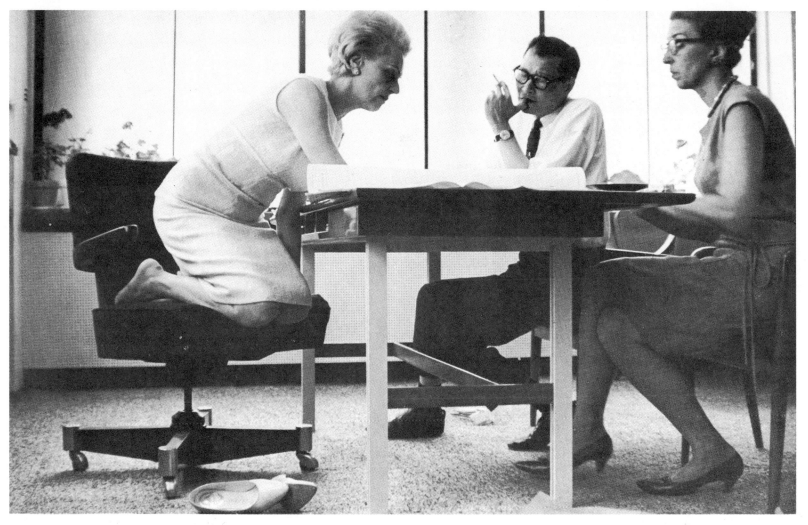

SHOES DISCARDED, Maria Bergson comes to grips with a design problem. Earlier, she canceled a vacation, decided to work through weekend.

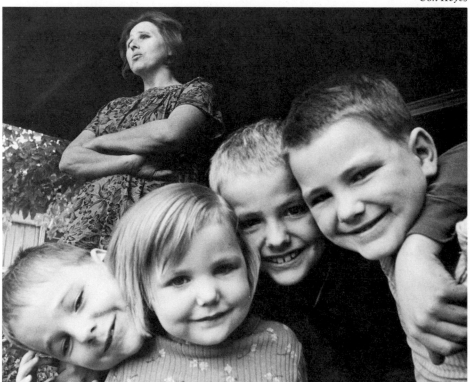

No matter how eloquent, most pictures need help. Uncaptioned photo at left conveys only a contrast in moods: smiling children, unsmiling mother. Photo comes sharply into focus when words are added:

Children free of care, mother sick at heart face an uncertain Christmas. Husband's desertion was first misfortune for Mrs. John Jones. The second: a fire which destroyed home and youngster's gifts.

The Editor

The heavy hand of help:

in support of worthy causes,

good intentions are not enough

Often when he tries to lend a helping hand, the editor reveals five thumbs. Whether his intention is to save lives, raise dues, reduce scrap or support a charity, he succeeds only in going through the motions. Rarely the emotions. He equates helping a cause with giving space to a cause. He is perfunctory where he ought to be provocative. His pages languish with canned material, repel with preachments. Seldom do they hit the reader where he lives; rarely do they possess the power to shock or stimulate, to arouse or amuse. There are only three things an editor has to do: educate, entertain and motivate. The first two he does passably well. It's the third—the area calling for the utmost ingenuity—that gets brushed off with indifference. Most editors are communicators of sorts. Precious few of them are motivators.

Example: pictures of United Fund committees are not likely to motivate anybody to dig deeper for contributions. The editor whose policy is to "show the committees" does little more than salve the egos of fund raisers. Considering the normal outlay for paper, engravings and printing, the price per ego has to be high.

Preferring a warmer approach, the publication at right gave wide berth to Red Feather committees and campaign statistics. Instead, it moved in on a foundling home in need of Red Feather dollars. It narrowed the focus to a little girl named Patty. When the camera caught a single tear at bedtime, the United Fund story began to pour out in non-fiscal terms.

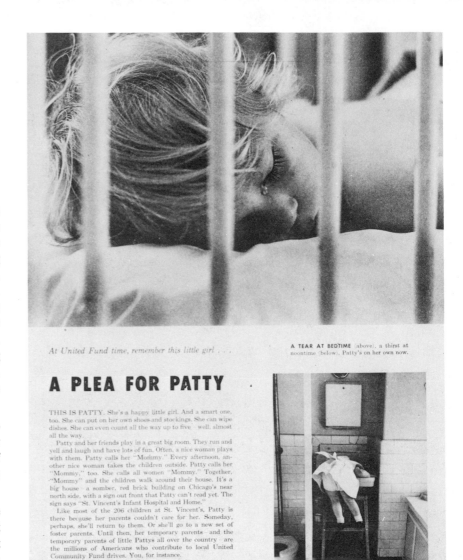

At United Fund time, remember this little girl . . .

A TEAR AT BEDTIME (above), a thirst at noontime (below), Patty's on her own now.

A PLEA FOR PATTY

THIS IS PATTY. She's a happy little girl. And a smart one, too. She can put on her own shoes and stockings. She can wipe dishes. She can even count all the way up to five - well, almost all the way.

Patty and her friends play in a great big room. They run and yell and laugh and have lots of fun. Often, a nice woman plays with them. Patty calls her "Mommy." Every afternoon, another nice woman takes the children outside. Patty calls her "Mommy," too. She calls all women "Mommy." Together, "Mommy" and the children walk around their house. It's a big house - a somber, red brick building on Chicago's near north side, with a sign out front that Patty can't read yet. The sign says "St. Vincent's Infant Hospital and Home."

Like most of the 206 children at St. Vincent's, Patty is there because her parents couldn't care for her. Someday, perhaps, she'll return to them. Or she'll go to a new set of foster parents. Until then, her temporary parents - and the temporary parents of little Pattys all over the country - are the millions of Americans who contribute to local United Community Fund drives. You, for instance.

Crusade emblem is displayed by Jim Gilbert, Generating Stations Office. Seated are Jim Barnhart, ... for Nick Mackovich; John Reilly, State Line, Don Quard, Ridgeland Dick.

Kelly, Crawford. Standing: Walter Molobicki, Calumet representing John Dramiciu; Steve Stankiewicz, Northwest; Bill Harris, State Line.

Crusade of Mercy needs your help

Kickoff date for the Company Crusade of Mercy is October 2, when more than 206 employe campaigners will solicit support for community funds and the Red Cross. Participating in the 26-pay-period deduction plan, in addition to the three Chicago divisions, are Northern, Western and Southern divisions, the Gen-eral Office, Tech Center and 12 generating stations.

This year the story of Chicago's Crusade of Mercy, and most other fund agencies in our area, are stepping up their goals to meet increased needs. The aim of our own Employe Civic Campaigns Committee, which spearheads the activity in the Company, is to extend the fine showing made by employes last year in the payroll deduction program. In the 1960 drive employes responded with contributions amounting to more than $202,000. Employe participation exceeded 85 per cent.

Arthur J. Moore, Western Division Vice-President is this year's Company chairman. Campaign co-chairmen are Charles Blankshain, Operating Manager's Office, and Joe Gedrick, Calumet Station, with Ray Young, Chicago Heights District Superintendent, and Joe Dudley, Waukegan Station, as assistant co-chairmen.

Members of the 36-man steering committee are ...

Ken Jennings, Engineering, and Bill Hostel, General Service, both Chicago North; Al Serenski, Sales Promotion-Chicago South. (Not present was Herman Becker, Meter-Chicago South.)

CRUSADE OF MERCY ... (Cont.)

Representing Chicago Central are R. E. Morrison, District Superintendent, and Andy DeVecchio, General Service.

Claude Simmons, Substation Director, Bernard Haggerty, Overhead-Joliet representing Al Thomas; Gus Kratzer, Will County Station, Harold Cavin, Sales Promotion-Harvey. Unable to be present was Harry Jack, Overhead-Hankston.

From left are Bill McLaughlin, Western Division Industrial Relations Manager; Cy Wilkinson, Aurora Station Superintendent; Bill Jack and Charlie Gelardi, both General Service-Maywood.

Russell Bennett, Joliet Station; Bill Loper, Director; Ralph Traylor, Overhead-Harvey; Gene Zeman, Operating, Clerical-Joliet referred to for Joe Emch, General Service-Joliet; and Roscoe Gill, Power Supply-Joliet.

Bob Bassett, General Service-Elmhurst, and John Gosnell, Overhead-Elmhurst. Not present was Curtis Petersohn, Aurora Station.

Sallie Pesey, Meter-Northbrook, Art Trexitson, Overhead-Crystal Lake; Ed Johnson, General Service-Mount Prospect; Paul Tinsley, Substation-Northbrook; Bob Bishop, Waukegan Station; and Lowell Koone, General Service-Waukegan.

Mike Cosgrave, Tooling; Orville Lucier, Purchasing referred to for Vince Parle, Commercial Office; John Dunkel, Industrial Relations-G.O.; and Dave Johnson, Shops and Tool Service.

Campaign sponsors Nicholas Galitano (center), Assistant to the Chairman, and Personnel Director Val Lester (right) appear with Ted Pariseter, large firms employe campaigns manager for the Chicago Crusade.

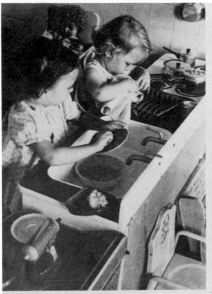

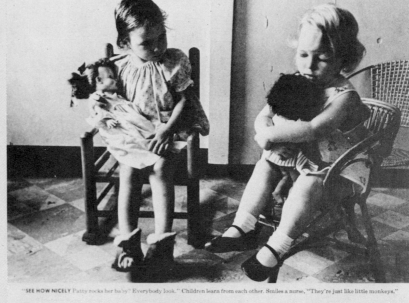

MAKE-BELIEVE "MOMMIES" tend to their chores. Children love to simulate home situations.

"SEE HOW NICELY Patty rocks her baby." Everybody look." Children learn from each other. Smiles a nurse, "They're just like little monkeys."

PEELING OFF shoes and socks, Patty prepares for bath.

"SOME OF THESE KIDS are going back to the same mess they came from," Sister Anthony says. "We try to teach them to help themselves."

PATTY

"They need a routine so desperately"

THE MOMENT you first walk into Unit One, Fourth Floor, and the children, giggling, chattering, shouting out their greetings, toddle across the room to embrace you ("Daddy? Daddy? Hi, Daddy!") - from that moment on, you begin to notice something special about them. You notice their self-reliance - tiny two-year-olds feeding themselves, putting on their shoes and stockings, eagerly undertaking little chores and responsibilities. You notice the gentle relationship with the nurses who look after them. A nurse never raises her hand to a child, never raises her voice. Politeness is the keynote. Even inevitabl: tantrums are handled calmly ("Would you like to go into the bedroom, Cindy? Then please stop crying.") The system works. "Youngsters crave order," Sister Anthony says. She is a registered nurse and a trained social worker. "They want to know where they stand. We make rules and we enforce them. We give the kids a routine - that's what they need so desperately - regular meals, naps, baths, playtime. Most important, we try to give them plenty of love."

6

WHAT'S A KISS

without a hug?

PR photos tend to be too pat. The heavy hand of stage direction is all too apparent. For reasons difficult to understand, few picture people are content to let things happen naturally. Typical of its genre, the "award-winning" picture on the far left is artificially cute. Much more poignant and moving is the unstaged scene at left where boy meets girl in a therapy room.

Helping hand: a way to kick boredom out of figures

"It's easy to become immune to the figures on highway accidents. We're exposed to them so often that we tune them out." Although the Sunday Magazine of Louisville's *Courier-Journal & Times* didn't mention it, the same thing applies to pictures of crumpled cars. There have been too many of them. A bashed-in auto is little more than a statistic wrapped in sheet metal. Even though it rarely commands a second look or a second thought, too many editors permit the view of the "totaled" car to stand for total camera coverage of an accident. Ever so much more compelling is this Louisville approach.

In "The Pain of Survival", a heap of twisted metal becomes the take-off picture for a poignant story of an accident's aftermath: "The car was just six hours old, and Duanne Puckett only 16, when it happened. The car never ran again, and neither will Duanne. She is a quadriplegic, paralyzed from the chest down since an auto accident in Shelbyville, Ky., February 25 . . . "

Introductory text included observations on accident victims in general: "Nobody bothers to keep track of how many are permanently disabled or paralyzed. Maybe somebody should. Maybe that would be the way to kick the boredom out of the figures. Death is final, sharp. To the survivors, the loss of a friend or relative may become less painful with time. But permanent disability is always there, dragging on the patient, family, friends. It costs a lot of money . . . It costs a great deal more in time, emotions, dreams."

When the focus narrowed again to Duanne, Bill Strode's camera took over. And Duanne's dreams, emotions and daily tribulations became vivid on the printed page.

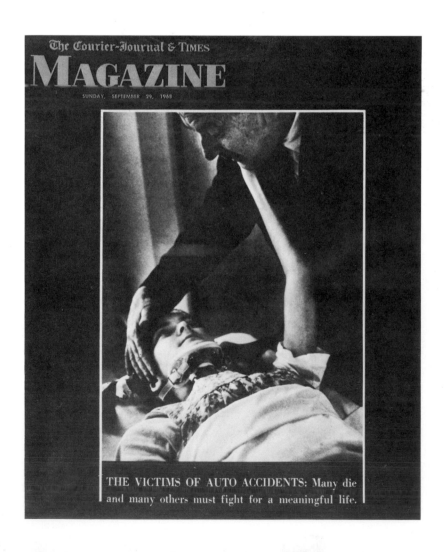

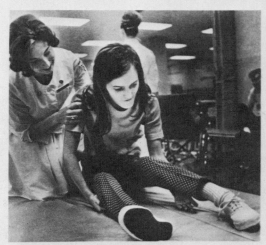

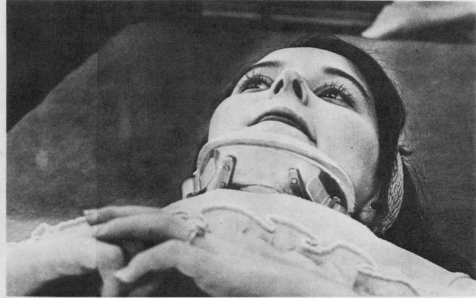

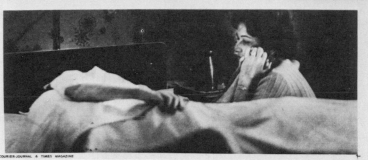

For Duanne, the struggle of learning to live again

The auto accident left Duanne a quadriplegic—paralyzed from the chest down, and with the use of her hands and arms affected. She was taken from her hometown, Shelbyville, Ky., to Louisville—first to a hospital, then to the Rehabilitation Center. There, under the guidance of therapists, Duanne exercised, lifted weights, learned how to use a special leather brace to hold a pencil and eating utensils. Her mother, her father, her sisters and her friends visited her frequently. She always wore colorful clothes, and even when flat on her back she insisted on wearing makeup—having her sister Marsha apply it.

Continued

Staff Photo-Essay by BILL STRODE

"Going back the first day of school was the hardest thing," she says

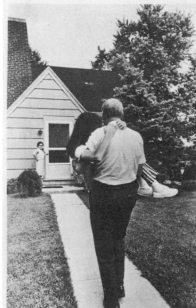

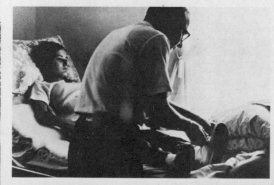

Duanne looked forward to returning home, but not to school. "Going back the first day of school was the hardest thing" of her entire rehabilitation, she says. So she slipped in by a side door. But her uneasiness vanished after one class. Classmates made room for her chair, and boys would pick up her wheelchair and carry her upstairs—often wordlessly—as they hurried between classes. At home, life was changed. Duanne's wheelchair was a new member of the family.

Continued

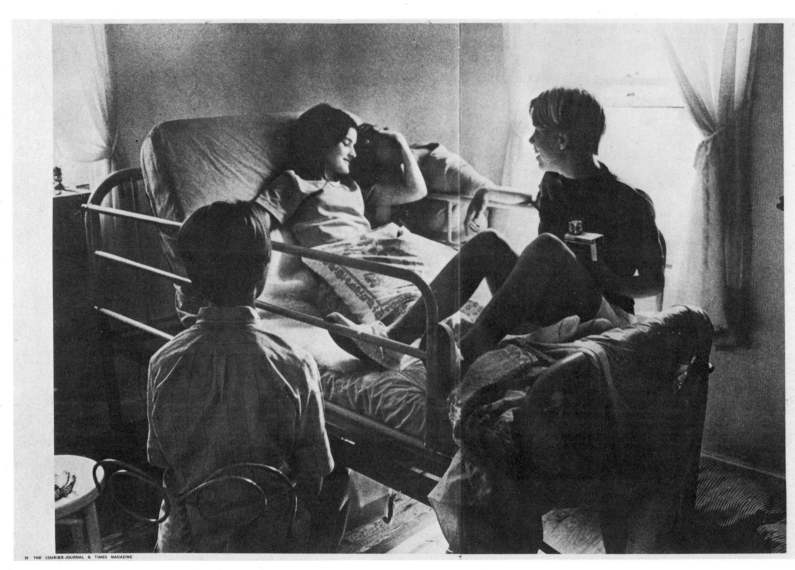

ACCIDENT VICTIMS
Continued

A lot of help from her friends

"Her family and friends were always there," said one person in trying to explain why Duanne was "the best-adjusted person I've ever seen." Almost every night schoolmates drop by to talk, watch TV, listen to records (Duanne has every one of Bill Cosby's) or take Duanne to a movie — usually a drive-in, so that she can rest in the car.

At the layout table, Bill Strode's photographs of Duanne Puckett were accorded respect that approached reverence. They were arranged with purpose and sized for impact. Warm scene above was 11 inches deep, 17 inches wide. Only one spread had as many as five pictures. There were no captions and text blocks were brief. But every word counted; no picture went unexplained. After four spreads of pictures came two pages of text: "A family's life changed at the snap of a finger." Like the pictures, the words were moving. And motivating.

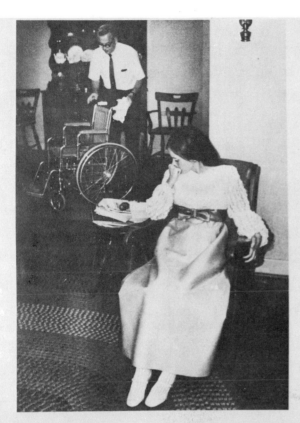

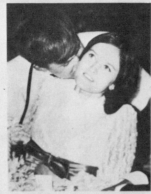

A new formal for the prom

Duanne kept up with her classmates. Even though, she couldn't lead cheers, her voice still urged on the football team. She directed a play.

She wore a new formal to the prom. She finished 12th in her class of 86 with a grade average of 92.49. Her parents proudly watched her graduate, but her father said, "You never fully accept it. You keep hoping—for a miracle . . ."

Continued

Admirable in this Sunday Magazine story was the editor's division of labor. The question of when to use words and how much play to give pictures recurs constantly in photojournalism. It is a wise editor who knows his own tools. Bill Strode's visual statements were strong and evocative. For eight uninterrupted pages they held center stage. The stage had been set by an introductory page of text. In an all-text finale, a writer's insights enriched Strode's images. A picture man and a word man each had his day; neither got in the other's way.

The Editor

To tease or not to tease: a pitch for the provocative opener

Concocters of TV drama do one thing surpassingly well: they hook the uncommitted viewer in a hurry. In the critical seconds before the commercial and the credits come on, they handcuff the dial-twirler and deliver him. Their bait: adroitly selected footage from action later on. It's a stratagem that print people might well adapt. The magazine parallel is the teaser page with a "stopper" photo and a come-on headline. A word of caution: unless the ingredients are provocative enough to halt the page-flipper in mid-flight or beguiling enough to lure him into the story, it's a waste of precious space. Conversely, if the teaser has what it takes to trap a reader and hold him, the editor squanders raw material by not exploiting it.

Charles Moore

What's a clerk from Ft. Wayne doing in a Sarawak jungle?

Ted Rozumalski

Who's the little swinger behind the barn?

Teasers occupy right-hand pages. They pose puzzles that must be quickly explained on subsequent spreads. In the examples shown here, the ex-clerk was a Peace Corps volunteer bringing 4-H to Borneo; the little swinger danced the hula in a barn-theater production of "South Pacific."

Covering flood-fighters along the Mississippi, the photographer saw whimsy in an ineffectual stop sign. To the editor, it was a stopper in more ways than one. Strong enough to stand alone as a right-hand opener, it was arresting enough to pique interest in the flood coverage that followed.

154

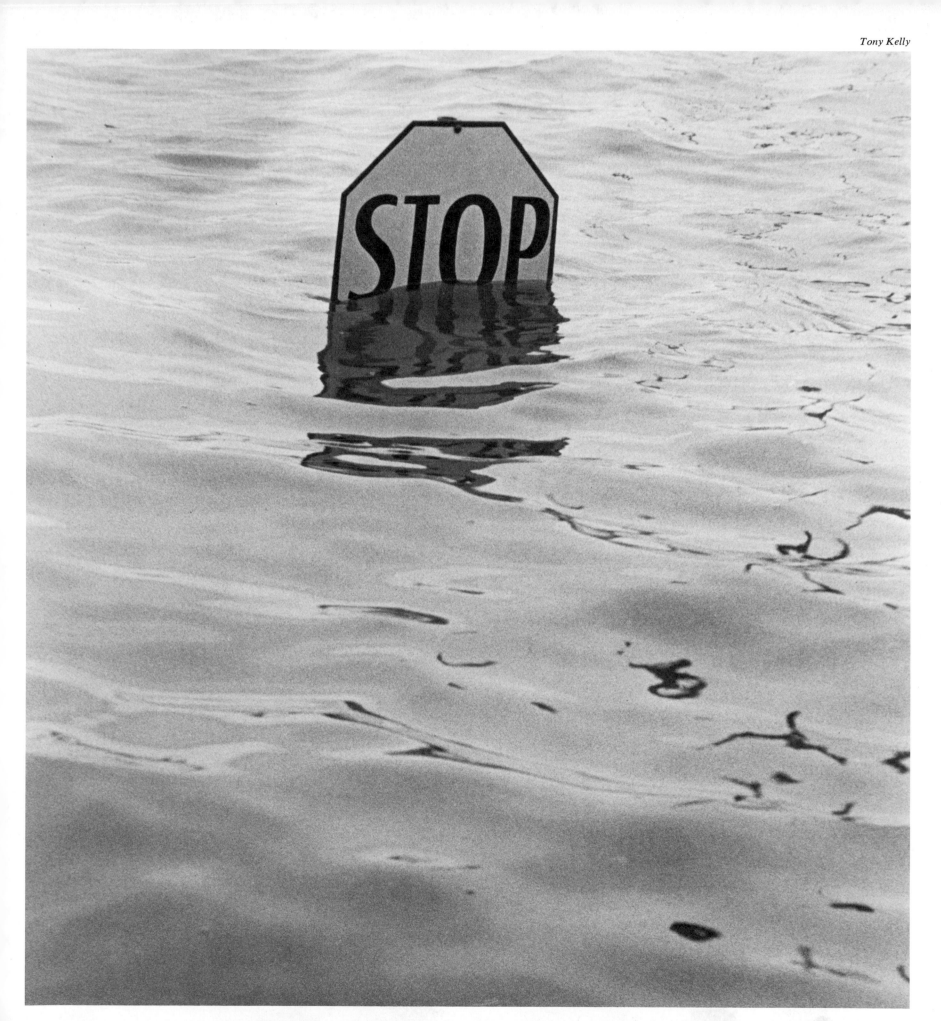

Behind three small symbols: a woman's concern for the men in her life

Industrial nurse

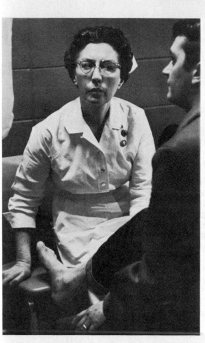

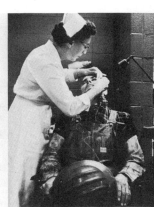

*attentive care
from head to foot*

TO THE MEN of Fort Wayne Works, Clara Simminger has many roles: head nurse in the medical department, trusted friend, counselor, and gracious lady whose talk, by turn, is gentle and blunt. She's a woman who says of her job: "You can't be company and you can't be union. You just have to be a person who's interested in people." And of the medical department: "Every morning when I come in this place I have a little feeling of pride." Part of a medical corps of 68 nurses and 48 doctors who provide all-shift care for employes at IH operations, Mrs. Simminger enjoys industrial nursing because "it gets you into every area of medicine there is."

As "family nurse" to Fort Wayne employes, her concern goes beyond repairing the damage when a wrench slips or a finger unexpectedly meets sheet metal. She will coax a man with a marital problem to see a reputable counselor, and urge the man with an emotional disturbance to seek aid at the proper community service agency. Over the years, International Harvester wives have learned they have an ally in Mrs. Simminger. Concerned for a husband's health, a wife will ask her to arrange an examination. Usually she urges, "Don't let him know I called." In such a conspiracy Mrs. Simminger often summons a group from the man's department, announcing that all are due for a physical. "We may pull in three or four to get one," she says. It's only natural that Mrs. Simminger understands and sympathizes with IH wives. She's one herself, married to Henry Simminger, of Parts Distribution Control.

SHARP ATTENTION of Fort Wayne Head Nurse Clara Simminger is focused on foot problem of David Goeltzenleuchter. On her uniform are IH 20-year service pin, circlets of Lutheran Hospital School of Nursing and American Association of Industrial Nurses.

LOOK UP, open wide. Under scrutiny: Melvin Houck's throat, Ben Markeske's eye.

FALLEN WARRIOR is William Lethwaite, machining and assembly foreman, resting after having injured hand bandaged. After accident or illness, employes must have regular checkups until recovery is complete.

With unconventional openers, even quiet stories can come on strong. To introduce a picture story on an industrial nurse, this editor selected a tight and telling closeup and gave it full-page treatment. Thirteen headline words reinforced the visual message: "Behind three small symbols: a woman's concern for the men in her life." Moving into the story proper, the editor remembered to do quickly one thing the opener failed to do: he gave the reader a good look at the story subject.

A word about the story's organization: in three days of shadowing the industrial nurse, photographer Declan Haun made nearly 1,100 exposures. From more than a thousand frames, the editor selected three pictures to document a single, simple point: "attentive care from head to foot." On the next spread, emphasis moved to hands: hands for healing; hands for paperwork. The final two pages dealt with two emergencies: "suture for a scalp" on the left; "concern for a coronary" on the right.

This matter of page organization cannot be overemphasized. The editor must be forever aware of the need for a visual story line. Given a set of *facts,* the editor will arrange, rearrange, find his theme, hit on a lead and off he goes. Give the same editor a set of *pictures* and his wits desert him. The man who sifts facts so meticulously becomes an aimless juggler of 8x10s. But he will never communicate fully until he insists that the pictures on his pages be as coherent as well-composed sentences.

Emphasis moves to hands

Industrial nurse

hands for healing a hurt;
eyes for preventing another

LOOKING AT A MAN over his cut finger, her smile takes some of the sting out of the iodine. By the time Mrs. Simminger has the bandage on, her patient may muster up a joke: "Gee, that's a first class job. But it'll never fit in a bowling ball." Part of Mrs. Simminger's time is spent trying to reduce the number of cut fingers — and more serious injuries — that occur in the plant. Working closely with Safety Director N. D. Schepelmann, she makes regular tours of work areas to check health and safety factors. Also on her schedule: work on the hearing conservation program of fitting men with ear plugs in heavy noise areas; monthly inspection of food handling areas, and visits to the Certified Handicapped Group where employes with disabling injuries work.

A disabling condition that concerns Mrs. Simminger intensely originates not in the plant, but in a bottle. When she learns a man is in danger of suspension because of excessive drinking, she summons him for a confidential talk. "I let them have it cold turkey," she says. "There's no point in beating around the bush." She gives him literature from Alcoholics Anonymous, asks him to telephone when he's thought it over. Usually he calls from a bar. To his aid Mrs. Simminger sends a veteran of AA. Working together, they often help the man conquer his problem and save his job.

GRACEFUL, manicured hand holds a less graceful hand steady for gentle repair work.

RESTLESS hand poised on file card confirms Mrs. Simminger's statement that she would prefer more time with patients, less with paperwork.

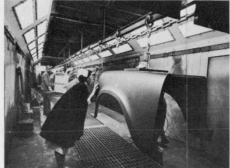

INVADING TERRITORY of paint shop employe (cap), nurse checks effectiveness of down draft in clearing work area of fumes.

WHITE UNIFORM and blue cape are bright note in plant. Her quips brighten day for Warren Fager, Lloyd Ramel and Wilf Wolfe.

6 / 7

Two pages, two emergencies

Industrial nurse *suture for a scalp*

A NURSE was a welcome sight to Don Leichty. He had just banged his head on an axle and was heading for the nearest of the five plant dispensaries. Mrs. Simminger, making one of her regular visits to the dispensaries, was on her way back to the main medical department when she met Leichty crossing the yard, holding his handkerchief to the wound. Her greeting and diagnosis: "Oh my, what have we got — a suture case." Patient in tow, she went back to the dispensary she had just left and helped Nurse Mary Ann Nuss administer first aid to Leichty's scalp. In contrast to young Leichty, other of Mrs. Simminger's patients are retirees from the plant. Through the years, they have come to consider IH doctors and nurses personal friends and continue to bring their cut fingers and illnesses to them rather than to an outside doctor. Says Mrs. Simminger, "They know they're welcome."

DOORSTEP EXAMINATION, fast first aid. Assembler Don Leichty cut head when he "came up too soon" under axle, had good fortune to encounter Nurse Simminger in yard.

COMFORTING heart patient, Mrs. Simminger sees James Williams into ambulance. With Nurse Wilda Blevins she watches vehicle leave for hospital.

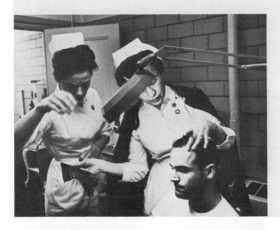

concern for coronary

AT FIRST, James Williams thought the pain in his chest would go away. But it only got worse. Finally, he left his work and went to the medical office. As soon as Mrs. Simminger heard his description of the chest pain she had him lie down, called for an ambulance. Waiting for it to come, he lay still, hardly moving a finger. Then the men came with a stretcher and Mrs. Simminger eased him onto it. Leaning close, she made reassuring small talk: "We're going to send a nurse along to hold your hand." She tucked blankets about him, placed a towel to shield his face from the snow. "The weather's awful out . . . It's changed quite a bit since you came in." She helped settle the stretcher in the ambulance, then stood watching as the vehicle pulled away. When a doctor telephoned the next morning to say that Williams was out of danger, Mrs. Simminger's face was as relieved as it had been anxious the day before.

9

Picture-handler's oath: "I will not mortise, tilt, mutilate, scallop, cookie-cut . . ."

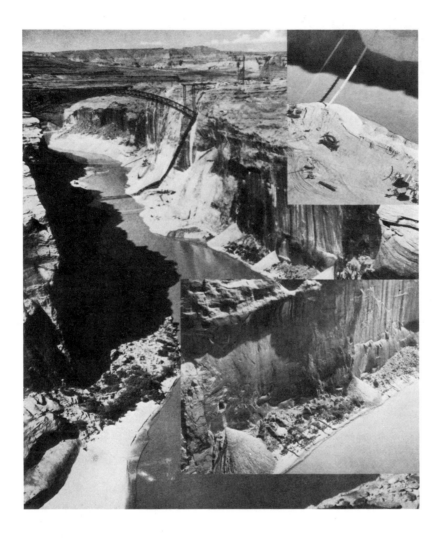

Whether or not he realizes it, the typical editor is partial to words. He works with words as he would with fine tools, choosing them with care, honing them, fussing over them. He professes the same high regard for pictures, but he fools nobody; his publication gives him away. If his respect for pictures were genuine, he would never put up with the abuses that mar his pages: the mortises, the blockouts, the insets, the many techniques of "design" that only despoil. His picture-handling is often archaic because he emulates other publications in his own field and because his contemporaries may be where *Life* and *Look* were in the 1930s. *Life* and *Look*, of course, never underestimated the incisive power of the photograph. But they did toy, in their infancies, with the tilted picture, the mortise, the cookie-cutter shape. They matured. As these examples painfully attest, not enough editors have learned the lesson. Every time he commits an act of photo mutilation the editor telegraphs his lack of understanding of what it takes to make pictures communicate.

Mutilated by a pair of mortises, canyon scene becomes a shambles. Even when less damaging, mortises are difficult to justify. Below left: superimposed clock only gets in way of picture, even blocks out skipper's face. Below: proper shape for pictures is the rectangle. Petal shapes betray lack of editorial taste.

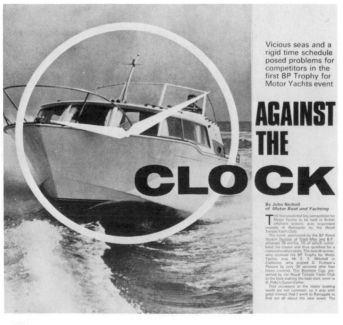

Shaping pictures to spell out headline spells ruin for the photography. Pictures become virtually impossible to read and headline word isn't legible, either.

Rectangular photo of expressway jam has built-in impact and provides its own emphasis. Is anything added by outlining an exclamation mark? What's the point?

Picture abuse: visual puns, trick screens

At mention of "worlds", globe shapes appear.

All too often, a reference to "wheels" leads to pictures-in-the-round.

One jarring practice that shouts "house organ" is the persistent use of the visual pun. The designer, presumably with the editor's consent, will latch onto a headline word and shape the pictures to fit. Thus "The Two Worlds of Gerald Butler" will lead predictably to two globe-shaped pictures, with Gerald barely visible among the meridians and parallels. At the mention of truck wheels and bowling balls, circles will appear as if by reflex. What happens to the balled-up pictures is of no apparent concern.

The balled-up pictures at right suffered a second indignity. They were roughed up at the engraver's. "Give me something different," an editor pleads. His graphics specialist responds with a trick screen and a fad is born. As other editors scramble aboard the bandwagon, "something different" quickly becomes a cliché. More to the point, the trick-screen technique rarely works. It seldom fits the editorial purpose and tends to get in the way of picture content. Strictly speaking, it is no longer photography but rather a tasteless imitation of the techniques of the artist.

Professionalism in photojournalism is best exemplified by:

 1—Straight photography

 2—A minimum of trickery in the darkroom, in layout and in reproduction.

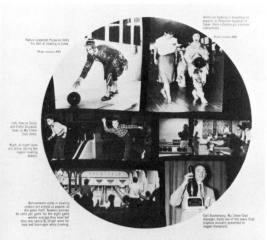

American bowling is becoming as popular as American baseball in Japan. Here a Geisha girl exhausts instructions.

32 MILLION WANT TO STRIKE
by Phil Meagher

TOURNAMENT
by BILLY SIXTY
The Milwaukee Journal

City Hall, Milwaukee, Wisconsin

The winner—Dave Davis

C. W. Miller, chief executive officer of Miller Brewing Company, presents $10,000 winner's check.

Balled-up bowling pictures shout "house organ." Cut-up pictures betray nonprofessionalism.

G. E. Jenks, retired utilities executive from Wyoming, talked with us about golf, gardening and poker.

The Sun City Rhythm Ramblers practice once a week and play at social functions.

The Sun City Square Dancers performed to "Up to Your Ears in Love." These couples convinced me they still are up to their ears in love.

Punning picture-handlers carve photos in shapes of bowling pins and musical notes but their pictures neither score nor sing.

". . . I have to do a lot of traveling . . ."

". . . our Ames promotional effort has met with great success . . ."

Editors employ trick screens with or without provocation. A reference to a marketing target prompted the concentric-circle screen in the reproduction on the opposite page. It missed the mark. The grain screen at left served only to fuzz the features of the interviewee. One professed reason for trick screens—and for techniques such as solarization, reticulation and posterizing—is "to lift pictures out of the ordinary." Example: "I used a 'cracked-oil' screen on the Easter tableau picture to give it the appearance of a painting." Photographs work best when they are reproduced as photographs. Beyond that, gimmickry with graphics will not disguise a bad picture. The instant the shutter clicks is the best time to lift a picture out of the ordinary.

Doing something about weather pictures, two editors take decidedly different tacks. Each editor tries to register the point that cloud-seeding can modify weather. Each interjects type in the picture area. But Editor A succeeds only in mutilating an excellent photograph. Like a gouge in the heart of an artist's canvas, his intrusive type panel is a variety of vandalism. He sets up a clash with a flash of lightning merely to get his type in. Editor B, meanwhile, employs type to shed light on the subject. A complex picture becomes meaningful with the deployment of labels and artwork. Normally, clarification of a photo is the caption's role. In this instance, there are too many elements in need of identification and explanation. With type, the picture communicates clearly, quickly. In the interest of legibility, the editor has reversed his type where background is dark. He has overprinted where picture area is light. With "They're burning hail out of the weather", he succeeded also in producing a headline that was both specific and engaging. His subhead: "For Hudson Valley fruit growers, the ugliest clouds have silver iodide linings."

The Weather:

doing something about it

FLAGSTAFF, ARIZ.

THE SAN FRANCISCO PEAKS, like a handful of stubby fingers, reach into cottony puffs of clouds above this mile-high city. On a summer day, observers can count on the white clouds to evolve into gloomy blacks and grays, streaked by fierce lightning. By late afternoon, though, the tumult drifts off into oblivion and an azure sky precedes a cloudless night.

Because this process is repeated day after day, the Flagstaff region has been the site of half a

THEY'RE BURNING HAIL OUT OF THE WEATHER

gentle rain—result of silver iodide generators

High cumulus thunderheads over Catskills. Radar has indicated heavy moisture cells.

silver iodide generator

ground generators located in mountains and around fringes of valley

propane fuel tank

silver iodide tank

As the professional editor knows, the technique that enhances one layout can cripple the next. This matter of type in pictures is a case in point. At left, the technique backfires. The editor had a strong picture of a pit crew. He had bright words to describe the action. But he loses both in a mishmash of white and off-white. Light tones in several areas of picture should have ruled out reverse type.

Reversing his type judiciously, this editor makes a good Hoffa picture better. Here are insolent words to arouse and challenge the reader. Legible against a dark background, the headline grabs rather than distracts. Prominent positioning heightens its impact. The most important consideration by far: type intrudes on no meaningful portion of the picture.

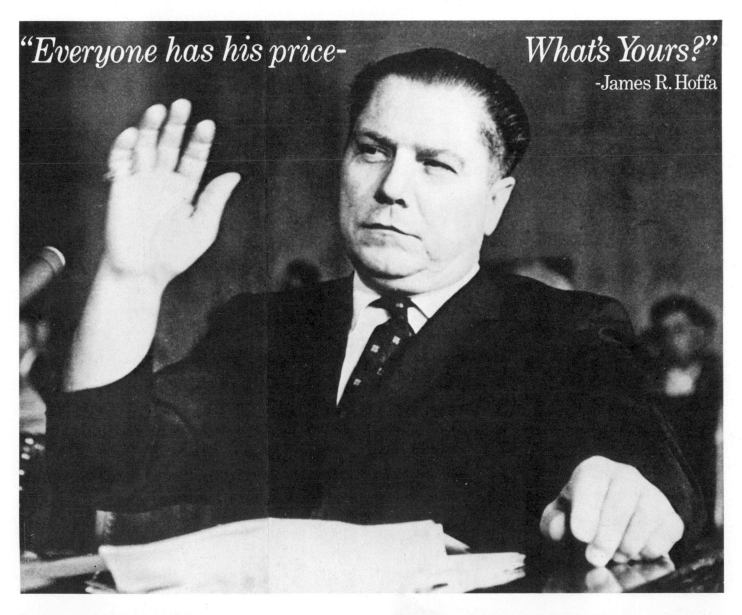

"Everyone has his price— What's Yours?"
-James R. Hoffa

Endless and ingenious are the devices with which an editor can mutilate his pictures. He vandalizes by cutting pictures into tiny squares. He bastardizes by mixing art and photography. The temptation to get cute and clever with pictures should be resolutely resisted. No editor would dream of instructing his compositor to pi his type. But he will often *pay* a layout artist to make a shambles of his photography! He won't play childish games with his prose. But he will permit the kind of picture nonsense perpetrated at left. He hasn't learned that chopped-up photographs are no better than scrambled sentences. Four scenes were squandered here to produce a hodgepodge. This is a classic case of overdesign, a malady shared by many high-budget publications. Pictures are used not as pictures but as decorative elements. The best picture-handlers

are purists. The best approaches are simple and straightforward. The safest rules are these:

If a picture is bad, it shouldn't be used.

If a picture is good, it should be given unimpaired display.

There is no point, really, in messing around.

Drawings and photographs do not mate well. The safest policy is to avoid mixing them. Alone, each medium can communicate effectively. Together they tend to get in each other's way. When drawing and photo try to say the same thing, they compete rather than complement. Two more techniques to avoid are the mortising and the tilting of pictures. To mortise is to mutilate. The tilted photo is passé, even in the family album.

Say man, what's with this marketing bag? What's this new scene at NI-Gas? I mean, like, the charts read a different tune.

Well, the tune you now read is one of harmony . . . one of a well-researched and well-organized organization . . . one in which all parts of the scene make up the whole "bag." Translation:

What is the new marketing concept at Northern Illinois Gas Company? It's not the same as before and what's the difference between marketing and just selling?

NI-Gas is now working together as one unit . . . one entity. Goal: To serve the customer most effectively and to make a profit.

In July of last year NI-Gas began a task that restructured and changed the sales philosophy of the gas utility. It formed a marketing organization. This organization is structured under the direction of Joe Gauthier, President. The marketing bag is under his umbrella.

Marketing, at NI-Gas, is part of the broader field of economics. It involves all of the activities which, in final analysis, result in the selling of natural gas. This means that every department and every individual at NI-Gas from Construction, Maintenance and Accounting to Customer Service, is in the marketing bag.

Marketing came of age because we live in a buyers' market. Service

is the name of the game. Doing a better job of satisfying the customer's material wants and needs: that's the bag. Marketing includes everything which directs the flow of goods and services from maker or supplier to user. Selling and advertising are a few of its parts. The entire bag contains advertising, selling, and a host of goodies such as determining the product line, product improvement, pricing (rates), packaging, market research, product promotion and profit. Quite a bagful.

Marketing is an umbrella that covers numerous related jobs, responsibilities which, at one time, were considered separate and on different tracks.

Marketing at NI-Gas is divided into three areas: Marketing Plans and Services, Marketing Implementation, and Corporate Development.

The marketing plans and services area gives the company direction in the selling of natural gas and provides technical assistance in the implementation of this selling activity. Marketing plans and services is the nucleus of the marketing bag. This is the area that segments our total market and determines the problems existing in a particular market (for example the residential gaslite and grill market), the opportunities that exist in that market, and the objectives which should be sensibly achieved

in that market. It then provides technical support in those areas.

Implementation, under the guidance of George Habenicht, Senior Vice President-Marketing, starts at the time the Market Planners are developing their plans for a particular market segment. Agreement must be reached with the Market Planners on what realistic, pertinent, challenging goals should be set for the next planning period. The market plan must be put into action and all the jobs necessary to accomplish this plan must be coordinated effectively. According to Habenicht, "It is the job of the implementer to see that NI-Gas attains all the goals in a market plan —to do this we depend upon measurement of plan performance and then consider corrective action, if necessary. The implementer must also see that the expenses are held within the budget plan . . ."

Habenicht says that, "For a company such as NI-Gas to grow and develop in the marketing sense, people must grow and develop in their jobs. Thus, while I am concerned with the implementation of the market plans, I am also concerned with the development of people . . . that is a major part of my job."

Corporate Development is a specialty area of the marketing function, according to Jim Diekmann, Vice President-Corporate Development. "In this area NI-Gas is con-

MARKETING/IT'S OUR BAG

The team most likely to achieve a happy blend of words and pictures consists of an editor who thinks visually and a photographer who thinks editorially. Each will respect the professionalism of the other. If words and pictures are to be equal partners, the same should be true of the men behind them. But not all editors have gotten the word. Some editors, blind to the shortcomings of their pages, are unable to perceive how much spark and sparkle the talented freelancer might supply. Other editors throw money away by using freelance photographers badly. In the interest of getting the most for each dollar he spends, the editor might consider a few do's and don'ts:

Do make sure, before handing out an assignment, that the story subject is a valid one, that visual possibilities truly exist. When assignments misfire, it is due usually to subject-failure, not photographer-failure. The editor had not done his homework; the situation or subject was not as represented.

Do brief the photographer thoroughly. He needs to know not only the broad outline of the story but many of the specifics. At the very least, he will need to know whether specialized equipment might be required. A camera with motor-drive, for example.

Do give the photographer freedom of expression.

Do not issue a series of directives: shoot this; shoot that. The publication photographer does not work the way a punchpress operator works. He is hired and compensated for his ability to conceive as well as to execute.

Do not, if accompanying photographer on assignment, introduce him as "my photographer" or "my cameraman." The editor-photographer relationship is not a father-son relationship; there is no pecking order. The relationship should be one of mutual aid, succor, support and comprehension.

Do not, out of deference to an important picture subject, make promises or assurances that are unrealistic. ("We know how busy you are, Mr. Executive, so we won't take but ten minutes of your time.") An editor who tends to be insecure should let the photographer make the approach; freelancers are rarely awe-struck.

Do run interference if necessary. When a pest gets in the way of the photography, take him out of the play by "interviewing" him.

Do stay out of camera range. Resist the urge to move in for quotes when photo action is hot and heavy. Facts can be gathered later; it is often now or never for pictures.

Do not burden the photographer with extraneous shooting. Let him concentrate wholly on the story at hand.

Do not place an arbitrary time limit on a photographer's coverage. Circumstances vary too widely from assignment to assignment. There may be occasions when the photographer will need to spend a day or more just making arrangements. This happens when research has been faulty and a natural story doesn't exist.

Do be prepared to pay the freelancer by the day, not by the picture. Day rates established by the American Society of Magazine Photographers usually apply. Most magazines are interested only in one-time publication rights. If the intention is to retain permanent possession of the negatives, say so—and be prepared to pay extra.

Do gamble occasionally on chancy assignments; the safer the assignment, the more predictable the pictures. Without surprises, the printed page soon palls.

Do ask for the photographer's opinion on picture choices. Sound him out on layout suggestions. His views need not prevail but they can open up exciting new approaches to picture-handling.

Do give the freelancer a chance to reshoot when his coverage is foiled by mechanical failure. Eager to make amends, most photographers will redo the job for expenses only.

Do pay freelancers promptly.

For his part, the freelancer could display more initiative. One way to break into print is to zero in on a likely publication and study it with care. Analyze its content and its target audience. Stay alert for story ideas that will serve the editor's purpose. Since sooner or later every editor is desperate for ideas, the idea-generating photographer will seldom lack for work.

If he is sharp, the photographer will continue to think like an editor as he does his shooting. He will be mindful always that his mission is to communicate, to make pictures for the printed page, not for the salon wall. He photographs for the story, not for his portfolio. And when his shooting is finished, there will be no gaps in the coverage, no holes to plague the editor at layout time.

If he is a real pro, the freelancer is not likely to gripe because the editor fails to show off his pet pictures to best advantage. More important is whether the *subject* has been shown off to best advantage.

If he hopes to work again for a knowledgeable editor, the freelancer will not substitute gimmickry for solid thinking. ("The subject was dull so I jazzed it up with fish-eye and distortion.")

If he feels that eccentric attire is an aid to his creativity, he'll be willing, when the occasion dictates, to make small concessions to convention. On assignment in a corporate boardroom, for example, he'll find he can function best if his garb is not conspicuous.

If he must make critically important setup pictures, in boardrooms or elsewhere, he will use stand-ins for dry runs. He will not ask corporate directors to wait while he fiddles interminably with lights and Polaroids.

If, when working alone, he wishes to multiply his effectiveness he will gather quotes on a portable tape recorder and provide the editor with tapes as well as film. Interviewing techniques vary. Some photographers use camera and recorder interchangeably, now one, now the other, back and forth. Others won't tape the first question until all the shooting is out of the way. A highly successful magazine freelancer explains why: "I find that when I photograph, I can't hear very well. My sensitivity is coming through my eyeballs. Instead of listening, I'm looking closely at a human being, looking at what he's revealing about himself. This becomes the basis of my inquiry. By the time I'm ready to interview him, we have established mutual respect. He's ready to unload his feelings. In most stories, there are really only six or seven questions you need to ask. But you explore these questions fully, asking them several times, several ways. That's how you get rich quotes, the really good stuff that makes a story memorable."

If he is to be truly effective, the freelancer must have human relations skills to match his camera skills. He will not get the cooperation he badly needs by pushing people around. He must be personable and professional in his approach.

Even if he is not encouraged to do so, the freelancer should indicate, on his set of contact proofs, his own picture preferences. With each mark of his grease pencil, he will say in effect: "Mr. Editor, please give this frame a second look."

This is the saddest paradox in photojournalism: so many dull pictures find their way into print; so many bright photographers find no editorial outlet for their work. Everybody loses, the reader most of all. The talented freelancer can make the editor look good, if only the editor is big enough to let him. Editors and photographers must work in concert, not in competition. Misunderstanding and misinterpretation must disappear. Before they can hope to communicate with anybody else, communicators must learn to communicate with each other.

There may be no better bargain in picture journalism than the services of a custom photo lab. The added amount he'll spend for quality prints is among the wisest investments an editor can make. Indeed no editor who cares at all about the look of his book would think of skimping at this stage of the production process.

A good lab can be invaluable not only for the commodity it sells but for the counsel it gives; not only for the care it takes with negatives but for the peace of mind it affords the editor.

There are photographers, of course, who prefer to do their own lab work and many of them print exceedingly well. It's one way of insuring that each enlargement captures the precise quality or mood the camera tried to catch. But long hours in the darkroom put no dollars in the photographer's pocket. The photographer—and more especially, the freelance photographer—is paid for shooting, not for burning and dodging. So more and more cameramen are staying behind their cameras and leaving the printing to custom labs.

Without question, the developing of film and the making of prints are often matters of interpretation. The only sure way to lead the lab technician to the right interpretation is to tell him what is expected: "This was shot in the rain; make it damp and depressing." "This is dusk, at the dark part of twilight. Don't print too brightly." "In first half of roll, the mood is more important than the subject's facial features. Let the face go in shadow." "Whatever you do, hold the detail in the face. The subject has to be recognizable." It gets back to the need for communicators to communicate. To put it figuratively, there's no point in keeping the darkroom man in the dark.

Generally speaking, it is not the professional cameraman who gives the photo lab fits. It's more likely to be the editor who doubles as photographer. He will not always compensate as he moves from indoor shooting to outdoor, either underexposing the one or overexposing the other. Developing by inspection, the lab technician will try to arrive at a happy medium but he will not be able to save extremes in exposure.

Compounding the problem, photographer-editors sometimes mix business and personal shooting on the same roll. The lab technician seeing two markedly different situations (and exposures) may work to save the wrong portion of the roll unless he is told specifically which half is important. It is impossible to furnish the lab too much information. For the editor totally in the dark as to what goes on there, a visit to a lab should be an early order of business. Following a roll of film from the moment the lab takes it in until it is processed and printed is the best way of grasping how much a lab can do and what it cannot do.

But even the editor who remains ignorant of lab processes should not hesitate to holler when he gets a print he doesn't like. One editor confides that he was too embarrassed to report a bad print because he didn't know what to *call* the problem! The lab in this instance had done a careless job of dodging. A remake would have been provided promptly, cheerfully and without charge, if only the lab had been apprised. Successful custom labs become successful because they care. When a print fails to measure up, they want to be told. Many times a little extra effort in the darkroom will eliminate the need for retouching.

Most custom labs are geared to give two-and-three-hour print service if necessary. And every editor in time of emergency will need to place a "super rush" order occasionally. But the editor who does so consistently may wind up without a lab. He will stir up resentment if he is overly demanding and if his every order is a crisis order. Moreover he will lose quality and pay a surcharge. Both are penalties for procrastination and poor organization of time.

Additional do's and don'ts for the editor:

Do study proofsheets with a good magnifying glass. It's one way of determining whether the frame being considered will print. If necessary for better legibility, order enlarged proofsheets.

One tip: if the pictures appear fuzzy, study the frame numbers. If the numbers are unsharp, so is the proofing. Order new contact sheets. If the numbers are sharp, the fuzziness is in the photography.

Do not instruct the lab to enlarge a small section of a 35-mm frame. Graininess will be excessive. Let the lab print the full frame 11x14 or 16x20. Crop the print. The area inside the crop marks should be at least as large as the area it will occupy on the printed page.

Do leave negatives at the lab if at all possible. Not only do most professional labs have good filing systems but they will store the negatives without charge. If your lab will not do so, change labs. If negatives must remain in your possession, develop respect for them. Protect them from fingerprints, scratches, dust and abrasions. Do not cut individual 35-mm negatives apart. Do not, under any circumstances, mark a negative to indicate cropping.

Do not expect professional results from amateur equipment. Low-price cameras, good enough for home use, won't do a job commercially. Do not blame the lab when inferior lenses fail to form superior images.

Do not let distance from a good lab be a deterrent. Custom labs, with few exceptions, tend to be concentrated in the largest cities. But the best of them will service clients in every state in the union. They will provide editors with free mailing bags for film. They will ship proofsheets and prints in sturdy boxes to protect against cracked corners. Day in and day out, first-class mail service is nearly as good as air mail; special delivery is a waste of money. The editor on a tight deadline should instruct the lab to ship by air express.

Do call on the lab for counsel. Develop a pleasant, productive relationship. The editor who needs help will be taken in hand. A lab that daily handles hundreds of rolls of film has encountered every problem imaginable. This expertise it will gladly share.

Do pay the lab promptly.

True or false? For best results in offset reproduction, furnish *flat* prints to the engraver. This is one myth that refuses to die. Whether his printing method is offset or letterpress, the editor in every instance should get a print that pleases him. The engraver's job is to try to achieve in the halftone the quality and contrast he sees in the print. The editor who asks for "more contrast" leaves the engraver guessing.

Within limitations, the engraver *can* add snap to a flat print. To a degree he can even comply with the editor's plea to "even up" flat and contrasty prints. But these things can be done more easily, more effectively and much more economically in the print-making stage. A remade halftone costs nearly ten times as much as a remade print.

Adjustments become more difficult at each successive stage of reproduction. If the photo lab has more leeway than the engraver, the engraver has more flexibility than the printer. To add ink to a bad halftone, once it is on the press, is to produce unwanted variations elsewhere on the form. The best way to print a sheet is with even ink coverage overall; good prints from the photo lab are a key to the good printed sheet.

But quality photo prints seem to be the exception, not the rule. An engraver explains: "Typically you get a packet of photographs, some bent and cracked, some glossy, some dull, some snapshots, some professional, all with different density ranges and no instructions from the editor except an occasional 'make it look good' or 'make this 2 ½ inches approx.' "

To further complicate life for engravers, some editors grease-pencil crop marks and instructions on the face of the photo, causing smudges of red to adhere to the cameraman's glass. Others carefully turn pictures over to put crop marks on the back, only to "emboss" the photos by pressing too hard with pen or pencil.

A procedure strongly recommended: mount each print on light cardboard. Indicate cropping and other instructions on the board, never on the photo itself. Once he suspects there may be problems with a print, the editor should forestall trouble by calling his engraver in. A close working relationship is vital. The engraver needs to know the kinds of things that are esthetically important to the editor; the editor needs to know the technical possibilities. Engravers and printers are more than vendors or suppliers. Properly used, they become extensions of the editor's staff.

Offset or letterpress? A number of factors should be considered, including the nature of the publication and the length of the run. Esthetically, each method has its adherents. Letterpress printers are able to achieve a rich effect by putting a lot of ink down. But on comparable paper stock, good offset printers can achieve comparable results. Generally speaking, offset is more appropriate for publications primarily photographic. Offset halftones are less expensive and accommodate longer press runs. Offset screens are finer, which means less compromise where contrast is concerned. The finer the screen, the easier it is to print a smaller highlight and a fuller shadow. This is what contrast is all about.

There are screens and there are screens. Example: the trade magazine editor who reproduces pictures of machinery and hardware will get snap and detail if the engraver uses a screen with a conventional dot. The editor, more concerned with faces and fleshtones, may be happier with the elliptical dot. It permits more smoothness in the critical middle tones. The editor hand-in-glove with his engraver is in the best position to pick up tips like these.

In offset reproduction most of the time and in letterpress some of the time, engraver and printer are one and the same. When they are not, it is imperative that the engraver be fully apprised of the way his halftones are to be printed. Is the press sheet-fed or is it web? Is 150-line screen run-of-the-mill for the printer or is he more comfortable with 133?

The printer's capabilities may also affect the choice of paper. While nothing prints a halftone better than enamel, some shops find enamel difficult to run. Still, smoothness of paper is far and away its most important property in printing; the rougher the sheet, the more distorted the dots. Beyond that, enamel has better ink hold-out. There is less absorption than with uncoated paper. Two other paper qualities are whiteness (of concern if reproduction is four-color) and brightness (the extent to which candlepower reflects off the sheet.) Bright sheets—whether enamel or uncoated—will print more contrast. Overall, the most felicitous paper may be dull-coated enamel, with a matte instead of a glossy finish. The ink shines but the paper doesn't; the dots seem to sit better and the type is easier to read.

More do's and don'ts for the editor:

Do provide the engraver with prints of consistent tone and contrast.

Do provide prints comparable in size to the size of reproduction. Actual size is the best size. Next best is oversize. Extreme undersize is the worst. The greatly enlarged reproduction is the most common cause of disappointment.

Do provide smooth-surface prints. Textured surfaces present problems.

Do not have prints in view when inspecting engraving proofs. Even the best proofs will disappoint when compared to rich black-and-white prints. Let the proofs stand on their own. When a proof is questionable, go back to the print. Solicit the engraver's judgment as to whether better reproduction is possible.

Do make sure if publication is offset that repro proofs of type are clean and even. Every flaw in the proofs will be picked up and exaggerated by the engraver's camera.

Do rely on the printer for dollar-stretching advice. Example: the editor who uses a second color on his front cover only may be passing up free color on as many as 15 other pages.

Do not risk misunderstanding by using technical jargon that may be inappropriate.

Do pick engravers and printers intelligently. Do make your expectations clear. Do give them every opportunity to produce. Do continue to care about quality. Do communicate.

THE DESIGNER IN THE PICTURE

Clarification,
unity,
cohesion,
esthetics,
are his responsibilities

At layout time, too many editors become abdicators. Having no convictions as to the visual forms their stories might take, they take the easy way out. They dump a mass of material in the lap of a layout man or designer and surrender all further responsibility. Badly needed at layout time is the same close relationship between editor and designer as should exist earlier between editor and photographer. But even before the designer enters the picture, the editor should have a visual product in mind, with photos selected accordingly. Editor and designer should agree on cropping, thus establishing the essential shapes of pictures. Together they should establish priorities: the relative size and importance of pictures; the order in which they will appear. With the story line agreed on, the designer's job is to articulate it: to solidify and refine; to contribute the esthetic qualities helpful in getting the story across. Cohesion should be one of the designer's prime objectives. He will achieve cohesion if he considers all of the elements —heads, pictures, text—as a single problem. He will regard each element as a story-telling device. In the interests of clarity and readability, he will bring type and photographs together in a tightly knit arrangement, integrating the gray area of the text with the rectangular shapes of the pictures, allowing the surrounding white space to achieve additional impact. He will permit the shapes of the pictures to dictate their arrangement on the pages. He will not try to squeeze them into an arbitrary layout. Indeed he will follow no arbitrary rules. He must follow the dictates of his own taste and experience, relying on his own judgment of weight and color and design. The designer will trim nonessential elements so that the message is clearly and forcefully presented.

The designer

The basic format: geometry and

the overall look

The good designer seeks a sense of unity for his pages while avoiding the pitfall of mechanical sameness. Paradoxically, he can achieve freedom and flow through the rigid discipline of geometry. Rather than a straitjacket, he has an architectural form into which he can drop his problems. On a heavy board he will indicate reference points and establish basic proportions for the single page and the two-page spread. If his page size is 8½ by 11, for example, he might use the 8½-inch square as a key unit. It becomes the basic proportion he can follow throughout the publication. His column will be 8½ inches deep. White area above the columns will permit consistent positioning of headlines and running heads. Along the diagonal of his square, the designer will indicate important intervals and useful shapes—including the square of the half page. This geometric framework will sometimes suggest ideal picture placement although it need not tie him down esthetically. His squares and reference points are essentially guides and reminders. The more he thinks about them, the more unity his pages will achieve. By placing translucent layout sheets over his underlay, the designer will be spared the trouble of measuring everything every time. If his publication has two different column widths—and it should never have more than two—the measure for each will be indicated. For unity's sake, the designer will maintain standard spacings—between photos, between columns, between photos and text. He will also maintain enough distance between himself and the drawing board so that he sees the total publication. Magazine spreads should contrast and complement. The challenge is to produce variety in layout while retaining the family resemblance that can give character to a publication. Study the thumbnails at right to see how these objectives were attained in 24-page magazine.

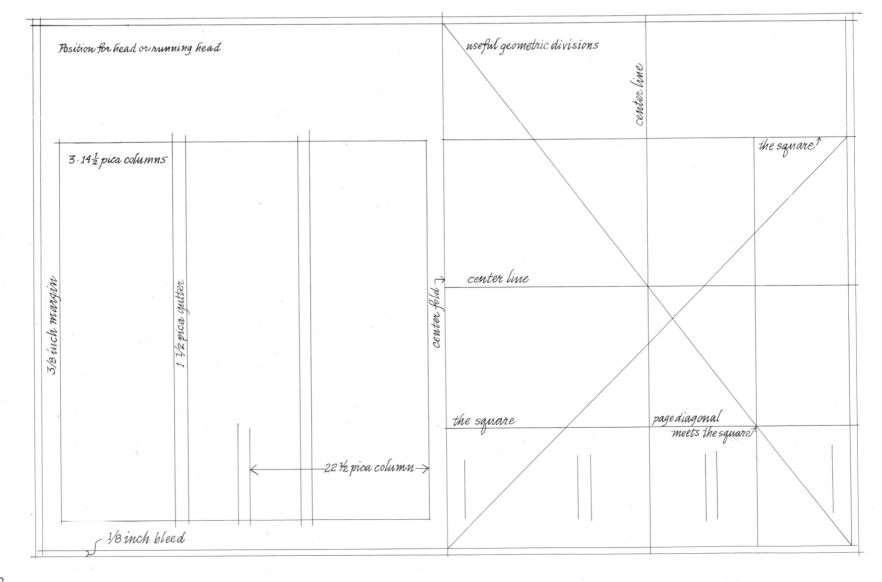

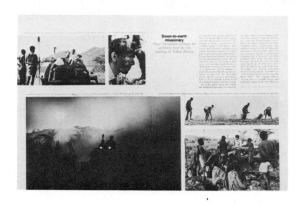
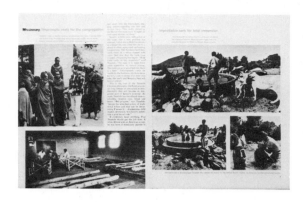

Dust-caked face on cover belongs to bulldozing missionary on first spread. Opening photo bleeds so spread will be read left to right. Strong night scene dominates.

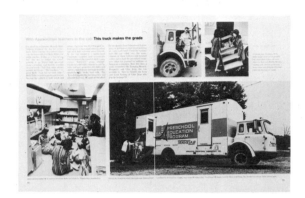

With missionary story ending on left-hand page, designer scales down photos to give more emphasis to right-hand opener. Full vertical and type over color help.

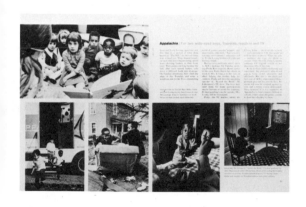
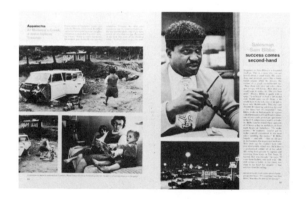
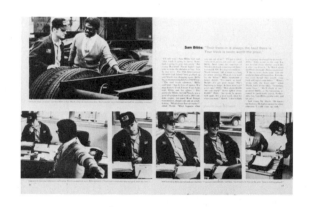

After horizontal layout on Appalachia, another left-page closer. Enlarged gutter separates stories. Large portrait in opener is balanced by smaller views above.

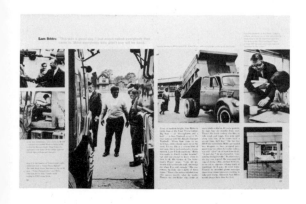
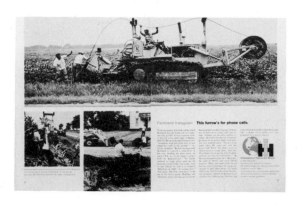
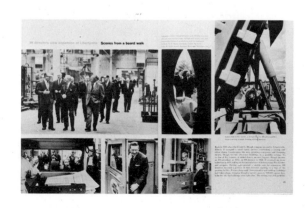

No single line of emphasis goes all the way across. Weight moves up and down from spread to spread, from the center to the top to the bottom of the pages.

The Designer

Body type: faces that work with pictures

Like vintage wines, type faces have personality traits that approach the human. Where one face reflects vigor, another exudes friendliness. Trying to establish the character of a publication, the designer will bear these traits in mind. Which face best suits his purpose? The pleasant Garamond . . . or the rigid and primly modern Helvetica? If the publication has a picture format, he would be well advised to choose a type that will hold itself back on the page. No designer would pick, as an example, a face as bold as 10-point Helvetica Medium for the text in a picture magazine. When the type itself sets up vibrations, the impact of the photographs will diminish.

Fortunately, there is no shortage of classic faces that can work well with pictures. Each has qualities to recommend it.

Baskerville: light, legible and pleasant. Bodoni: prim but beautiful; spare and legible; holds good horizontal line. Caledonia: has vigor of design; size is large in relationship to its point size. Caslon: good if face is well-cut; especially beautiful in larger sizes. Garamond Old Style: light and friendly. Helvetica: one of the best of the sans serifs; contemporary. Times Roman: compact: designed for London *Times*, has close relationship to classic Roman alphabet.

Once he makes his selection, the designer should stay with the face for captions, perhaps dropping down to 8-point type on a 12-point base as opposed to 10-on-12 point for body copy. One thing to avoid—unless in a second color—is the bold-face caption. Eye competition is set up—and photographs have a hard time establishing their own emphasis—when captions are stronger, bolder than the text.

As body copy for this book, the designer selected Times Roman, a classic face based on Roman monumental letter-forms and adapted for modern editorial and advertising use. The designer standardized on two widths for columns: 25 picas and (see above) 17½ picas. Nearly all of the body copy was set in 10 point with two-point leading. The 12 examples of type faces shown at right are all recommended for use with pictures. They were set 12-on-14 point. Although too large for body copy, 12-point is useful in this instance because the character of each type face can be more readily discerned and the differences among them more clearly observed.

How is one to assess and evaluate a type face in terms of its esthetic design? Why do the pacemakers in the art of printing rave over a specific face of type? What do they see in it? *Good design is always practical design.* And what they see in a good type ABCDEFGHIJKLMNOPQR 1234567890

BASKERVILLE—2 pt. leaded 23 characters to 10 picas

How is one to assess and evaluate a type face in terms of its esthetic design? Why do the pacemakers in the art of printing rave over a specific face of type? What do they see in it? Why is it so superlatively pleasant to their eyes? *Good design is always practical design.* ABCDEFGHIJKLMNOPQRST 1234567890

BODONI BOOK—2 pt. leaded 25 characters to 10 picas

How is one to assess and evaluate a type face in terms of its esthetic design? Why do the pacemakers in the art of printing rave over a specific face of type? *Good design is always practical design.* What do they see in it? Why is it so superlatively ABCDEFGHIJKLMNOPQR 1234567890

CALEDONIA—2 pt. leaded 23 characters to 10 picas

How is one to assess and evaluate a type face in terms of its esthetic design? Why do the pacemakers in the art of printing rave over a specific face of type? *Good design is always practical design* What do they see in ABCDEFGHIJKLMNOPQRS 1234567890

CASLON No. 137—2 pt. leaded 24 characters to 10 picas

HOW IS ONE TO ASSESS and evaluate a type face in terms of its esthetic design? Why do the pacemakers in the art of printing rave over a specific face of type? *Good design is always practical design.* What do they see in it? Why is it so superlatively pleasant to their eyes? And what they
ABCDEFGHIJKLMNOPQRSTI 1234567890

GARAMOND OLD STYLE—2 pt. leaded 26 characters to 10 picas

How is one to assess and evaluate a type face in terms of its esthetic design? Why do the pacemakers in the art of printing rave over a specific face of type? What do they see in it? Why is it so superlatively
ABCDEFGHIJKLMNOPQ 1234567890

PALATINO—2 pt. leaded 2.2 characters per pica

How is one to assess and evaluate a type face in terms of its esthetic design? Why do the pacemakers in the art of printing rave over a specific face of type? *Good design is always practical design.* What do they see in it? Why
ABCDEFGHIJKLMNOPQ 1234567890

HELVETICA—2 pt. leaded 2.0 characters per pica

HOW IS ONE TO ASSESS and evaluate a type face in terms of its esthetic design? *Good design is always practical design.* Why do pacemakers in the art of printing rave over a specific face of type?
ABCDEFGHIJKLMNOPQ 1234567890

PRIMER—3 pt. leaded 21 characters to 10 picas

How is one to assess and evaluate a type face in terms of its esthetic design? Why do the pacemakers in the art of printing rave over a specific face of type? What do they see in it? Why is it so superlatively pleasant to their eyes? *Good design is al-*
ABCDEFGHIJKLMNOPQRS 1234567890

NEWS GOTHIC LIGHT—2 pt. leaded 23 characters to 10 picas

HOW IS ONE TO ASSESS and evaluate a type face in terms of its esthetic design? Why do the pacemakers in the art of printing rave over a specific face of type? *Good design is always practical design.* What do they see in it? Why is it so superlatively
ABCDEFGHIJKLMNOPQR 1234567890

TEXTYPE—2 pt. leaded 23 characters to 10 picas

How is one to assess and evaluate a type face in terms of its esthetic design? Why do the pacemakers in the art of printing rave over a specific face of type? What do they see in it? Why is it so superlatively pleasant to their eyes? *Good de-*
ABCDEFGHIJKLMNOPQRS 1234567890

OPTIMA*—2 pt. leaded 22 characters to 10 picas

HOW IS ONE TO ASSESS and evaluate a type face in terms of its esthetic design? Why do the pacemakers in the art of printing rave over a specific face of type? *Good design is always practical design.* What do they see in it? Why is it so superlatively pleasant to
ABCDEFGHIJKLMNOPQ 1234567890

TIMES ROMAN—2 pt. leaded 23 characters to 10 picas

Headline type: inference, emphasis, harmony

When it comes to determining the style and character of a publication, no type is as instrumental as the type selected for headings. The designer has a number of options here. He can mix a strong sans-serif head with a body of classic Roman. He can use the same style type for heads as for body, going simply to a larger size. There is no one "right" way. But the best way to achieve graphic unity is to follow one style throughout, changing it only for emphasis when the story warrants.

The classic Roman styles are standbys of the typographic designer. They express dignity, solidity, refinement. In all probability, they will be useful always. But the publication wishing to be more contemporary in tone would select a modern sans serif. The sans serifs have been designed for quick reading, for strength, for boldness, for a modern look that is trim and spare. The Germans and the Swiss were the first to develop this typographic style in which ornamentation and all extraneous elements were stripped away. Some gracefulness and elegance disappeared, too, but the message became important. The relationship between type and photographs became more dynamic.

One tip: when a designer selects the same face for both head and body, he would be well advised to isolate the head with white space. If his head is bold-face, he can bring it close to the text. As for sizes, the designer's intuition will serve him best. Depending on a headline's length, 18-point is usually large enough. Indeed, when centered in white space, even a 10-point head can speak with authority.

For headings on this and all other text pages, the designer selected 11-point Times Roman italic, only one size larger than the body type. He used no mechanical means, except positioning, to emphasize the heads.

For a look at Helvetica at work, turn to one of the divider pages in this book and study the headline arrangement. The main head on each divider page gets bold display in 14-point Helvetica. The subhead is set in lower case with centered lines. A modern face, Helvetica contrasts dramatically with the serif type in which the text is set. Body type on the divider pages is Times Roman, set this time in 11-point with two-point leading.

Isolate to emphasize

BIG
to dominate

NOVA AUGUSTEA
ABCDEFGHIJKLMNOPQRSI
abcdefghijklmnopqrstr|12345

COLUMNA OPEN
ABCDEFGHJKLMNI2345

MICHELANGELO
ABCDEFGHIJKLMNOP|12345

PALATINO
ABCDEFGHIJKLMNOPQRSTUVW
abcdefghijklmnopqrstuvwxyz|12345

SISTINA
ABCDEFGHIJKLMNOP | 12345

TIMES ROMAN
ABCDEFGHIJKLMNOPQRSTUVW
abcdefghijklmnopqrstuvwxyz | 132456

WEISS ROMAN
ABCDEFGHIJKLMNOPQRSTUVWXY
abcdefghijklmnopqrstuvwxyz | 12345678

ALTERNATE GOTHIC No. 3
ABCDEFGHIJKLMNOPQRSTUVWXYZABCD
abcdefghijklmnopqrstuvwxyz | 1234567

AURORA CONDENSED
ABCDEFGHIJKLMNOPQRSTUVWXYZABCDEFGHIJK
abcdefghijklmnopqrstuvwxyzabc | 1234567890

FRANKLIN GOTHIC
ABCDEFGHIJKLMNOPQRST
abcdefghijklmnopqrs | 12345

FUTURA ULTRA BOLD
ABCDEFGHIJKLMNOPQRSTUVWS
abcdefghijklmnopqrstuv | 12345

NEWS GOTHIC
ABCDEFGHIJKLMNOPQRSTUVWX
abcdefghijklmnopqrstuvwx|12345

UNIVERS 65—DEMIBOLD
ABCDEFGHIJKLMNOPQRSTUVG
abcdefghijklmnopqrstuvw | 12345

VENUS MEDIUM
ABCDEFGHIJKLMNOPQRSTUVWX
abcdefghijklmnopqrstuvwxyz|123456

VENUS BOLD
ABCDEFGHIJKLMNOPQRSTUVW
abcdefghijklmnopqrstuvwx | 12345

VENUS EXTRA BOLD CONDENSED
ABCDEFGHIJKLMNOPQRSTUVWXYZABCDEFGHI
abcdefghijklmnopqrstuvwxyzabc | 1234567890

WHEDONS GOTHIC OUTLINE
ABCDEFGHIJKLMNOPQRSTUVWXY
abcdefghijklmnopqrstuv | 12345

The designer

Headline type: graphic, symbolic, exotic

Like garments, some type faces are serviceable day in and day out. Others should be reserved for very special occasions. Used intelligently—which is to say sparingly—exotic type faces can be highly effective. They can establish atmosphere. They can grab attention. At times, they can make graphic statements that are beyond the scope of conventional type. Indeed, when the letters are particularly ornate, they can make statements that are almost pictorial.

So it is with "The Land", the heading shown on the opposite page. Seeking something symbolic for a collection of drawings of farm and countryside, the designer found a Victorian hand-lettered type with the rustic charm he wanted. Wisely, he used it frugally: two short words; seven letters in all.

Even a single letter is sometimes sufficient, as in the case of the Medieval "D" at right. Besides being decorative, it functions as a bull's-eye and it becomes the dominant cover element in a bank booklet on trusts.

Served in small helpings and not as a normal diet, scripts and shaded letters can provide symbolism, also. "Balthus" (opposite page) is set in Thorne-shaded type to express the three-dimensional quality of this French painter's work.

All of the type examples shown at right are esthetically strong. They have character and are well-designed. They can bring interesting variety to the publication page. Even though infrequently used, they should be a part of the young designer's vocabulary of material.

CLOISTER BLACK

ABCDEFGHIJKLMNOPQ
abcdefghijklmnopqrstuvwxy 12345

FRAKTUR

ABCDEFGHJKLMNOS
abcdefghijklmnopqrst 12345

FREEHAND

ABCDEFGHIJKLMNOPQRSTUVW
abcdefghijklmnopqrstuvwxyz | 1234567890

SOLEMNIS

ABCDEFGHIJKLMNO12345

WEDDING TEXT

ABCDEFGHIJKLMNOPQRST
abcdefghijklmnopqrstuvwxyzabcdefg | 12345

THE DECLARATION OF TRUST

THE NORTHERN TRUST COMPANY

ULTRA BODONI
ABCDEFGHIJKLMNOPQR
abcdefghijklmnopq | 12345

JIM CROW
ABCDEFGHIJK | 12345

FONTALES
ABCDEFGHI | 12345

ORNAMENTAL NO. 8—(CICERO)
ABCDEFGHIJKLM | 12345

LATIN BOLD CONDENSED
ABCDEFGHIJKLMNOPQRSJ
abcdefghijklmnopqrs | 12345

LATIN WIDE
ABCDEFGHIJKI
abcdefghij | 12345

PLAYBILL
ABCDEFGHIJKLMNOPQRSTUVW
abcdefghijklmnopqrstuvwx | 12345

ARISTON LIGHT
ABCDEFGHIJKLMNOPQRST
abcdefghijklmnopqrstuvwxyzabcde | 12345

BOND SCRIPT
ABCDEFGHIJKLMNOP
abcdefghijklmnopqrstuvwry | 12345

LEGEND
ABCDEFGHIJKLMNOPQRT
abcdefghijklmnopqrstuvwxyz | 1234567890

BALTHUS

AUGUSTEA INLINE
ABCDEFGHIJKLMN 12345

CHISEL
ABCDEFGHIJKLMNOPQRS
abcdefghijklmnopvr | 123456

THORNE SHADED
ABCDEFG | 12345

TRUMP GRAVURE
ABCDEFGHIJKI | 12345

The cover: to intrigue, to identify, to introduce

Every cover is a challenge. Whether on the newsstand—where it must fight every other cover for attention—or whether it graces the publication delivered free-of-charge, a cover must be functional in a number of ways. Whatever the publication, the cover must be a magnet involving the reader's interest. Its first job is to intrigue, to whet the appetite for an important story inside. The casual looker must be persuaded to turn the page. But also the cover, by means of distinctive design, must sustain the publication's identity. Even a publication issued as infrequently as four times a year will win instant recognition when its cover design is distinctive and consistent. In the case of the sponsored publication (see below), the publisher, too, deserves prominent billing.

Consider the old and new cover styles of the corporate magazine in question. Through the use of caps in the old logo, heavy emphasis was placed on "World." In the process of simplifying the format and arriving at a design both clean and modern, it seemed sensible to give the sponsoring company equal play. In the new style, "World" appears in black, "International Harvester" in color and, for better legibility, all of the type is set in the same size.

One problem with the old format was finding an area where the logo could be inserted without harming the photo. What was needed, in effect, was a picture with waste area. In its modern dress, the logo no longer interferes. The new format allows for tighter, better composed photos. But since very few photos are cover candidates, the cover is always a challenge. To fill the bill, the cover picture must make its statement simply, clearly, quickly. It should relate to material inside. It should be symbolic, posterish and dramatic in value. Above all, it should intrigue.

Conspicuous trademark puts publisher first.

Names of sponsor and magazine get equal weight.

Without words, distinctive Lamp connotes oil firm.

When there are no ad pages to get in the way, the front cover should be a direct lead-in to the opening story. Displayed back-to-back, cover and story become integral, one supporting and reinforcing the other. As an introduction to Ansel Adams (above), the reader gets a strong middle-distance view of the photographer on the cover, a long view of the same scene on page 2 and a tight closeup on page 3. Repeating but not repeating, three views produce a three-dimensional effect. Imaginative cropping and sizing help launch the story.

The cover: table of contents

Perhaps because of the demands made on them, few magazine covers are esthetically strong. Particularly on general circulation magazines, contents must be showcased, the logo must pop out and the illustration must grab. All elements must jell but not encroach. In this *Look* cover they blend to a remarkable degree. The type face for the contents is clean and tasteful. Like the oval face of the girl, it is enhanced by the solid background. Down to the brass button on the lower right, the photo is tailored to the format. This is sound design. Covers of sponsored publi-cations will also double as tables of contents. But kept publications can afford to understate. In *The Northerner's* version, detail of old bronze door, employes and roll of computer tape stood for stories on bank traditions, personal quality of banking and the future of banking.

Trying always to keep the cover photographic can be a trap. There are times when no picture in hand makes the right graphic statement. There is a place for both the design cover and the typographic cover in the picture-format magazine. There is a time for symbolism on the cover, whether in the form of artwork or stylized photography. An abstract design symbolizing Lake Michigan is apt for *Chicago* magazine. Pentagon shapes on red, white and blue hard-hats are most suitable for an issue of *Fortune* dealing with the industrial-military complex.

Each cover has good contemporary design. Except for varying degrees of bad taste in the use of type and color, most newsstand magazines tend to look alike. All seem to be yelling at the same pitch. Well-designed covers neither scream nor shout. Excellence has a voice of its own.

183

The Family of Man

The greatest photographic exhibition of all time — 503 pictures from 68 countries
created by Edward Steichen for the Museum of Modern Art

Prologue by Carl Sandburg

Words and Pictures

an introduction to photojournalism

Wilson Hicks

LIFE's former Executive Editor tells the story behind picture magazines and discusses the products of editors, writers, and photographers

CARL MYDANS
MORE THAN MEETS THE EYE

Humanity in all its various forms of heroism and infamy, pride and humility as seen by a great photographer — a responsive human being

PICTURE EDITING

PHOTOGRAPHY IS A LANGUAGE

The decisive Moment

Photographs by Henri Cartier-Bresson

STEICHEN

THE PICTURE HISTORY OF PHOTOGRAPHY
from the earliest beginnings to the present day
BY PETER POLLACK
revised and enlarged edition

PHOTOJOURNALISM

Pictures for magazines and newspapers

ARTHUR ROTHSTEIN

BEAUMONT NEWHALL

THE HISTORY OF PHOTOGRAPHY
from 1839 to the present day revised and enlarged edition

BASIC LIBRARY FOR THE PHOTOJOURNALIST

Leaders
in visual communication
recommend and comment on
books most valuable

On display at left are ten basic books recommended as "most valuable to aspiring photojournalists." They emerged as "top ten" in a recent revision and updating of a study made in 1964 by Fred K. Paine, then a graduate student at the University of Missouri School of Journalism. Purpose of the study was "to learn the opinions of leaders in the field about the most important books." In choosing the survey participants, Prof. Cliff Edom (faculty adviser) selected "important and successful, yet varied representatives of photojournalism"—23 photographers, editors, journalism professors and curators of photography. The study was valuable because it developed a bibliography that was more than an academic exercise. For the first time a potential reader could evaluate a book on the basis of who recommended it. Beyond that, each reply revealed something of the respondent's philosophy toward photojournalism. The books chosen were as varied as the personalities and the backgrounds of the participants. However, of the 110 books named, 16 titles received four or more votes and indicated the beginning of a consensus on basic books. Given the list of 16, the participants were invited in 1971 to add or delete titles to arrive at ten books that should be *basic background* for photojournalists. They were asked to assume (1) that the reader has a basic knowledge of photo techniques and (2) that the reader wants to learn to communicate through the medium of the printed page. Capsule critiques of the "basic 10" are included on the next two pages. On the pages that follow, the survey participants appear with their personal choices and comments.

Books cannot make a photojournalist or a picture editor out of a casual reader. While reading will never be a substitute for learning-by-doing, the right books can shortcut many of the pains of trial and error as well as sharpen taste, judgment and visual thinking. The problem is to sort out those most valuable from the hundreds of photography books available. These ten were chosen by an outstanding group of photographers, editors and journalism professors as *basic background* reading. While five of the books are now out of print and available only in libraries, searching them out will be rewarding. Each of the ten has significantly influenced picture thinking in journalism.

1

WORDS AND PICTURES by Wilson Hicks Harper & Bros., 1952

This is a landmark book in magazine photojournalism by the picture editor (1937–1945), then executive editor of *Life* magazine until 1950. Hicks stated: "I have concerned myself mainly with the techniques of photojournalism as *Life* applies them." The first section of the book has a trenchant analysis of essential differences between words and pictures and their interdependence in photojournalism. It should be must reading for anyone who wants to communicate with pictures.

"In journalistic print, the first-hand account which comes closest to the actuality of an event is the picture story; good headlines plus good photographs, plus good captions."—Wilson Hicks.

2

THE FAMILY OF MAN (Record of the photographic exhibit created by Edward Steichen for the Museum of Modern Art.) Simon & Schuster; Maco (paper), 1955

This monumental exhibit was the product of the biggest picture-editing project in history. More than two million pictures were screened to 10,000. Finally chosen were 503 photographs made in 68 countries by 273 photographers. Steichen wanted to make the positive visual statement that, wherever in the world you find them, people are very much alike. He found his theme, "the family of man," in a Lincoln speech. The pictures are organized around the basic experiences of all people from birth to death. Drawing heavily on magazine photojournalists and documentary photographers, Steichen and his assistant, Wayne Miller, chose pictures for their story-telling content as much as for their artistic merit. The result is picture editing at its best.

"The exhibition . . . demonstrates that the art of photography is a dynamic process of giving form to ideas and of explaining man to man." —Edward Steichen

3

PICTURE EDITING by Stanley E. Kalish and Clifton C. Edom
Rinehart, 1951

This book was a trailblazer in organizing the basic principles behind "the most nebulous of editorial techniques"—the handling of pictures in newspapers. "Part One: Pictures and Picture Editing" states the case for their importance and analyzes picture "sense," judgment, ideas, and policy. Readers today will find this section most valuable. "Part Two: The Picture Editor at Work" deals with specific techniques (some of which are outdated)—picture handling, words for pictures, layout, the picture page.

"The key to successful picture editing is the feeling for pictures . . . a person who is going to edit pictures successfully must live pictures, must sense pictures, must interpret every experience in the light of the picture it suggests."—Kalish and Edom

4

PHOTOJOURNALISM by Arthur Rothstein.
Revised 2nd edition, Chilton, 1965

Subtitled "Pictures for Magazines and Newspapers," it is a contemporary survey of the field. Differences between newspapers and magazines complicate Rothstein's discussion of them simultaneously. News and feature photographs, the photo sequence, and picture story are more sharply delineated than are the roles of the picture editor and the art director. Understandably, the book draws heavily on Rothstein's experience at *Look* magazine and emphasizes that publication's approach to photojournalism. The illustrations are effective.

"The reporting camera does what no other medium can do. It opens up new vistas and bares the relations of people to their environments with unequalled precision"—Arthur Rothstein

5

THE DECISIVE MOMENT by Henri Cartier-Bresson.
Simon & Schuster, 1952

In a title as famous as his work, Cartier-Bresson sums up his approach to photography. This superbly printed book with its Henri Matisse cover became a collector's item soon after publication. Its 126 prints are reproduced on 11 x 14½-inch paper in three sizes: half page, full page, or double-page spread. In a concise, straightforward introduction Cartier-Bresson explains his guiding principles. THE WORLD OF CARTIER-BRESSON, Viking Press, 1968, is essentially a revision of the earlier book and is more readily available.

"Of all the means of expression, photography is the only one that fixes forever the precise and transitory instant."—Henri Cartier-Bresson

6

PHOTOGRAPY IS A LANGUAGE by John R. Whiting.
Ziff-Davis, 1946

This early work succinctly analyzes the photographic and editorial thinking that is needed to produce the picture story. The book itself is an excellent example of photojournalism. The pictures are tied closely to the text while words add meaning to the pictures. It is a vintage book that has aged well.

". . . Pictures, plus related facts, plus visual presentation constitute the language of photography."—John R. Whiting

7

MORE THAN MEETS THE EYE by Carl Mydans.
Harper & Bros., 1959

In a loosely chronological series of vignettes, Carl Mydans re-creates the visual images of memory that surround those created by his camera. A book without a single picture, it begins about the time the first issue of *Life* magazine was going to press and ends in Korea in 1951. Mydans writes: "For me the memories of the decisive actions I have covered and the world leaders I have photographed have dimmed. Instead I see sharp images and hear clear sounds coming back, over the years, of ordinary souls caught in the convulsions of war and war's aftermath." His insight and sensitivity come through in a clean, vivid prose style that marks him as one of the finest writers in photojournalism.

" In black silhouette the town was moving: a mass of passing, flickering cigarette ends, of almost indiscernable figures lumbering under heavy packs . . . like a showing of endless footage of underexposed film."—Carl Mydans

8

THE PICTURE HISTORY OF PHOTOGRAPHY by Peter Pollack.
Harry N. Abrams, 1969

This is a major revision and expansion of an exciting book that in 1958 sold out its first printing in a month. It is less a formal history than a pageant of 742 notable photographs "from the earliest beginnings to the present day." About a third of the book is devoted to "Postwar Trends" in which 19 new sections profile the accomplishments of individual photographers, some of whom Pollack chose not to include in his first edition. W. Eugene Smith, for example, is now represented in 14 pages that he himself laid out and captioned.

"The most important use of photography was in communication. . . . Photography has become as important as the word—perhaps more important as all linguistic barriers fell before this 'picture talk'."—Peter Pollack

9

THE HISTORY OF PHOTOGRAPHY by Beaumont Newhall.
Museum of Modern Art, Doubleday, 1964

Here is a book that has grown and improved through four editions to become a standard reference work. Newhall's writing is accurate, straightforward and easy to read. Of special interest to the photojournalist are chapters titled Straight Photography, Documentary, Instant Vision, For the Printed Page. The book closes with a perceptive summation of recent trends. The weakness in his selection of pictures to represent publication photography is the heavy emphasis on portrait types. Only four pictures in this chapter are as recent as the 1950's.

"The greatest challenge to the photographer is to express the inner significance through the outward form."—Beaumont Newhall

10

A LIFE IN PHOTOGRAPHY by Edward Steichen.
Doubleday, 1963

Here is a summation of 69 years in nearly all phases of photography by a man who often led its rapid development. The 234 illustrations parallel the text which is divided into 15 sections. His candor holds reader interest, and his modesty is refreshing. It is a life worth knowing.

"Photography is a medium of formidable contradictions. It is both ridiculously easy and almost impossibly difficult."—Edward Steichen

Harold Blumenfeld

Harold Blumenfeld

A newsman for more than 40 years, Harold Blumenfeld has long crusaded for better pictures and better picture use. A man with strong feelings about the power of pictures, he emphasizes: "Photos are not 'art' to be used merely to break up type areas in a page. Photography is another language that some newspaper editors have not learned to use properly." He adds: "Photographers are pretty darn good these days, but we need more and better picture editors."

Blumenfeld, a graduate of New York University, regarded himself as a "word man" until he became one of the founders of Acme Newspictures. He took up photography so he could talk the language of the cameramen on his staff. To encourage his people to get more dramatic, candid and honest pictures, he soon advocated the use of small roll-film cameras and varied focal-length lenses in their press photography.

Blumenfeld served as editor of Acme Newspictures until it was acquired by United Press International in 1952. He was Executive Newspictures Editor of

Note: All books recommended are listed alphabetically by author along with publisher and date at the end of this section.

UPI from 1957 to 1968 when he became Director of Special Projects. In this capacity he supervised the picture content of UPI's book publications, including the best seller, FOUR DAYS.

For a "lifetime of service to press photography," Harold Blumenfeld received in 1969 the Sprague Memorial Award, NPPA's highest honor. In retirement since January, 1971, he continues to "keep on writing and talking and helping with editing problems."

Blumenfeld: *"I really don't think you can teach anyone how to edit pictures by printing a set of ground rules in a book. One must feel, see and smell a good picture, and let the glands and imagination act up when editing for publication. Here are the books I recommend to the young visual communicator:"*

FOUR DAYS, edited by UPI.

"This is a complete photographic record of the four days from J.F.K.'s assassination to his burial. All are spot news pictures made with no stage directing or setting up. Here is a good marriage of words and pictures. Running text provides most of the caption material. The book is a good example of pictures in sequence telling a story."

W. EUGENE SMITH, HIS PHOTOGRAPHS AND NOTES. An Aperture Monograph.

"Smith is the true photojournalist, whose greatness still goes unrecognized. He has been a photographer for newspapers, magazines, industry—and a photographer for W. Eugene Smith. His photos, from simple to complex life including a war, are great studies of people backgrounded by events. Here is a good book for photojournalists to study."

AMERICAN ALBUM—HOW WE LOOKED AND LIVED IN A VANISHED U.S.A. Rare photographs collected by the editors of American Heritage.

"This is a wonderfully edited and printed book of pictures taken in the last century and in a small part of the 20th. The excellence of the photographs, taken with crude equipment compared to today's small cameras, should be studied by young photographers because photographic technique seems to be forgotten as young photographers run film through cameras without having a viewpoint."

THE CONCERNED PHOTOGRAPHER edited by Cornell Capa.

"Here in book form are exceptional pictures made by exceptional photographers from an exhibition with the same title."

WORDS AND PICTURES by Wilson Hicks.

"Pictures need a few words, and words need pic-

tures to hold reader attention and help tell the story. It's still the best of the books that touch this important concept."

PHOTOJOURNALISM by Arthur Rothstein.

"It probably comes closest to a textbook on all phases of picture editing. Rothstein's recent updating makes it current whereas other picture-editing books are still in the Speed Graphic flash-bulb era."

THE FAMILY OF MAN by Edward Steichen.

"This is a great collection of pictures which follows a simple but important theme."

PHOTOGRAPHY IS A LANGUAGE by John Whiting.

"Yes it is, and Whiting's book holds up better than some of the others on photojournalism. I understand he is updating it, which is good news."

THE HISTORY OF PHOTOGRAPHY by Beaumont Newhall.

"Any dedicated student or practitioner of photojournalism should know the basic history of photography. Newhall's history is definitive, accurate and easy to read."

Rich Clarkson

A skilled, prize-winning photographer, Rich Clarkson has also been deeply involved in educational activities for the National Press Photographers Association. To a question on how the cross-country Flying Short Course might be improved, a Los Angeles news photographer responded: "Find another Rich Clarkson." As national educational chairman, Clarkson has for four years assembled outstanding faculty teams for this important program. Among his other roles: chairman of the Pictures-of-the-Year competition; director of the student intern program; high school program director for NPPA.

Clarkson began working for the Lawrence (Kansas) *Daily Journal-World* while still in high school and became its first staff photographer while attending the University of Kansas. After graduating in 1956 with a degree in journalism, he served for two years in the Air Force as an information services officer. He then went to the Topeka *Capital-Journal* as chief photographer and since 1964 has been the paper's director of photography. Possessing a sharp eye for young talent, Clarkson has recruited an excellent photo staff for his paper.

He has freelanced for many of the major magazines, most frequently for *Sports Illustrated*. Besides illustrating several books, Clarkson co-authored THE JIM RYUN STORY published in 1967 by

Rich Clarkson

James Colson

Doubleday in the U.S. and by Pelham Books in England. Ryun is the record-breaking distance runner whom Clarkson encouraged to go into photojournalism. Clarkson's choices:

WORDS AND PICTURES by Wilson Hicks.

"This would be the first book I would recommend for a reading list. It will put everything else in perspective for someone concerned with photojournalism or visual communication. It is quite concerned with a particular magazine at a particular time but, remembering that, it's still valuable."

PICTURE EDITING by Kalish and Edom.

"This is rather old and out of date now. Hopefully, no one puts together *Milwaukee Journal* picture pages that way. Yet recognizing that much has changed, this book probably offers as much good thought as any ever done in the area of picture intent and use. Example: the excellent chapter for a newspaper's picture policy."

PHOTOJOURNALISM by Arthur Rothstein.

"The revised edition of the best book on all aspects of photojournalism makes it good and contemporary again. It's a perfect survey of the field and the only real hole in its coverage is television and film which anyone concerned with visual communications today must watch carefully."

THE FAMILY OF MAN by Edward Steichen.

"Of course, an obvious example of good and great photographs. But it's not the individual pictures that make this book valuable, it is their selection and combination, their use in concert that makes this the number one picture book to read, re-read and carefully consider."

VISUAL PERSUASION by Stephen Baker.

"Few of us know what pictures are really doing in readers' minds. This book is old now, but the messages are still pertinent. Individual reactions to pictures may have changed, but the important message to the photographer is still clear: start considering what photographs *really* communicate. It is a must book in my list."

A LIFE IN PHOTOGRAPHY by Edward Steichen.

"Through all this comes a unique philosophy that is well worth considering. Even if Steichen's contributions had yet to be discovered, if recognition had not yet come, if accomplishment was not yet noted—it would be well worth considering."

SUCCESSFUL COLOR PHOTOGRAPHY by Andreas Feininger.

"A good technical book essentially, but that's not what it seems to be. At first look, it's an elegant picture book. It's when you start reading through

the back pages that you see a craftsman using his mind, and the lessons are many."

LIFE LIBRARY OF PHOTOGRAPHY by the editors of Time-Life Books.

"This series is uniquely good and certainly contemporary. It is offering a really unique combination of nuts-and-bolts equipment discussion with both historically significant and currently excellent pictures. If I were to have read a prospectus on the series, I would have said there was no way it would come off. But it does and very well at that. And there is good material of value for everyone from the novice to the practiced professional."

James Colson

Professor James Colson has come full circle. He began as a still photographer, switched to cinema, and then returned to photojournalism. Colson, who has been successful in both fields as practitioner and teacher, knows now his first choice was the right one. He sees great potential in the communication power of the printed page. "I think," Colson says, "a whole movement in communication was lost, or delayed, or repressed because many word-picture communicators defected to film. I want to see much more experimentation with multiple picture-word combinations."

After studying still photography under Walt Allen, Clarence White, and Betty Truxell at Ohio University and a two-year stint as a Signal Corps photographer in Panama, Colson got the hard-to-earn M.A. Degree in Cinema at U.C.L.A. He has been supervisor of film production at Wayne State University and a film maker for independent producers. He recently made two motion pictures about the blind and "learned a lot about visual communication from them." Since 1968, he has taught photojournalism at the University of Texas at Austin where he has access to the famed Gernsheim Photography Collection. Colson sums up his endeavors by saying, "I am trying to understand and help others understand *camera communication."*

Colson: *"I believe that the book background of a photojournalist should include reading in seven broad categories. These categories may be imprecise because some books fit more than one, but it is more important that each category be well represented, than any particular book be noted. This is a personal list of books that are pivotal to my thinking and work. There are many more books of significance. By listing 28 works I haven't played the rules of the game so the ten 'most' have been starred—but it wasn't easy."*

Nature of Photography (regardless of use)

*THE PHOTOGRAPHER'S EYE by John Szarkowski.
"Neat, solid, basic thinking about photography. Brief statements illustrated from a broad cross section of photographic history."

*PHOTOGRAPHERS ON PHOTOGRAPHY edited by Nathan Lyons.
"The thinking and reminiscences of many major photographers. No illustrations."

*EYE, FILM AND CAMERA IN COLOR PHOTOGRAPHY by Ralph M. Evans.
"Much of the sophisticated thinking in this book applies to all photography. Very definitive about the nature of camera communication."

Nature of Photojournalism

*WORDS AND PICTURES by Wilson Hicks.
"Eighteen years should have given us something more in this vein, but I know of nothing that imparts as much general insight into the nature of photojournalism."

PHOTOGRAPHY IS A LANGUAGE by John R. Whiting.
"A very general book about how pictures work, and how photojournalists work. Another old book for a fast-changing field that has not been adequately replaced."

HOW LIFE GETS THE STORY by Stanley Rayfield.
"The main value of this series of two-page vignettes is its illustration of the drive and ingenuity needed in photojournalism."
PHOTOJOURNALISM by Arthur Rothstein.

The History of Photography

*THE HISTORY OF PHOTOGRAPHY From the Camera Obscura to the Beginning of the Modern Era by Helmut and Alison Gernsheim.
"There is nothing so comprehensive on the subject. Very well illustrated and well documented."

THE PHOTOGRAPH, A SOCIAL HISTORY by Michel Braive.
"Quite a different look at photo history. Also extremely well illustrated. Diffuse writing style that makes a lot of significant points about the nature of photography. A necessary interpretative balance to Gernsheim."

THE PICTURE HISTORY OF PHOTOGRAPHY by Peter Pollack.

PHOTOGRAPHY AND THE AMERICAN SCENE by Robert Taft.

THE DAGUERREOTYPE IN AMERICA by Beaumont Newhall.
"Anyone really interested in how photography has developed will attend to the last three listings."

Visual Communication

*ART AND VISUAL PERCEPTION, A PSYCHOLOGY OF THE CREATIVE EYE by Rudolf Arnheim.
"Arnheim's examples are from painting and the traditional visual arts, but this work should be of tremendous value in helping understand how picture elements work."

VISION IN MOTION, I by Laszlo Moholy-Nagy.
"The New Bauhaus philosophy of visual art. There is one chapter on photography but the entire work is a stimulating thesis."

VISUAL PERSUASION by Stephen Baker.

PHOTO-VISION by Ray Bethers.
"This and Ray Bethers' other books are easily absorbed instruction in composition which the photographer can apply. Especially helpful to the photographer with no formal art or art history background."

Visual Design

*VISUAL DESIGN: A PROBLEM-SOLVING APPROACH by Lillian Garrett.
"The most lucid and useful design book I've met."
LANGUAGE OF VISION by Gyorgy Kepes.

"More profound than lucid. Useful when absorbed slowly."

The Craft of Photojournalism (More "how to" and less philosophical than the category *Nature of Photojournalism)*

Andreas Feininger.
"Everything. I use his THE COMPLETE PHOTOGRAPHER as a basic text. He is the rare "how to" writer who understands and explains *why* in communication terms."

TECHNIQUES OF PHOTOJOURNALISM by Milton Feinberg.
"I find the organization of this book awkward, but there is a lot of useful information for the advanced photojournalism student."

BASIC PHOTOGRAPHY, A PRIMER FOR PROFESSIONALS by Michael J. Langford.
"A lot of basic photographic knowledge in a book that is useful for reference and teaching."

VIEW CAMERA TECHNIQUE by Leslie Stroebel.

LIGHTING FOR PHOTOGRAPHY, MEANS AND METHODS by Walter Nurnberg.
"Two special cases which must be noted are: 1) the lesson notebooks to the *Famous Photographers Course* which have invaluable craft advice, and 2) the LIFE LIBRARY OF PHOTOGRAPHY, which combines some technical information, some history, and some inspiration by example."

Examples for Inspiration

*W. EUGENE SMITH, His Photographs and Notes. An Aperture Monograph.
"For so many of us Smith is *the* example of both dedication and result. For one small book there is a broad representation of his work here."

*THE CONCERNED PHOTOGRAPHER edited by Cornell Capa.
"Because we are trying for a list of basic books, this one book has the work of six very good photojournalists and a title that emphasizes a major point about the work."

For inspiration by thought and picture the publication *Aperture* deserves special mention.

*THE WORLD OF HENRI CARTIER-BRESSON by Cartier-Bresson.
"The Decisive Moment is still as impressive, but this more recent work is more inclusive of Bresson's work, and more available."

THE FAMILY OF MAN by Edward Steichen.
"The best known example of what Nancy Newhall

Joe Costa

William Gruenberg

Arnold H. Crane

calls "additive captions" at work, in which "the writing leaps over the facts and adds a new dimension."

Joe Costa

For many, Joe Costa's name triggers a mental association with press photography and well it might. Costa was a founder, first president and, for 18 years, chairman of the board of the National Press Photographers Association. He also edited the association's National Press Photographer magazine. An award highly cherished by press protographers is given annually for "outstanding initiative, leadership and services in advancing the goals of NPPA in the tradition of Joseph Costa . . . "

Improving the image of the press photographer through emphasis on professionalism and education has been Costa's long-time objective. His 51 years in news photography began with the New York *Morning World* in the days of glass plates and flash powder. In 1947, after 20 years with the New York *Daily News,* he became photo supervisor and chief photographer for King Features Syndicate and the Sunday *Mirror Magazine*. When the *Mirror* folded in 1963, he freelanced for a brief period before joining World Book Science Service as an illustrations editor. Although he reached the age of compulsory retirement in 1969, he has remained active as freelancer, consultant, writer and lecturer.

Joe Costa's photographs are included in the permanent collections of the Brooklyn Museum and the Smithsonian, with Syracuse University the principal repository of his life's work. He is a faculty member of the Famous Photographers School of Westport, Connecticut, editor of the COMPLETE BOOK OF PRESS PHOTOGRAPHY and author of BEGINNER'S GUIDE TO COLOR PHOTOGRAPHY.

Costa: *"I've selected these ten books because together they come as close as is possible (with the books available today) to covering the field of photojournalism in a way that will be of most help to people aspiring to a career in this field. Please note that I did not include* LOOTENS ON PHOTO-GRAPHIC ENLARGING AND PRINT QUALITY, *by J. Ghislain Lootens, only because of the instruction to assume 'that the reader has a basic knowledge of photo technique.' However, emphasis on Lootens' subject is more necessary than ever, considering the quality of prints turned out by so many practitioners today."*

WORDS AND PICTURES, Wilson Hicks.

PICTURE EDITING, Kalish and Edom.

PHOTOJOURNALISM, Arthur Rothstein.

THE FAMILY OF MAN, Edward Steichen.

PHOTOGRAPHY IS A LANGUAGE, John Whiting.

THE HISTORY OF PHOTOGRAPHY, Beaumont Newhall.

THE COMPLETE BOOK OF PRESS PHOTOGRAPHY, edited by Joseph Costa.

MORE THAN MEETS THE EYE, Carl Mydans.

THE SCREEN ARTS, Edward Fischer.

NON-VERBAL COMMUNICATION, Jurgen Ruesch and Weldon Kees.

Arnold H. Crane

A man with multiple interests, Arnold Crane is not easily categorized. Among his other pursuits, he is a trial attorney who has found time to build one of the world's finest libraries of photographic history. His collection includes photographs, ephemera and some 7,000 books, a number of them rare enough to be kept in bank vaults. But he regards himself as a specialist rather than a collector and believes in sharing his materials with serious students of photography.

Crane has, since 1968, written a regular column relating to photographic books for *Panorama,* the Saturday supplement in the Chicago *Daily News,* and serves also as contributing editor to Compton's Encyclopedia, where his subject is photography.

"Books I recommend"

morial Award states, "To Clifton C. Edom in recognition of his devoted service in advancing photojournalism, idealistically and practically, as author, editor and teacher; for his initiative in creating high-level photo competitions, in developing the University of Missouri Photo Workshop, in founding Kappa Alpha Mu, the national honorary photojournalism fraternity . . ."

Edom: *"The first ten books that I would recommend for students who plan to make photojournalism their life's work are fairly recent publications. I have purposely avoided the how-to-do-it and picture editing books that were selected in the original book survey. I want to bring to the student a freshness not found in the mechanical approach.*

THE FAMILY OF MAN by Edward Steichen.

"A great collection of pictures. Roy Stryker said it gave both a new dimension and a new popularity to photography as communication."

THE DECISIVE MOMENT by Henri Cartier-Bresson.

"Cartier-Bresson, recognized as one of the outstanding photographers of all time, is a great reporter and a great technician."

MORE THAN MEETS THE EYE by Carl Mydans.

"This book without a single picture proves that the good camera reporter can have a way with words."

JAPAN by Werner Bischof.

"He was recognized as the photographer's photographer . . . a great man."

PORTRAIT OF MYSELF by Margaret Bourke-White.

"A fine autobiography revealing what it is that makes a good photographer click."

YANKEE NOMAD: A PHOTOGRAPHIC ODYSSEY by David Douglas Duncan.

"The autobiography of an outstanding photojournalist."

ERICH SALOMON: PORTRAIT OF AN AGE by Hans de Vries and Peter Hunter-Salomon.

"An intimate picture of the world's first 'candid' cameraman, written by his son . . . a wonderful book."

THE CONCERNED PHOTOGRAPHER edited by Cornell Capa.

"A beautiful collection of pictures by six photojournalists: David 'Chim' Seymour, Andre Kertesz, Robert Capa, Werner Bischof, Leonard Freed, Dan Weiner."

THE EYE OF EISENSTAEDT by Alfred Eisenstaedt with Arthur Goldsmith.

"It surpasses Eisenstaedt's WITNESS TO OUR TIME

because this smaller, more informal book gives us a closer touch with the photographer."

LIFE LIBRARY OF PHOTOGRAPHY by the editors of Time-Life Books.

"This series of books acts as a cornerstone and will plug the gaps left by the previous nine books."

"The ten "must" books listed above should be only the beginning of a reading program. I would expect my students to read the following books which I consider important:"

AMERICAN PHOTOGRAPHS by Walker Evans.

"Representative of the documentary school and of the work done by FSA under Roy Stryker, this book was labeled both an 'artistic accomplishment' and 'Roosevelt propaganda.' "

12 MILLION BLACK VOICES by Richard Wright with photo direction by Edwin Rosskam.

"The story of the Negro in America in photos taken for the Farm Security Administration. An excellent job of tying text and photos together."

MEMORABLE LIFE PHOTOGRAPHS with foreword by Edward Steichen.

"An exhibition by the Museum of Modern Art from the first 15 years of *Life*."

MR. LINCOLN'S CAMERAMAN: MATHEW BRADY by Roy Meredith.

"The pictures are interesting to compare with modern war photography and documentary work."

SLIGHTLY OUT OF FOCUS by Robert Capa.

"A sensitive photographic story of the European theater in World War II accompanied by a lively account of his experiences as a combat photographer. If not available, see IMAGES OF WAR edited by Cornell Capa."

THIS IS WAR by David Douglas Duncan.

"The ordeal suffered by U.S. marines in Korea. A text block introduces three sections of pictures that have no captions."

PICTURE MAKER OF THE OLD WEST, WILLIAM HENRY JACKSON by Clarence S. Jackson.

"An outstanding pictorial record of the western frontier by a developer of camera documentation and reportage."

AMERICA AND ALFRED STIEGLITZ by Waldo Frank et al.

"Twenty-four articles create a collective portrait of a great photographer."

JIMMY HARE, NEWS PHOTOGRAPHER by Cecil Carnes.

"The biography of the first news cameraman to

gain international reputation. His career began when *Colliers* magazine sent him to cover the Spanish-American War in 1898 and continued to World War I."

FACES OF DESTINY by Yousuf Karsh.

"Karsh explains the lighting techniques and methods that have made him famous in portraiture."

THE PICTORIAL PRESS: ITS ORIGIN AND PROGRESS by Mason Jackson.

HOW THE OTHER HALF LIVES by Jacob Riis.

YOU HAVE SEEN THEIR FACES by Erskine Caldwell and Margaret Bourke-White.

SHOOTING THE RUSSIAN WAR by Margaret Bourke-White.

HOME TOWN by Sherwood Anderson with pictures from the Farm Security Administration.

HOW LIFE GETS THE STORY by Stanley Rayfield.

DAYS TO REMEMBER by John Gunther and Bernard Quint.

A CHOICE OF WEAPONS by Gordon Parks.

DOROTHEA LANGE LOOKS AT THE AMERICAN COUNTRY WOMAN (commentary by Beaumont Newhall).

DOROTHEA LANGE (introductory essay by George P. Elliott).

THE PHOTOGRAPH, A SOCIAL HISTORY by Michel F. Braive.

HOUSE OF BONDAGE by Ernest Cole.

AMERICAN ALBUM—HOW WE LOOKED AND HOW WE LIVED IN A VANISHED U.S.A. Rare photographs collected by the editors of American Heritage.

SELF PORTRAIT, U.S.A. by David Douglas Duncan.

A LIFE IN PHOTOGRAPHY by Edward Steichen.

HISTORY OF PHOTOGRAPHY by Beaumont Newhall.

PICTURE HISTORY OF PHOTOGRAPHY by Peter Pollack.

WORDS AND PICTURES by Wilson Hicks.

PICTURE EDITING by Kalish and Edom.

THE TECHNIQUE OF THE PICTURE STORY by Daniel D. Mich and Edwin Aberman.

PHOTOGRAPHY IS A LANGUAGE by John Whiting.

PHOTOJOURNALISM by Arthur Rothstein.

Alfred Eisenstaedt

Alfred Eisenstaedt's name should be familiar to

Alfred Eisenstaedt

Steve Raymer

James A. Fosdick

anyone interested in photojournalism. If not, his credentials are on record in WITNESS TO OUR TIME, an autobiography, and THE EYE OF EISENSTAEDT, written in collaboration with Arthur Goldsmith. Born in West Prussia in 1899, the durable Eisenstaedt has had camera in hand since 1929 when he began pioneering the candid camera news photo for German picture magazines and Associated Press. His European reputation came to the attention of Daniel Longwell of Time, Inc., who was preparing a prototype dummy of *Life* magazine. In December, 1935, Eisenstaedt came to the U.S. and soon after joined Longwell's staff as one of the original quartet of *Life* photographers. In the years since, he has handled more than 1,600 assignments for the magazine and has had 64 *Life* covers. Most of the world's great personalities have been subjects of his portraiture.

Eisenstaedt has been acclaimed internationally. He was Magazine Photographer of the Year in 1950 and chosen as one of the world's ten best photographers in a 1958 poll conducted by . *Popular Photography*. The German Photographic Society awarded him its Cultural Prize and in 1961 he was presented with the 1,000,001st Leica camera. There have been two major exhibits of his work. The first, by George Eastman House in 1954, toured the U.S. and overseas. In 1963, the Smith-

sonian held a widely acclaimed Alfred Eisenstaedt exhibition. He is also a member of the guiding faculty of the Famous Photographers School. Eisenstaedt's recommendations:

WORDS AND PICTURES by Wilson Hicks.

PICTURE EDITING by Kalish and Edom.

THE FAMILY OF MAN by Edward Steichen.

THE CREATIVE PHOTOGRAPHER by Andreas Feininger.

PHOTOGRAPHY IS A LANGUAGE by John Whiting.

VISUAL PERSUASION by Stephen Baker.

THE DECISIVE MOMENT by Henri Cartier-Bresson.

FEININGER ON PHOTOGRAPHY by Andreas Feininger.

MORE THAN MEETS THE EYE by Carl Mydans.

SUCCESSFUL COLOR PHOTOGRAPHY by Andreas Feininger.

James A. Fosdick

James A. Fosdick has a wide-ranging interest in visual communication and is vitally concerned with the problems of how to best educate the photojournalist. As a professor of journalism, Fosdick directed the nationally known Kent State Univer-

sity Short Courses from 1948 to 1958, a period when interest in photojournalism was rapidly developing. This pioneering annual seminar attracted the country's best professional photographers.

Fosdick went on to study for his doctorate in mass communications at the University of Wisconsin and is presently a professor in the School of Journalism there and chairman of the Journalism Extension department. To develop young communicators he organized and directs the successful Wisconsin High School Journalism Workshops each summer. He has directed research in newspaper picture usage and source, the relationship between professionalism and performance in newspaper photography, journalism as a career choice, photography in war and peace. In the Association for Education in Journalism he has been chairman of the Photojournalism Division.

Prior to becoming an educator, Fosdick was a newspaper reporter-photographer, a company magazine editor and an army Captain in the Adjutant General's Department. His recommendations:

THE PHOTOGRAPH, A SOCIAL HISTORY by Michel F. Braive.

"Useful as a historical documentary of the uses and emphases which have been placed and misplaced on photography in its various social set-

195

tings over the years."

LIFE LIBRARY OF PHOTOGRAPHY by the editors of Time-Life Books.

"This series may well be *the* basic set of books for the photographer and photojournalist."

THE STUDENT JOURNALIST AND PHOTOJOURNALISM by Herb Germar.

"From a working (Minneapolis *Star*) newsman and picture editor, this is a book with much practical information and guidance, plus some history and esthetical background, for the editor or reporter or photographer who will be working with pictures. Primarily for newspaper workers."

THE COLOR BOOK by Andreas Feininger.

"Thorough and basic, this is a complete course in color for the photographer, well organized and well-illustrated."

ODD WORLD: A Photo Reporter's Story by John Phillips.

"From a successful photo-reporter—that is, one who can make pictures as well as write stories— this book brings out the importance of the photojournalist being aware of the world around him, its social, economic, and political realities, and the people who influence these realities . . . in order that he can anticipate the news and report and interpret it meaningfully for his audience. Phillips is not as good a photographer as, say, David Douglas Duncan, but he is perhaps at least as good a reporter and a writer. Too many photographers have a limited view of the world and limited capabilities with words."

THE EYE OF EISENSTAEDT by Alfred Eisenstaedt and Arthur Goldsmith.

"Reveals the personal philosophy and insights which contribute to the success of one of our greatest photojournalists."

NONVERBAL COMMUNICATION by Jurgen Ruesch and Weldon Kees.

"Photojournalists should realize that their pictures have a broader purpose than to attract readers and sell publications. Pictures are messages which can communicate. They are largely nonverbal communications and how they are perceived by editors and other readers influences what, if any, effects they will have. This book, among others, should help one understand how people perceive pictures as they try to understand relationships in their world."

WORDS AND PICTURES by Wilson Hicks.

"Though the picture magazine appears to be on its

way out, this book is still useful to one who wishes to understand the philosophy of the picture communication process and the relevance of words and juxtapositions."

PICTURE EDITING by Kalish and Edom.

"Does for the newspaper photojournalist what Hicks achieves for the magazine photojournalist . . . and a little more. Could be updated some, but is still valuable for education in newspaper picture editing."

PHOTOGRAPHY IS A LANGUAGE by John Whiting.

"Too bad this is out of print. Always has been an excellent book for helping the photographer develop his mind for meaningful picture stories. The interviews with successful photographers are stimulating . . . should be modernized with taped interviews with some of the current crop of top photojournalists."

Paul Fusco

Paul Fusco achieved what many photography majors only dream about. He began working for a major picture magazine while still a student. John Durniak in a 1962 issue of *Popular Photography* reported how it happened: "Allen Hurlburt, *Look* magazine art director, discovered Paul Fusco while helping Ohio University photography students lay out their pictures 'as *Look* would do it.' Fusco's pictures impressed Hurlburt who arranged for the student to take a summer job in the *Look* lab. 'He is one of the best journalistic photographers to come along,' said Hurlburt."

He feels best when he visually probes problems, the kind into which he can sink his teeth. As a concerned photographer he strives to make his readers concerned, too. His subjects range from the population crisis in India to the threatened destruction of Baja California by tourism; from Appalachian mining towns to the iron curtain countries. During the last five years he has suggested most of his own story ideas.

After the Korean war in which he was a Signal Corps photographer, he majored in photography at Ohio University and graduated with honors in 1957.

His interest in Cesar Chavez and the grape workers led to a *Look* story and eventually to a book in collaboration with George Horwitz titled LA CAUSA (Collier-Macmillan, 1970). With Bernard Gunther he has also produced SENSE RELAXATION: BELOW

Paul Fusco

YOUR MIND, a book on self awareness through exercise.

Fusco: "Unfortunately, I am not aware of any really good book on the subject at all, and I name the following, not because of what they say about photojournalism, but because of what the authors tried to do with the pictures. For me, their picture use says a great deal more about photojournalism than any book I've ever seen on editorial photography. Even Hicks' book is far from adequate.

"Since no one seems to be willing or able to make sense out of all that is going on in the field by trying to interpret and explain the different approaches being made, about the best anyone can do is to make sure that he is seeing as much as possible of what is being done in dailies and weeklies and books. The problem, as I see it and remember it from my own days as a student, is not just being exposed to the terribly exciting and immediate photographs of 'news events,' but to also look at and feel those stories of every-day matters that are really underlying strengths and weaknesses of our society.

"There seems to be two very important considerations in looking at the editorial photography being done today. First, in my own student days, there was all too much energy put into esoteric discus-

W. E. Garrett

sions and arguments about the 'art' of photography. We seem to be all too concerned as a group about being accepted. All we really should be concerned about is that it is a medium with which we can tell people something about other people or places and visually tell how we, as photographers, think and feel about a story subject. We know it works, and that should be enough. To learn about photojournalism, we should try to determine as specifically as possible exactly what the photographer intended to say and not be concerned only with the esthetics. Second, we should try to determine why pictures are used *together*. A picture alone says one thing. Used with others it takes on different and, hopefully, larger meanings. Pictures are used together to say something the single picture could not adequately explain. I suggest the following books not only for the worth of the individual pictures but because of the way they are used together to try to get at more encompassing and complex meanings. What is important is learning how to use pictures in combination.

"I can't emphasize enough, *look perceptively at what's being used!*"

WORDS AND PICTURES by Wilson Hicks.

THE FAMILY OF MAN by Edward Steichen.

THE PICTURE HISTORY OF PHOTOGRAPHY by Peter Pollack.

THE DECISIVE MOMENT by Henri Cartier-Bresson.

MORE THAN MEETS THE EYE by Carl Mydans.

THE INHABITANTS by Wright Morris.

PITTSBURGH by Eugene Smith (1959 *Photography Annual*).

THE AMERICANS by Robert Frank.

THE PENINSULA by Don Moser.

DAY BOOKS by Edward Weston. Vol. 1 Mexico, Vol. 2, California.

DIALOGUE WITH SOLITUDE by David Heath.

W. E. Garrett

At *National Geographic* magazine W. E. (Bill) Garrett has achieved a distinguished record as an editor, photographer and designer of photo exhibits. He joined the staff of the *Geographic* in 1954 as a picture editor after completing a major in journalism at the University of Missouri. During his tenure he has achieved the honor of "Magazine Photographer of the Year" in national competition, contributed pictures and text to more than a score of major stories, designed and produced photographic exhibitions for the New York World's Fair and Pictures of the Year competitions. Intellectually and verbally facile, Garrett has been a stimulating participant in photojournalism seminars at numerous universities as well as a staff member of the University of Missouri Photo Workshop for four years. His experience in all aspects of editorial production has given Bill Garrett a unique insight into visual communication problems. He is now an Assistant Editor.

Garrett: *"Many of the current illustrated books use photography better than books addressed to the photographic profession. David Douglas Duncan's books are good examples. The Texas Quarterly, for instance, uses photography effectively.* YEAR OF THE LAND, *published by the Canadian Government, is a huge volume of pictures on Canada which sold originally for $25 in 1967. Now out of print, the price has increased ten to twelve times. In these days of declining markets for still photography this success is encouraging.*

*"*PHOTOGRAPHIC LITERATURE *published by Morgan and Morgan is a 335-page bibliography of books and articles related to photography, cataloguing over 12,000 publications from Leonardo da Vinci's Journals up to 1962. Under news or journalistic photography they list only 17 books."*

WORDS AND PICTURES by Wilson Hicks.

"A classic even though dated."

PICTURE EDITING by Kalish and Edom.

"Still a primer for a newspaper photographer."

PHOTOJOURNALISM by Arthur Rothstein.

"Basic book and good."

THE FAMILY OF MAN by Edward Steichen.

"A subject vital to the 'information repertoire' of any photojournalist."

THE PICTURE HISTORY OF PHOTOGRAPHY by Peter Pollack.

THE HISTORY OF PHOTOGRAPHY by Beaumont Newhall.

"A knowledge of history prevents the necessity for repeating mistakes and can inspire new ideas."

THE COMPLETE BOOK OF PRESS PHOTOGRAPHY edited by Joseph Costa.

"Good both for practical as well as historical reasons."

THE DECISIVE MOMENT by Henri Cartier-Bresson.

"A great, if not the greatest, picture book!"

Robert E. Gilka

A LIFE IN PHOTOGRAPHY by Edward Steichen.
"Very valid to know Steichen as an influence."

MORE THAN MEETS THE EYE by Carl Mydans.
"Proof that word and picture talent often is common to the same person. Biographies or autobiographies of the great men of any field are valuable."

"Additional books that I personally recommend:"
SELF-PORTRAIT: U.S.A. by David Douglas Duncan.

SLIGHTLY OUT OF FOCUS by Robert Capa.

FROM ONE CHINA TO THE OTHER by Henri Cartier-Bresson.

THE YEARS WITH ROSS by James Thurber.

PEOPLE OF MOSCOW by Henri Cartier-Bresson.

HALFWAY TO FREEDOM by Margaret Bourke-White.

VANITY FAIR by Cleveland Amory and Frederic Bradlee.

THE PHOTOGRAPH, A SOCIAL HISTORY by Michel F. Braive.

THE HISTORY OF PHOTOGRAPHY, From the Camera Obscura to the Beginning of the Modern Era by Helmut and Alison Gernsheim.

Robert E. Gilka

As an extracurricular activity, Robert E. (Bob) Gilka has probably taught as many photographers and editors how to communicate with pictures as any full-time educator. In fact, teaching is a kind of second profession for him. During his 10 years as Sunday magazine editor and, later, picture editor of the *Milwaukee Journal,* he taught journalism courses at Marquette University. He has been a perennial staffer at the University of Missouri Photo Workshop, lecturer, and director of the annual cross-country Flying Short Course sponsored by the National Press Photographers Association and the U.S. Department of Defense. In addition, he is on the judges' panel for the William Randolph Hearst Foundation photojournalism scholarships and for three years was chairman of the NPPA education committee.

Gilka, who joined the staff of *National Geographic* magazine in 1958 as an assistant illustrations editor, became Director of Photography in 1963. In that position he promoted a program for summer trainees. College photojournalism students, selected on the basis of their picture portfolios, work with staff photographers or on their own to learn the realities of magazine photography.

Believing that photographers improve professionally by understanding the problems and philosophy of picture editing, Gilka was instrumental in arranging for *Geographic* staff photographers to work as picture editors for periods as long as six months. For his unselfish devotion to improving the quality of photojournalism and his guidance of young photographers, Gilka in 1967 received the National Press Photographers Association's highest honor, the Joseph A. Sprague Memorial Award. He also received the By-Line award for service to his profession from his alma mater, Marquette University. His choices:

PICTURE EDITING by Kalish and Edom.
"Still the basic picture editing guide, despite the fact that it is long overdue for revision. It is a tribute to the authors that so much still is valid."

THE FAMILY OF MAN by Edward Steichen.
"This book offers a great way to see good pictures, fast. It may be one of the few photographic books to 'live'."

THE HISTORY OF PHOTOGRAPHY by Beaumont Newhall.
"Yes, a must, still."

THE DECISIVE MOMENT by Henri Cartier-Bresson.
"The philosophy still is valid, although the book now is old."

SELF PORTRAIT: U.S.A. by David Douglas Duncan.
"For what may be the first time, a front ranking photojournalist shows how to work for, compete against, complement, and out-perform television while covering a major news event with still cameras."

MASTERS OF PHOTOGRAPHY by Beaumont and Nancy Newhall.
"A must, not for picture content alone, but because it offers pertinent comments on some of the early photographers now all but forgotten."

PARIS by Robert Doisneau.
"In a grimmer and grimmer world, some relief. One of the real humorists with a camera."

THE WORLD IS YOUNG by Wayne Miller.
"One of the few picture books serious enough and important enough to have and to hold."

LANGUAGE OF VISION by Gyorgy Kepes.
"Necessary for its lessons in design and composition, although the writing could be much more down to earth."

PHOTO-VISION by Ray Bethers.
"Good for its mechanics."

Russell Lee

Russell Lee's depth, compassion and understanding of the human condition make him a memorable photojournalist and an inspiring teacher. He came to national prominence during 'the bitter years' of the Great Depression. As a member of Roy Stryker's Photographic Unit in the Farm Security Administration, Russell Lee photographed those people whom President Roosevelt called "one-third of a nation ill-housed, ill-clad, ill-nourished." He went on to picture the way of life of the small town, rural areas, and Americana in general. One of his perceptive photo essays was "Pie Town, New Mexico" in which he quietly observed and recorded resettled migrants building a new life.

In 1946, he made a visual survey of the health and living conditions of bituminous coal miners for a government agency. He has gone on to extensive industrial and journalistic photography in Mexico, South America, Europe, Africa, and the Middle East. The results of three months of photography

Jim Bonar

Russell Lee

appeared in "Image of Italy," a special issue of *The Texas Quarterly* (1960) that was widely acclaimed.

Russell Lee, like many well-known photographers, changed career directions several times before discovering the camera's potential. Beginning as a chemical engineer, he switched to art. After attending the California School of Fine Arts, he moved to Woodstock, N.Y. where he studied painting with John Sloan and at the Art Students League. When he bought his first camera at age 32, he began photographing regional events such as county fairs, Father Divine and his angels, bootleg coal mining, and winter street scenes in New York City at the depth of the depression.

Russell Lee's work has appeared in many exhibits prior to his traveling Retrospective Exhibition (1965) that originated at the University of Texas. Collections of his photography are held by the Museum of Modern Art and the University of Louisville.

Russell Lee actively began sharing his rich photographic experience as a teacher when he became a staff member of the second annual University of Missouri Photo Workshop in 1950. He continued his association with this pioneering project until

1965 when he set up courses in photography for the Art Department of the University of Texas at Austin where he now teaches.

Lee: "*In the list of books and publications that I consider important to the aspiring photojournalist, I especially wish to emphasize the significance of the titles in the third group.*

From the Technical point of view:

BASIC PHOTO SERIES. The Negative. The Print. Natural Light Photography by Ansel Adams.

THE COMPLETE PHOTOGRAPHER by Andreas Feininger.

PHOTO-LAB INDEX by J. S. Carroll.

Modern Photography magazine.

Popular Photography magazine.
"Particularly the columnists."

From the Visual point of view:

THE FAMILY OF MAN by Edward Steichen.

THE PICTURE HISTORY OF PHOTOGRAPHY by Peter Pollack.

THE DECISIVE MOMENT by Henri Cartier-Bresson.

THE SKIRA series of art books dealing with all periods and forms of art.

LET US NOW PRAISE FAMOUS MEN by James Agee and Walker Evans.

Publications of The Museum of Modern Art.

Publications of The New York Graphic Society.

Infinity magazine.

Aperture magazine and books.

DU magazine.

To help build a broad base of knowledge about the world we live in, with particular emphasis on the U.S.A.

A STUDY OF HISTORY by Alfred Toynbee.

NORTH AMERICA by J. Russell Smith and M. O. Phillips.

LATIN AMERICA by Preston E. James.

A NATION TRANSFORMED—CREATION OF AN AMERICAN SOCIETY by Sigmund Diamond.

THE POPULATION BOMB by Dr. Paul R. Ehrlich.

THE SILENT SPRING by Rachel Carson.

THE ENVIRONMENTAL HANDBOOK edited by G. DeBell.

MOMENT IN THE SUN by Robert and Leona Train Rienow.

Yoichi Okamoto

THE MIND OF THE SOUTH by W. J. Cash.

The works of Walter Lippmann, Lewis Mumford, Margaret Mead, Clyde Kluckhohn, Ashley Montague.

Current publications in addition to the news and picture magazines:

New York *Times*, Wall Street *Journal*, Manchester *Guardian*, Paris *Match*, *The Saturday Review*, *Harper's*, *The Atlantic*.

Yoichi Okamoto

Yoichi Okamoto did what no other photographer has been able to do. He produced the first complete chronology of a U. S. President while in office. Having the confidence of Lyndon B. Johnson as well as top security clearance, Okamoto had complete freedom to record intimate personal moments, secret decision-making sessions and meetings with world leaders. Day and night for five years Okamoto's life belonged to the President. He took an estimated 75,000 pictures of history being made. Okamoto says: "I would classify my work at the

White House as that of a 'photographic-historian'."
The American Society of Magazine Photographers
cited Yoichi Okamoto "for bringing the highest
standards of photojournalism to documenting a
moment of American history."

Okamoto's career has been in military or government service except for a stint as a newspaper
photographer for the Syracuse *Post-Standard* after
graduating from Colgate University in 1938. He
enlisted in the Army in January 1942 and served as
a photography instructor in the Signal Corps until
appointed photographic officer to General Mark
Clark. In this capacity he was responsible for all
still and motion picture coverage for U. S. Forces
in Austria. In 1948, he joined the U. S. Information Service in Vienna and headed a staff of 40
Austrian photographers, editors and technicians.
Six years later he became Chief of the Still Picture
Branch of the U.S.I.A. in Washington, D.C.

Edward R. Murrow, the late director of U.S.I.A.,
asked Okamoto to photograph Vice President Johnson on his official visit to Berlin in August 1961
after the East Germans erected "the wall." Pleased
with Okamoto's coverage, Johnson requested that
he accompany him on his subsequent overseas
missions.

In 1962, at the request of the Department of State,
Okamoto made a six-month, round-the-world lecture and teaching tour on trends and techniques of
U.S. photojournalism aimed at foreign professional
photographers.

Okamoto has taught courses in creative photography, lectured at ASMP and NPPA seminars, and
for five years has been a staff member at the University of Missouri Photo Workshop. He has received the Certificate of Merit from the Miami
Conference on Communication Arts and the Newhouse Award from Syracuse University.

Okamoto: *"The basic list of photojournalism books
worries me. The technical books (Feininger) and
the historical (Pollack) are still valuable, but I
wonder if Hicks, Kalish and Edom, Whiting, Mich
aren't too outdated. They might confuse more than
help, considering today's market. Ralph Crane's
'Bad Boy' story, landmark that it was, would be
tough to sell today."*

WORDS AND PICTURES by Wilson Hicks.

PICTURE EDITING by Kalish and Edom.

THE FAMILY OF MAN by Edward Steichen.

THE CREATIVE PHOTOGRAPHER by Andreas Feininger.

Arthur Rothstein

VISUAL PERSUASION by Stephen Baker.

THE PICTURE HISTORY OF PHOTOGRAPHY by Peter
Pollack.

THE DECISIVE MOMENT by Henri Cartier-Bresson.

SUCCESSFUL COLOR PHOTOGRAPHY by Andreas Feininger.

A LIFE IN PHOTOGRAPHY by Edward Steichen.

"A walk through a life of photography with a giant
who knew how to stay with or ahead of his times."

MORE THAN MEETS THE EYE by Carl Mydans.

"A lesson in journalistic thinking."

*"My supplementary list of books has nothing to do
with photography but will help students understand our changing times and possibly help them
'get with it' with their cameras."*

RECOVERY OF CONFIDENCE by John Gardner.
 (or any of Gardner's books)

"Former Secretary of the Department of Health,
Education and Welfare, now head of the citizens'
lobby, Common Cause, Gardner is one of America's best thinkers. He offers practical solutions to
our problems. His writings can open many new
horizons for photographers if they really want to
get involved."

THE SELLING OF THE PRESIDENT 1968 by Joe McGinniss.

"To me, a most frightening book, revealing the
public gullibility that must be fought with rational
journalism and conscientious visual persuasion."

LET US NOW PRAISE FAMOUS MEN by James Agee
and Walker Evans.

"A lesson in observation, the importance of minutiae and the practice of empathy."

THE BROTHERS KARAMAZOV by Feodor Dostoevsky.
"A study of human motivations."

WALDEN by Henry David Thoreau.

"A lesson in thinking and developing convictions
as your own thing."

SELF PORTRAIT: U.S.A. by David Douglas Duncan.

"Beautiful reproduction and fine combination of
words and pictures that 'take us there' with the
photographer.

TOKYO by William Klein.

"A subjective look at a city and its people—subtle,
stimulating and sometimes frightening."

Arthur Rothstein

Graduating from Columbia University in the hard
times of 1935, Arthur Rothstein began his professional photographic career in fitting fashion: he
went to work for the Farm Security Administration
to help document the depression's effects. His most
famous picture, Dust Bowl, was made a year later
in the Oklahoma panhandle. A view of an impoverished farmer and his young sons walking in
eye-stinging dust past a half-buried shed, the photo
is considered a classic. Rothstein left FSA in 1940
to become a staff photographer for *Look* magazine
and later director of photography. During World
War II he was a Signal Corps photographer in China,
Burma and India.

His photographs are in permanent collections in
the Museum of Modern Art, George Eastman
House, the Library of Congress and the Royal
Photographic Society of Great Britain. He has received numerous awards in competitions and honors
from professional associations and societies.

A prolific writer and a specialist in color photography, Rothstein has authored CREATIVE COLOR and
CREATIVE PHOTOGRAPHY NOW as well as columns on
the subject for photo magazines. He collaborated
with William Saroyan on LOOK AT US, a book of

words and pictures about the U.S. His book, PHOTOJOURNALISM, is discussed on these pages as basic reading on the subject.

In addition to his photography and writing, Rothstein is a faculty member of the Graduate School of Journalism, Columbia University.

Rothstein: *"My selection is based on the premise that these books are to serve as a basic background for the photojournalist. Therefore, I have not included many worthwhile picture portfolios and works that demonstrate the visual thinking of individual photographers. I have also eliminated many books that are about technique because such methods often become obsolete. All the books I have listed contain facts, history and philosophies of special interest to editorial photographers."*

WORDS AND PICTURES by Wilson Hicks.

"An account of the visual thinking at a national picture magazine during its peak of pictorial influence."

PICTURE EDITING by Kalish and Edom.

"A basic text on picture use with much valuable information."

PHOTOJOURNALISM by Arthur Rothstein.

"The theory and practice of making photographs for publication."

PRESS PHOTOGRAPHY by Rhode and McCall.

"Photojournalism with emphasis on techniques for the newspaper."

PHOTOGRAPHY IS A LANGUAGE by John Whiting.

"A discussion of how the photograph becomes a medium of communication."

THE PICTURE HISTORY OF PHOTOGRAPHY by Peter Pollack.

"Examples of great photography from the beginning, with perceptive comments."

THE HISTORY OF PHOTOGRAPHY by Beaumont Newhall.

"A scholarly, historical analysis of trends in photography."

THE TECHNIQUE OF THE PICTURE STORY by Mich and Eberman.

"An early, still valid description of methods used for relating pictures to each other and to the text."

SAY IT WITH YOUR CAMERA by Jacob Deschin.

"An inspirational book of timeless truths."

INK ON PAPER by Edmund Arnold.

"Details about how pictures and graphics are used in modern publications."

Flip Schulke

Flip Schulke

Freelance photojournalist Flip Schulke's "specialty" in photography is complete diversity. He handles news, feature, sports, industrial and advertising photography with equal facility. If he were to admit a specialty, it would have to be underwater photography in which he has spectacular success. His beneath-the-surface pictures have won three medalist awards from the Underwater Photographic Society and the title "Underwater Photographer of the Year" (1967) at the International Underwater Film Festival. In 1959, his "Underwater Look at Water Skiing" won a first in the sports picture story category of the Pictures of the Year Competition, and in 1966, "Namu the Killer Whale" received third prize in the magazine picture story category of the same competition.

Schulke's portraits of the wife of Astronaut Gordon Cooper, and Mrs. Martin Luther King won firsts in national competition in 1965 and 1968. His news picture "Oxford, Mississippi Tear Gas" also received first prize in 1963.

His work is widely published in foreign publications as well as domestic, in general interest magazines as well as industrial. He has contributed a number of major stories to *Life* and *National Geographic* magazines.

After graduating from Macalester College in 1953, Schulke spent three years as an instructor and photographer at the University of Miami. There he was closely associated with Wilson Hicks. He left to launch a freelance career in association with Black Star.

Flip Schulke strives to have his pictures communicate what he knows, feels and believes. He says he does his best work on stories in which he is personally and emotionally involved. His concern and involvement also make him a very effective lecturer and instructor.

Schulke: *"I really wouldn't want to take any of the ten books I originally suggested off my 'must reading' list, so what I want to do is add a few more, for after all, none of us would really get anywhere reading ten books."*

WORDS AND PICTURES by Wilson Hicks.

"This is the only book which gives a photographer some idea of how a national magazine operates. More than a 'how-to-do-it' book, its philosophy of words and pictures is very important to an aspiring photojournalist. It has been of great help to me in my career."

THE FAMILY OF MAN by Edward Steichen.

"It is probably the best collection of journalistic work, between covers. Wouldn't it be wonderful if such a definitive work could be published, say, every 10 years?"

VISUAL PERSUASION by Stephen Baker.

"It gives some very helpful thoughts on arranging visual matter in the 'frame'. It also emphasizes the role of pictures in advertising and their emotional and intellectual effect on the viewer."

MORE THAN MEETS THE EYE by Carl Mydans.

"A photographer needs to be a *journalist* and this book shows and proves it without pictures."

Thomas R. Smith

much can be learned from all of his images."

"I agree with Russell Lee's very good reading suggestions for general background and would like to add two more:

Transaction magazine for general sociological background on today's problems. Keeps one right up to date.

Psychology Today magazine. If you have to take pictures of people, you must know how best to deal with them. This magazine is helpful in the whole area of inter-personal relationships.

"I would like to suggest my favorite trick to get to look at as many published pictures as possible. Make friends with the owner of the local magazine store. Take pictures of his kids or whatever. Then you can browse over hundreds of magazines without ruining your pocket book. My own newsdealer gets many foreign magazines, and I have learned a lot from *Stern* (Germany), *Epoca* (Italy), *Twen* (Germany), *Manchete* (Brazil), *Popular Photography Italiana* (Italy).

Thomas R. Smith

Thomas R. Smith has devoted his career to sharpening and refining the techniques of picture editing. His professionalism was recognized when he twice won the title of Picture Editor of the Year (1965, 1967) in the national competition conducted by the University of Missouri, NPPA and World Book Encyclopedia.

After graduation from the University of Missouri School of Journalism in 1952, Smith spent four years on the picture desk of the *Milwaukee Journal*. Since then he has worked for *National Geographic* magazine where, as associate illustrations editor, he supervises the editing, layout and production of all pictures for the magazine.

Like many of his colleagues Smith has also been an active educator. He has taught a class in photojournalism at George Washington University for nine years, conducted the photography session at the Missouri High School Publications Workshop for six, and has been on the staff of the University of Missouri Photo Workshop for nine sessions. His recommendations:

SUCCESSFUL COLOR PHOTOGRAPHY by Andreas Feininger.

"A good technical book."

THE STORY OF ART by E. H. Gombrich.

"Covers the subject well, one which I feel the photographer should have more than a nodding acquaintance with. I personally warn against getting too wrapped up in the other visual arts or you won't develop those aspects of photography which make it unique and different from the other visual arts."

LANGUAGE OF VISION by Gyorgy Kepes.

"An older book that contains much about how we 'talk' with vision and visual effects in a 'frame'."

THE WORLD IS YOUNG by Wayne Miller.

"An example of one good photojournalist's view of an all-inclusive topic. It shows photojournalistic 'thinking'."

CORRECTIVE PHOTOGRAPHY by Lewis Kellsey.

"Again an older book but a short book which teaches nearly all there is to know technically about corrections which can be made with a view camera."

OBSERVATIONS by Richard Avedon.

"One photojournalist's thoughts on people. Interpretive photography examples."

YANKEE NOMAD by David Douglas Duncan.

I PROTEST by David Douglas Duncan.

SELF PORTRAIT: U.S.A. by David Douglas Duncan.

"If one really cares, I mean really *cares,* a photojournalist's ideas and feelings and thoughts can come across. Duncan is still the photojournalist's photojournalist. He still *cares,* and cares a helluva lot. He goes, he photographs, he gets published, he influences. And through it all, his resulting product pays his way. He has a rare kind of genius (and I realize that few are geniuses) from which we can learn so much. The reader should realize that Duncan was handed nothing on a silver platter. He *earned* by hard work, sweat and real guts his reputation and place in photojournalism. Sometimes I feel that the technical ease of 35mm photography today hinders rather than helps the development of the type of photojournalist Dave Duncan typifies."

W. EUGENE SMITH, His Photographs and Notes. An Aperture Monograph.

"He is one of the 'masters' and it shows through in this book. Gene Smith has had his problems, but

WORDS AND PICTURES by Wilson Hicks.

"Still a must for aspiring photojournalists."

PICTURE EDITING by Kalish and Edom.

"Best in its time. Needs updating."

PHOTOJOURNALISM by Arthur Rothstein.

"Good, solid advice."

PRESS PHOTOGRAPHY by Rhode and McCall.

"My text for five years."

THE FAMILY OF MAN by Edward Steichen.

"A landmark achievement in our profession."

PHOTOGRAPHY IS A LANGUAGE by John Whiting.

"A literate, yet uncomplicated statement on what it's all about."

THE HISTORY OF PHOTOGRAPHY by Beaumont Newhall.

"For me, the best of the histories."

THE DECISIVE MOMENT by Henri Cartier-Bresson.

"The essence of photojournalism is seeing and communicating. C-B sees better than most."

A LIFE IN PHOTOGRAPHY by Edward Steichen.

"We should study our giants—those with great influence like Steichen."

MORE THAN MEETS THE EYE by Carl Mydans.

"It is good to step aside and analyze, to weigh the worth of what we do. Mydan's book is inspirational."

Edward Steichen

When Edward Steichen was asked to revise and update his book recommendations, he replied: "I do not remember having participated in your polling project in 1964, and I do not wish to comment on any book on photography as I don't believe in such a means of educating photographers.

"The only advice I have to give is to keep on photographing, which is the best way of learning." Despite his change of mind, Steichen's original list was an excellent one and worth studying:

FAMILY OF MAN by Edward Steichen.

PHOTOGRAPHY IS A LANGUAGE by John R. Whiting.

THE HISTORY OF PHOTOGRAPHY by Beaumont Newhall.

WORDS AND PICTURES by Wilson Hicks.

MORE THAN MEETS THE EYE by Carl Mydans.

PHOTOGRAPHY AND THE AMERICAN SCENE by Robert Taft.

IMAGES OF WAR by Robert Capa.

ERICH SALOMON: PORTRAIT OF AN AGE by Hans de Vries and Peter Hunter-Salomon.

THE PAINTER AND THE PHOTOGRAPHER by Van Deren Coke.

AN AMERICAN EXODUS, A Record of Human Erosion, by Dorothea Lange and Paul Taylor.

Arthur Witman

A pace-setter in photography, Arthur Witman in the early '30s pioneered in two areas: in-depth picture coverage and the use of 35-mm cameras in press assignments. He covered an enormous variety of subjects and won numerous awards during his 26 years on the staff of *Pictures,* the high-quality Sunday supplement of the St. Louis *Post-Dispatch.* One of his pictures, a rural audience reacting to a traveling tent show, has a prominent place in THE FAMILY OF MAN. Among the many honors accorded Witman: University of Missouri School of Journalism Medal "for distinguished service in journalism" in 1964; Joseph A. Sprague Memorial Award; Kappa Alpha Mu's Founders Award; five awards in the annual TWA photographic competition.

A charter member of the National Press Photographers Association, Witman was its only two-time president (1954-1958). He has been active in its educational programs as a Flying Short Course lecturer, including three series of courses in Europe for military photographers. He also represented NPPA on the American Council for Education in Journalism from 1960 to 1968.

A long-term photo project for Witman was his color documentation of the construction of the Gateway Arch in St. Louis. These pictures became a part of his recently published guide book on the city.

During four years in the U.S. Army Air Service (1923-1927), Witman became an instructor in aerial photography. After his discharge he worked for Fairchild Aerial Survey until, in 1932, he began 37 years of distinguished photography for the *Post-Dispatch.* In "retirement," he has served as visiting professor at Southern Illinois University Department of Journalism and has freelanced. His book choices:

WORDS AND PICTURES by Wilson Hicks.

PICTURE EDITING by Kalish and Edom.

PHOTOJOURNALISM by Arthur Rothstein.

PRESS PHOTOGRAPHY by Rhode and McCall.

THE FAMILY OF MAN by Edward Steichen.

THE CREATIVE PHOTOGRAPHER by Andreas Feininger.

PHOTOGRAPHY IS A LANGUAGE by John Whiting.

Arthur Witman

THE DECISIVE MOMENT by Cartier-Bresson.

FEININGER ON PHOTOGRAPHY by Andreas Feininger.

SUCCESSFUL COLOR PHOTOGRAPHY by Andreas Feininger.

"Additional books I personally recommend:"

PHOTOGRAPHY, ITS MATERIALS AND PROCESSES by C. B. Neblette.

"Contains a wealth of technical information."

WITNESS TO OUR TIME by Alfred Eisenstaedt.

"Chronicles contemporary history."

ERICH SALOMON: PORTRAIT OF AN AGE by Hans de Vries and Peter Hunter-Salomon.

THE WORLD OF ATGET by Berenice Abbott.

"These books enable one to judge modern photojournalism from the viewpoint of the pioneers."

SHADOW OF LIGHT by Bill Brandt.

COLOR PHOTOGRAPHY by Eliot Elisofon.

PHOTOGRAPHIC VISION by Zvonko Glyck.

"These reveal interesting techniques."

LIFE LIBRARY OF PHOTOGRAPHY by the editors of Time-Life Books.

203

Steve Honigsbaum

Donald K. Woolley

Donald K. Woolley

Donald K. Woolley is an eye-opener on the speaker's rostrum as well as an innovative, challenging teacher of photojournalism at the University of Iowa where he received his M.A. in 1965. A graduate in photojournalism at the University of Missouri, he has had extensive newspaper experience on Missouri weeklies and dailies. He is as effective behind a camera as in front of a typewriter. Woolley also spent two years in public relations for a large shoe manufacturer. He has kept in close touch with newspapermen through active participation in the Iowa and National Press Photographers Associations. In 1968, he won the Governor's Award for the picture best depicting Iowa's beauty.

Woolley: *"I'd like to call my list 'The first ten books I'd suggest reading,' and they are not in the order of my preference. For some people ten books is a lifetime of reading, unfortunately. For others, ten is a few weeks' reading. Some people use books to decorate with. I want to emphasize that reading books and studying pictures never ends. Anyone who lands at a strange airport and doesn't head for the newsstand to pick up the local papers to see what's going on pictorially isn't really interested in picture editing and photojournalism."*

WORDS AND PICTURES by Wilson Hicks.

"Words and Pictures *do* go together—and Hicks makes this clear."

PICTURE EDITING by Kalish and Edom.

"This book is quite outdated but serves as part of the history of picture editing, the way things used to be done. The section on modular makeup should be forever banished; this concept of picture editing has long passed from the scene of the progressive magazines and papers. Pictures are not blocks."

PHOTOJOURNALISM by Arthur Rothstein.

"Again, dated but with enough that remains unchanged to inspire and instruct the beginner in our field."

THE FAMILY OF MAN by Edward Steichen.

"I would include this for inspiration. I use it in teaching picture editing and have the students cut it up, lay out pages on themes such as 'peace', 'war', 'happiness of childhood', etc. This not only exposes them to great pictures but gives them exercise in scaling and laying out pages."

THE CREATIVE PHOTOGRAPHER by Andreas Feininger.

"Yes, yes, yes!"

PHOTOGRAPHY IS A LANGUAGE by John Whiting.

"And I'll go along with this one too!"

VISUAL PERSUASION by Stephen Baker.

"This book is a must. It offers insight into the theory of pictorial representation. It should make the reader aware of how visually oriented we are."

NONVERBAL COMMUNICATION by Jurgen Ruesch and Weldon Kees.

"Pictures include various elements of nonverbal communication (gestures, signs, expressions) as well as being a form of nonverbal communication themselves. To understand the whole, we must understand the parts. This book helps to achieve this."

ART AND ILLUSION—A Study in the Psychology of Pictorial Representation by E. H. Gombrich.

"Again, some background into what pictures are all about."

TECHNIQUES OF ADVERTISING PHOTOGRAPHY by Joachim Giebelhausen.

"I have always felt that advertising to a large extent pioneers in new ways of telling—and that is what photojournalism is all about, isn't it? Telling!"

Bibliography

Abbott, Berenice. THE WORLD OF ATGET. Horizon, 1964.

Adams, Ansel. BASIC PHOTO SERIES: Natural Light Photography, 1963, The Print, 1967, The Negative, 1968. Morgan & Morgan.

Amory, Cleveland and Frederic Bradlee. VANITY FAIR. Viking, 1960.

Agee, James and Walker Evans. LET US NOW PRAISE FAMOUS MEN. Houghton Mifflin, 1960. Ballantine, 1970 (paper).

American Heritage. AMERICAN ALBUM—HOW WE LOOKED AND LIVED IN A VANISHED U.S.A. Simon & Schuster, 1968.

Anderson, Sherwood. HOME TOWN. Alliance, 1940.

Arnheim, Rudolf. ART AND VISUAL PERCEPTION. University of California Press, 1954. 4th printing, 1969 (paper).

Arnold, Edmund. INK ON PAPER. Harper & Row, 1963.

Avedon, Richard and Truman Capote. OBSERVATIONS. Simon & Schuster, 1959.

Baker, Stephen. VISUAL PERSUASION. McGraw-Hill, 1961.

Bethers, Ray. PHOTO-VISION. St. Martin's Press, 1957.

Bischof, Werner. JAPAN. Simon & Schuster, 1955.

Bourke-White, Margaret.

PIATILETKA, Russia's Five Year Plan by Michael Farbman, photos by Bourke-White. New Republic, Inc., 1931.

NEWSPRINT. International Paper Sales Co., Inc., 1939.

SHOOTING THE RUSSIAN WAR. Simon & Schuster, 1942.

HALFWAY TO FREEDOM. Simon & Schuster, 1949.

PORTRAIT OF MYSELF. Simon & Schuster, 1963.

Braive, Michel. THE PHOTOGRAPH, A SOCIAL HISTORY. McGraw-Hill, 1966.

Brandt, Bill. SHADOW OF LIGHT. Viking, 1966.

Brassai. PARIS DE NUIT (PARIS AT NIGHT) Arts et Metiers Graphiques, 1933.

CAMERA IN PARIS. Focal Press, London, 1949.

Caldwell, Erskine and Margaret Bourke-White. SAY, IS THIS THE U.S.A.? Duell, Sloan & Pearce, 1941.

YOU HAVE SEEN THEIR FACES. Modern Age Books, 1937.

Capa, Cornell, editor. THE CONCERNED PHOTOGRAPHER. Grossman, 1969.

Capa, Robert. IMAGES OF WAR. Grossman, 1964.

SLIGHTLY OUT OF FOCUS. Henry Holt, 1947.

Carnes, Cecil. JIMMY HARE, NEWS PHOTOGRAPHER. Macmillan, 1940.

Carroll, John S., editor. PHOTO-LAB INDEX. Morgan & Morgan, 23rd edition 1964. (continuously updated).

Carson, Rachel. THE SILENT SPRING. Houghton, 1962. Crest, 1970 (paper).

Cartier-Bresson, Henri. THE DECISIVE MOMENT. Simon & Schuster, 1952.

THE EUROPEANS. Simon & Schuster, 1955.

PEOPLE OF MOSCOW. Simon & Schuster, 1955.

FROM ONE CHINA TO THE OTHER. Universe Books, 1956.

THE WORLD OF HENRI CARTIER-BRESSON. Viking, 1968.

Cash, W. J. THE MIND OF THE SOUTH. Knopf, 1960.

Cole, Ernest. HOUSE OF BONDAGE. Random House, 1967.

Costa, Joseph, editor. THE COMPLETE BOOK OF PRESS PHOTOGRAPHY. National Press Photographers Association, 1950.

De Bell, Garrett, editor. THE ENVIRONMENTAL HANDBOOK. Ballantine, 1970.

De Vries, Hans and Peter Hunter-Salomon. ERICH SALOMON: PORTRAIT OF AN AGE. Macmillan, 1968.

Deschin, Jacob. SAY WITH YOUR CAMERA. Ziff Davis, 1960.

Diamond, Sigmund. A NATION TRANSFORMED—CREATION OF AN INDUSTRIAL SOCIETY. Braziller, 1963.

Doisneau, Robert. PARIS. Simon & Schuster, 1957.

Dostoevsky, Feodor. THE BROTHERS KARAMAZOV. 1880. Macmillan, 1948. Bantam, 1970 (paper).

Duncan, David Douglas. THIS IS WAR. Harper & Bros., 1951.

YANKEE NOMAD. Holt, Rinehart & Winston, 1966.

I PROTEST. Signet, 1968.

SELF PORTRAIT: U.S.A. Abrams, 1969.

Ehrlich, Paul R. THE POPULATION BOMB. Ballantine, 1968.

Eisenstaedt, Alfred. WITNESS TO OUR TIME. Viking, 1967.

Eisenstaedt, Alfred with Arthur Goldsmith. THE EYE OF EISENSTAEDT. Viking, 1969.

Elisofon, Eliot. COLOR PHOTOGRAPHY. Viking, 1961.

Evans, Ralph. EYE, FILM AND CAMERA IN COLOR PHOTOGRAPHY. Wiley, 1959.

Evans, Walker. AMERICAN PHOTOGRAPHS. Museum of Modern Art, 1938. Harper & Bros., 1951.

Feinberg, Milton. TECHNIQUES OF PHOTOJOURNALISM. Wiley, 1970.

Feininger, Andreas. FEININGER ON PHOTOGRAPHY. Ziff-Davis, 1949.

SUCCESSFUL COLOR PHOTOGRAPHY. Prentice-Hall, 1954. 4th ed., 1966.

THE CREATIVE PHOTOGRAPHER. Prentice-Hall, 1955. 6th printing, 1967.

THE WORLD THROUGH MY EYES. Crown, 1963.

THE COMPLETE PHOTOGRAPHER. Prentice-Hall, 1966.

THE COLOR PHOTO BOOK (II). Prentice-Hall, 1969.

Fischer, Edward. THE SCREEN ARTS. Skeed & Ward, 1960.

Frank, Robert. THE AMERICANS. Aperture-Grossman, 1968, '69.

Frank, Waldo, et al. AMERICA AND ALFRED STIEGLITZ. Doubleday, 1934.

Gardner, John. RECOVERY OF CONFIDENCE. Norton, 1970.

Garrett, Lillian. VISUAL DESIGN: A PROBLEM-SOLVING APPROACH. Reinhold, 1967.

Germar, Herb. THE STUDENT JOURNALIST AND PHOTOJOURNALISM. Richards Rosen, 1967.

Gernsheim, Helmut and Alison Gernsheim. THE HISTORY OF PHOTOGRAPHY FROM THE CAMERA OBSCURA TO THE BEGINNING OF THE MODERN ERA. McGraw-Hill, 1969.

Giebelhausen, Joachim. TECHNIQUES OF ADVERTISING PHOTOGRAPHY. Kling Photo Corp., 1964.

Glyck, Zvonko. PHOTOGRAPHIC VISION. Chilton, 1965.

Gombrich, E. H. ART AND ILLUSION—A STUDY IN THE PSYCHOLOGY OF PICTORIAL REPRESENTATION. Princeton University Press, 1961.

THE STORY OF ART. Phaidon, 1966.

Gräff, Werner. ES KOMMT DER NEUE FOTOGRAF! (THE NEW PHOTOGRAPH IS COMING!). Verlag Hermann Reckendorf, 1929.

Gunther, John and Bernard Quint. DAYS TO REMEMBER. Harper & Bros., 1956.

Heath, David. DIALOGUE WITH SOLITUDE. Horizon Press, 1965.

Hicks, Wilson. WORDS AND PICTURES. Harper & Bros., 1952.

Bibliography

Jackson, Clarence. PICTURE MAKER OF THE OLD WEST, WILLIAM HENRY JACKSON. Scribner, 1947.

James, Preston E. LATIN AMERICA. Odyssey Press, 1964.

Kalish, Stanley E. and Clifton C. Edom. PICTURE EDITING. Rinehart & Co., 1951.

Karsh, Yousuf. FACES OF DESTINY. Ziff-Davis, 1946. PORTRAITS OF GREATNESS. Thomas Nelson, 1959, '60, '61.

Kellsey, Lewis. CORRECTIVE PHOTOGRAPHY. L. F. Deardorff, 1947.

Kepes, Gyorgy. LANGUAGE OF VISION. Paul Theobald, 1951.

Klein, William. TOKYO. Crown, 1964.

Lange, Dorothea. DOROTHEA LANGE. Museum of Modern Art, Doubleday, 1966.

DOROTHEA LANGE LOOKS AT THE AMERICAN COUNTRY WOMAN. Ward Ritchie Press, 1967.

Lange, Dorothea and Paul Taylor. AN AMERICAN EXODUS, A RECORD OF HUMAN EROSION. Reynal & Hitchcock, 1939.

Langford, Michael J. BASIC PHOTOGRAPHY, A PRIMER FOR PROFESSIONALS. Focal Press, 1965.

Lyons, Nathan, editor. PHOTOGRAPHERS ON PHOTOGRAPHY. Prentice-Hall, 1966.

McGinniss, Joe. THE SELLING OF THE PRESIDENT. Trident, 1969. Pocket Book, 1970 (paper).

Meredith, Roy. MR. LINCOLN'S CAMERAMAN: MATHEW BRADY. Scribner, 1946.

Mich, Daniel D. and Edwin Eberman. THE TECHNIQUE OF THE PICTURE STORY. McGraw-Hill, 1945.

Miller, Wayne. THE WORLD IS YOUNG. Ridge Press, 1960.

Moholy-Nagy, Laszlo. MALEREI, FOTOGRAPHIE, FILM (PAINTING, PHOTOGRAPHY, FILM). Albert Langer Verlag, Munchen, 1927. Facsimile in English translation, MIT Press, 1967.

VISION IN MOTION. Paul Theobald, 1947.

Morris, Wright. THE INHABITANTS. Scribners, 1946.

Moser, Don. THE PENINSULA. Sierra Club, 1962.

Mydans, Carl. MORE THAN MEETS THE EYE. Harper & Bros., 1959.

Newhall, Beaumont. THE DAGUERREOTYPE IN AMERICA. Duell, Sloan & Pearce, 1961.

THE HISTORY OF PHOTOGRAPHY. Museum of Modern Art, Doubleday, 1964.

Newhall, Beaumont & Nancy Newhall MASTERS OF PHOTOGRAPHY. Braziller, 1958.

Neblette, C. B. PHOTOGRAPHY, ITS MATERIALS AND PROCESSES. D. Van Nostrand Co., 1952. 6th edition, 1962.

Nurnberg, Walter. LIGHTING FOR PHOTOGRAPHY, MEANS AND METHODS. Pitman, 1948. Chilton, 16th revised edition, 1968.

Parks, Gordon. A CHOICE OF WEAPONS. Harper & Row, 1966.

Penn, Irving. MOMENTS PRESERVED. Simon & Schuster, 1960.

Phillips, John. ODD WORLD: A PHOTO REPORTER'S STORY. Simon & Schuster, 1959.

Pollack, Peter. THE PICTURE HISTORY OF PHOTOGRAPHY. Abrams, 1958. Revised and enlarged edition, 1969.

Porter, Eliot. IN WILDNESS IS THE PRESERVATION OF THE WORLD. Sierra Club, 1962.

Rayfield, Stanley. HOW LIFE GETS THE STORY. Doubleday, 1955.

Renger-Patzsch, Albert. DIE WELT IST SCHON (THE WORLD IS BEAUTIFUL) Kurt Wolff Verlag, 1928. EISEN UND STAHL (IRON AND STEEL). H. Rechendorf, Berlin, 1931.

Rhode, Robert B. and Floyd H. McCall. PRESS PHOTOGRAPHY. Macmillan, 1961.

Rienow, Robert and Leona Train Rienow. MOMENT IN THE SUN. Dial, 1967. Ballantine, 1970 (paper).

Riis, Jacob. HOW THE OTHER HALF LIVES. Scribner, 1904.

Roh, Franz. FOTO AUGE (PHOTO EYE). Werkbund, Stuttgart, 1929.

Rothstein, Arthur. PHOTOJOURNALISM. Chilton, 1957. 2nd edition, 1965.

Ruesch, Jurgen and Weldon Kees. NON-VERBAL COMMUNICATION. University of California Press, 1956.

Schulthess, Emil. AFRICA. Simon & Schuster, 1959. THE AMAZON. Simon & Schuster, 1962. ANTARCTICA. Simon & Schuster, 1966. CHINA. Viking, 1966.

Skira, Albert. THE SKIRA SERIES OF ART BOOKS. Arno, 1968.

Smith, Eugene. "Pittsburgh," *Photography Annual*, 1959.

W. EUGENE SMITH, HIS PHOTOGRAPHS AND NOTES. An Aperture Monograph, 1969.

Smith, J. Russell and M. O. Phillips. NORTH AMERICA. Greenwood, 1942.

Steichen, Edward. MEMORABLE LIFE PHOTOGRAPHS. Museum of Modern Art, 1951.

THE FAMILY OF MAN. Simon & Schuster, 1955. Signet, 1967.

A LIFE IN PHOTOGRAPHY. Doubleday, 1963.

Stroebel, Leslie. VIEW CAMERA TECHNIQUE. Communication Art Books, 1967.

Szarkowski, John. THE PHOTOGRAPHER'S EYE. Museum of Modern Art, 1966.

Taft, Robert. PHOTOGRAPHY AND THE AMERICAN SCENE. Macmillan, 1938. Dover, 1964 (paper).

Thoreau, Henry David. WALDEN. 1854. Prentice-Hall, 1968.

Thurber, James. THE YEARS WITH ROSS. Little, Brown & Co., 1959.

Time-Life Books, editors. LIFE LIBRARY OF PHOTOGRAPHY. 1970, '71.

Toynbee, Alfred. A STUDY OF HISTORY. Oxford University Press, 1934. Dell, 1970 (paper).

Weston, Edward. DAY BOOKS. Vol. I, Mexico, 1961. Vol. II, California, 1966. Horizon Press & George Eastman House.

Whiting, John. PHOTOGRAPHY IS A LANGUAGE. Ziff-Davis, 1946.

Wright, Richard with photo direction by Edwin Rosskam. 12 MILLION BLACK VOICES. Viking, 1941, '42, '46.

Picture Credits

Adelglass, Melvin 19
Bischof, Werner 181 top left
Bonar, Jim 199 left
Brower, Dr. L. P. 60–61 top
Connor, Dennis 53
Coyle, Bob 108
Cupp, David 15, 20, 22, 23
Daran, Walter 21 top
Doisneau, Robert 138
Edmonds, Barry 113, 115
Ford Motor Co. 136 bottom left
Georgia, Lowell 27
Goodman, Robert B. 180 top center
Gruenberg, William 191 right
Grossman, Shelly 14
Haun, Declan 156, 157
Harris, Wade 183 left
Hartup, Carl R. 180 bottom center
Honigsbaum, Steve 204
Janu, Rudolph 72, 73
Kelly, Tony 155
Keyes, Con 147 bottom
Kinney, Dallas 109
Koner, Marvin 100, 101, 102, 103
Koshollek, George P. 52
Kuykendall, Bill 116, 117
Larson, Henry F. 137 bottom right
Lightfoot, Robert M. III 5, 66, 67
Linck, Tony 16
Lopez, M. Leon 21 bottom, 38, 78, 127 top right
Los Angeles County Air Pollution Control District 51
Luster, Bill 111
Matthews, Merrill 107
McCullough, Robert 130
McDougall, Angus 10, 12, 17 top, 18, 24, 26, 28, 29, 30, 31, 32, 34, 36 top, bottom right, 39, 43, 44, 46, 48, 49, 54, 55, 58, 62, 63, 64, 65, 76, 79–92, 94, 95, 96, 97, 118, 119, 120, 122 bottom, 123, 125, 126–127 bottom, 127 top left, 128, 129, 131, 133, 134 right, 135 bottom, 140, 146, 147 top, 148–149 top, 149 bottom right, 180 right, 181 bottom, 184

McNear, Everett 170, 178, 179, 180, 181 bottom, 182 right
Moore, Charles 154 right
Nadel, Leonard 75
Parks, Winfield 139 top
Patterson, Nolan 37 top, 180 top left
Peterson, John 132 bottom
Pickerell, James H. 13
Raymer, Steve 195
Roberts, Bruce 47, 70–71
Rozumalski, Ted 124, 154 left
Sarsini, Enrico 35
Sisson, Jane 137 top
Smith, Verna Mae 193 right
Spiegel, Ted 17 bottom, 40, 41, 98, 99
Sroda, Dick 110, 112
St. Gil, Marc 56
Stage, John Lewis 162 bottom
Strode, Bill 150, 151, 152, 153
Swanson, Dick 57
Swartz, Fred 60–61 bottom
Towers, Bob 180 bottom left
Turner, L. Roger 42
Van Wormer, Joe 59
Zug, Joan Liffring 139 bottom

Index